CONTENTS

ACKNOWLEDGMENTS

Tracing these drawings has taken me two years. Foremost among those I wish to thank in this connection is Evelyn Joll of Thomas Agnew & Sons, without whose willing help this book would not have been possible. My thanks must go also to the many necessarily anonymous owners of drawings who have allowed their much-loved works to be photographed and reproduced here and who have kindly permitted me to intrude on their privacy in order to do so.

A profound debt of gratitude must be paid to Dr John Gage. His authoritative knowledge of Turner's life and works would make one feel totally insufficient were it not balanced by his desire to share the fruits of his labours, and he has made his enthusiasm for this book clear from the very start. I must also thank him for reading my manuscript and for his many helpful suggestions in connection with it. Andrew Wilton must also be thanked for his useful critical contribution, and I am deeply indebted to him for consenting to write an Introduction.

Others whom I wish to thank are Iain Bain whose exhaustive knowledge of early nineteenth-century engraving sent me to many invaluable sources; Mr James Edwards, Archivist of the Department of Archives and Manuscripts at the University of Reading, Berkshire, for help with the Longman archives; Anne Tennant for allowing me to quote from the Rogers letter discovered by her; the indefatigable Ann Forsdyke; Peter Moore, David Hofman and Martyn Tillier of the British Museum Print Room; Julian Agnew; Susan Valentine of Thomas Agnew & Sons Ltd; David Posnett of the Leger Gallery; Charles Leggatt of Leggatt Brothers; Edward King of Messrs Spink & Son Ltd; Angus Lloyd of Oscar & Peter Johnson Ltd; Matthew Alexander of the Guildford Museum for his great help with *St Catherines Hill, Guildford*; Patrick Cormack MP and Mrs Jane Fiddick of the House of Commons Library for their help with the drawing of *Northampton*; Mrs Ginsburg of the Dress Department of the Victoria and Albert Museum; Miss Arnold of Northampton Public Library; A. W. Moore, Keeper of Art at the Atkinson Art Gallery, Southport, for facilitating the reproduction of *Tynemouth*; Michael and Sidney Bartholomew of Washington D.C. for their running help in attempting to trace drawings that have disappeared in America; Rodney Burke, Librarian of Chelsea School of Art, and his predecessor Clive Philpott; Jacky Pearce, Gillian Hunkin and Vivienne Shadboult of Chelsea School of Art Library, Lime Grove; Coral Macpherson, Jane Churchill and Jacqueline G. Darville for typing the manuscript with endless patience.

E. S.

CREDITS

Photography
Mick Duff: Plates 4, 7, 13, 15, 19, 21, 24, 25, 26, 29, 33, 35, 36, 37, 39, 41, 46, 52, 62, 73, 75, 85, 90
John Freeman: Plate 93, Illustration 1
Anthony Price: Plate 78
John Webb: Plates 12, 68

Illustrations
The illustrations reproduced in the text are by kind permission of the following: The British Museum 3, 4, 5, 6, 7, 8, 9, 10, 12; Leger Gallery 11; Wolverhampton Art Gallery and Museums 1.

NOTE TO THE READER

The term 'drawings' used throughout this book is the traditional appellation for watercolours.

Where there are discrepancies between picture captions and commentary titles, the commentary titles are correct.

INTRODUCTION
by Andrew Wilton

Turner is often thought of as a painter who progressed with magnificent and revolutionary thoroughness from a pedestrian, topographical discipline to the sublimities of a visionary, if not an abstract art. Topography was merely the uninspiring loam in which his career took root; the radiant blossom itself bore no trace of its murky origins. Certainly, it is sometimes hard to recognize in the golden mists and 'tinted steam' of his mature paintings anything of the painstaking architectural drawing, the conscientious perspective and neat colouring, that made up his earliest exercises. In the opinion of many people indeed, mists and steam were extraneous to the topographer's language, phenomena which, if sometimes picturesque, tended to obscure 'truth'.

And yet the topographical school in England was rarely, if ever, as limited in its practice as such basic principles might imply. Its finest exponents brought a controlled and orderly, but fresh and vital, vision to the world around them, and while pursuing an unpretentious *métier* whose aim was to supply information merely, they wrought remarkable changes in the technical application of their chosen medium of watercolour. Topography was not a phenomenon of the eighteenth century which died in the romantic revolution, never to be reborn. It was one of the hardiest of art forms—largely because of its practical origins—and survived the technical and aesthetic upheavals of the period to become a fruitful theme in the nineteenth century.

It remains commonplace today, though for the most part the photographer has replaced the draughtsman as its principal exponent. The Impressionists frequently practised topography, recording the Paris that they knew, and the countryside of their holiday weekends, just as English artists recorded London and the rustic or antiquarian charms of the country around it, as an expression of pleasure in seen things. If the Impressionists evolved a new way of saying what they had to say, the eighteenth century topographers did no less: many of them can be classed among the most technically inventive painters of their period.

Turner, the most inventive of them all, by no means felt topography to be an inhibiting mode, from which it was necessary to burst free. He worked in several other *genre*, and developed them astonishingly, it is true. The 'grand style' of historical painting, the most ambitious art form of the time, was as much his medium as was view-painting. But while he transformed this, and other academically respectable forms such as idealized landscape, into a rarefied personal language, he worked in the mode of topography all his life without feeling the need to change its essence. He did, however, bring about an unexpected *rapprochement* between historical painting and topography, which was crucial to both strands in his art. But that *rapprochement* was made possible by Turner's acute perception of the real nature of topography, and his adaptation of his art to express it to the full.

What then does 'topography' consist of?

According to a periodical of the early 1780s which devoted itself specifically to the subject, topography involved two distinct activities: on the one hand 'Delineations of the Face of Countries', and on the other local history, as manifested in antiquities and 'The History and Description of Eminent Seats and Stiles of Architecture'. The topographer's task was both to describe present appearance, and to reconstruct past history. These aims might be achieved verbally or pictorially; obviously, the artist was initially employed simply as illustrator of the historian's argument, making factual records of evidence as it was found in ruined buildings, inscribed monuments, earthworks and so on. Monumental surveys like Francis Grose's *Antiquities of England and Wales*, published between 1773 and 1787, or Daniel Lyson's *The Environs of London*, of 1792–6, which was 'an historical account of the towns, villages, and hamlets, within twelve miles of that capital . . . with biographical anecdotes', usually published engraved views of the buildings that form the subjects of successive short descriptive articles. Such views were required to be literal records, and were often conscientiously stripped of any emotional suggestions: scientific history was the object; charm and atmosphere strictly eliminated.

Despite the proliferation of learned topographical tomes, this was never the most important application of the artist's skills. More frequently he was required to make drawings for private pleasure, or for engraving as plates to be sold either in series or separately, partly for information, but partly for the decorative value of compositions depicting elegantly planned country houses and parks, or ancient and crumbling religious or military edifices. Regardless of technical distinctions between what was 'picturesque' and what was 'beautiful' (in the eighteenth century the terms had quite precise meanings), topographical draughtsmen endeavoured to create attractive images carrying with them some atmosphere of their own—if only the vague appeal of bland summer sunshine on tidy sweeps of lawn. In cases like these, where there might be no accompanying text, the artist had to do more than simply draw what he saw. He had to suggest what could not necessarily be seen: the social, economic and historical associations of the spot. Sometimes this was easy. A brand-new country house could be shown in its grounds, with formal gardens, timber-yielding woods, lakes, cornfields, and industrious gardeners, woodmen, shepherds, harvesters at work. This idea, most gratifying to the landowner, went back to the large painted house-portraits, projected in bird's-eye view by countless hack viewmakers, often of Dutch origin, throughout the seventeenth century. An urban subject also supplied its own easily found social detail; the life of the place could

be evoked by a judicious sprinkling of folk in the street—tradesmen, fashionables, schoolboys, beggars, and so on, gave life to the scene and implied the larger context of the surrounding world.

Artists confronted a greater problem in the case of buildings without modern connections. A ruined abbey or castle, perhaps standing in open country, bore a message which rather eluded such easy reference. A popular solution to the difficulty was to introduce visitors from afar, tourists and searchers for beauty and history. A well-dressed gentleman extending an arm in astonishment was a simple formula, a ready-made symbol of the aesthetic and intellectual attractions of the spot. Such devices were employed automatically, from a proper sense of how the viewer understands what the artist is saying: like the chorus in a tragedy, the figures in a view explain it to us, and help us to get it into focus. At the same time, scenes such as hayfields and market squares could not really be expressed at all without the humanity that made them 'work'.

This perception was vital to Turner. His earliest exhibited watercolour, which appeared on the walls of the Royal Academy in 1790, when he was fifteen, exemplifies the basic principle. (Note that topography was not excluded from the Academy: it was by this date a wholly acceptable and flourishing branch—if a minor one—of serious art.) Turner's drawing shows the yard in front of Lambeth Palace in London, and though the venerable masonry of the Palace itself is the ostensible subject, we are inevitably preoccupied by the people in the street that takes up the foreground. They are not many: a fashionable couple is almost isolated in the centre; but beyond them we see a man on a bench outside a wine-shop, talking with the shopman through the window; a woman carrying a bundle on her head, and accompanied by a boy and a frisking dog; a man attending to an upturned rowing-boat (we are close to the river); and an approaching waggon. The variety of life is grasped and expressed by a careful selection of representative 'staffage'. This is a very early example, in which we can see Turner's heavy dependence on his masters—especially, here, the architectural topographer Thomas Malton, for whom he had been working a year or two before

this. But already we detect a more purposeful discrimination, a nicer economy of statement, than we find in Malton and his contemporaries. Turner intends that this view should be, not merely an account of the visible facts of the site, but a lively, rounded picture of the place, its inhabitants and their doings.

In the same way—though with noticeably greater skill—he responded a little later to another London street scene. A building was destroyed by fire in Oxford Street in January 1792, and Turner was not satisfied with a mere elevation of the ruin— fascinating as that was to him, for the cold weather had turned the water from the hoses to icicles which caught the rosy light of the early morning, a motif that he explored on its own account. He wanted to convey the atmosphere of the scene as he found it: the activity of the firemen, with their engine, buckets and hoses; the gathered crowds, the inquisitive children, a party surveying the damage. The fact of the fire is recorded as a thorough journalist might have written it up; as an event involving many people in different ways. This sense of the interaction of people with their environment underlies all the best topography. It was to become an important theme of much romantic landscape painting, and for Turner it was an essential element in nearly all his art. We have only to think of some of his most famous paintings to realise that even in his grandest and least 'topographical' moments he was concerned with the same thing. *Calais Pier* (1803), for instance, records the dangers of the sea as they affect those who travel on it, or seek their livelihood by it. Even a grandiose, idealized scene like that of *Dido Building Carthage* (1815) is realised, not merely as an assemblage of splendid theatrical elements, but as a coherent social and historical phenomenon, in which administrators, architects and engineers, stevedores, carpenters and masons, are all evidently engaged in a project that Turner has conceived as a paradigm of human achievements and their eventual failure.

In *Dido* Turner was, of course, painting landscape on the most elevated and serious level. Its allusion to the hallowed art of Claude Lorraine, who had invented the 'Sunset Harbour' theme in

the seventeenth century—is deliberate and calculated to contribute to the grandeur of its impact. But while Turner practised his art on such widely different levels, it was nevertheless the same art; the same penetration and comprehension were brought to bear on rustic cottages and village streets as on the imagined glories of the mythological past.

We have moved ahead rather rapidly to measure the scope of Turner's view of landscape; in so doing we have progressed from the mundane life of contemporary London to a more abstract kind of subject-matter. But Turner himself did not 'progress' in this way. For him, both preoccupations marched together, and each stimulated and influenced the other. The heroic always benefited from the immediacy of his observations of the world about him, while his everyday topography borrowed, more and more, the dignity of his classical pictures.

Turner's was a mind that lent itself to the expansion and multiplication of detail, both imagined and observed. His grasp of the totality of a scene, and his wish to express that totality in the terms of serious art, inevitably led to a cramming of his picture-spaces with the most heterogeneous matter; rather as a novelist will invent a whole city and its population in order to present a way of life and examine human behaviour in detail. There is at least one watercolour of the 1790s which is prophetic of this important theme in Turner's art, and particularly illuminating in relation to the 'England and Wales' series. This is the view of *Woolverhampton, Staffordshire* (Ill.1) which appeared at the Royal Academy in 1796. Here Turner gives us an extraordinarily rich and complete account of a fair in the streets of the town, the old buildings that we should expect to be the focus of his concern almost obscured by the tents and awnings, scaffolds and placards and platforms among which stall-holders cry, buyers haggle, children and dogs play, actors leap, musicians perform, and a mass of multifarious activity goes forward. This is the delighted fascination with life that links Turner so closely to Hogarth and Dickens as one of the great English commentators on the contemporary world. And like those men, Turner had a wonderful

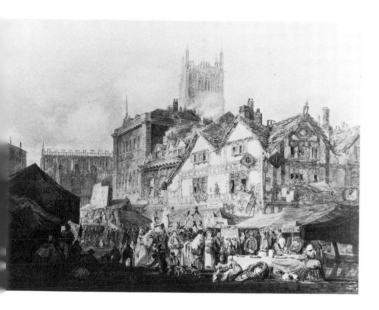

1 Woolverhampton, Staffordshire (320mm × 420mm, 12½" × 16 2/5")

breadth of sympathy: as Ruskin knew, his understanding of the world was equalled only by Shakespeare. (In the 'England and Wales' drawings, he was sometimes to take his sympathy where Ruskin was unable to follow.)

The composition of *Woolverhampton* is almost impenetrably complex. The eye darts rapidly from part to part, just as it would on such an occasion in reality. Turner nevertheless subdues the scurry of detail: he throws a broad light across the scene, giving prominence to some features, obscuring others in the shade. He even manages by this means to stress the picturesque architecture beyond the crowds. This is not the uniform insistence on each separate part that makes a picture like Frith's *Derby Day* (1858), for example, difficult to read and absorb. The composition remains a single coherent whole.

As his ideas expanded, Turner's need to reconcile proliferating detail with a broad compositional scheme became acute. He developed a watercolour method which gave him enormous scope in the rendering of minutiae: using a small pointed brush he worked in tiny strokes, building up form while at the same time suggesting its elusiveness and mobility. Such a process was as effective in rendering the movement of light and shadow across a hillside as it was in recording the subtle life of a human face, and it was a technique that Turner borrowed from the miniature portrait-painters. But the mosaic of small touches was not itself enough. It had to be combined with a broader plan. From an early date Turner had experimented with methods of binding his compositions together into unified structures. His practice as a painter probably suggested to him that by 'laying in' the main masses of his design in boldly opposed blocks of colour he could achieve a balance and unity that would underpin the elaborate statement that was to be evolved later. In the course of working out these foundations of basic colour he produced many studies which are more or less devoid of specific detail, and which simply explore the possibilities of an overall scheme. During the 1810s and 1820s the presence of these 'colour structures' becomes increasingly apparent in the finished watercolours: by mentally stripping away the accretion of detail we can uncover in any one of them a basic opposition of, say, blue and ochre, or purple and green, which may not correspond at all to the precise forms of the image itself, but exists in its own right as the foundation of Turner's design, and blends the forms into masses, opposing each other on a principle of composition that overrides specific appearances.

The evolution of this working process, which enabled Turner to cram complex, often very grand ideas into a small space, was probably a direct consequence of his work as a designer of views for engraving. The eighteenth-century survey of antiquities and picturesque views remained very popular throughout the first half of the nineteenth century, and though its subject-matter varied over the years (foreign views, for instance, began to be popular after 1815), it remained a mixture of history, aesthetics, and engraved illustration. In spite of his constant activity as a painter Turner found time to contribute very substantially to this continuing tradition; so much so that we can examine only a representative sample of his output as a topographical illustrator here. Two of his patrons were especially influential in shaping the development of his work in this *genre*. One was the local historian Thomas Dunham Whitaker, whose *History of the Original Parish of Whalley and Honour of Clitheroe* came out in 1801 with plates engraved after Turner. In these designs Turner restricted himself to a modest format, with relatively simple records of the sites; he used figures only occasionally, and indulged in no dramatic flights of imagination. But when Whitaker commissioned plates for a 'History of Richmondshire' (part of Yorkshire and Lancashire) in 1816, a far more impressive set of watercolours appeared. The mountains and dales of Yorkshire, the striking settings of its towns, inspired Turner to produce a series of masterpieces in which the scenery and antiquities of the region are presented with breathtaking grandeur, and at the same time enlivened with figures that illustrate precisely the life of its inhabitants. The bleakest spot is not without its clambering goats or lonely wayfarer; the most distant prospect is punctuated with the rising columns of smoke that indicate labour or habitation. By these means the viewer is invited to experience the full extent of the scenery presented.

Another of Whitaker's enterprises, a history of Leeds and its neighbourhood with the Old English title of *Loidis and Elmete* (1816), prompted a view of that city which exemplifies the 'total topography' of which Turner had become such a master. It shows the town in its hollow of hills, the houses and spires partly obscured by the smoke of the modern factories that were transforming it into a thriving city. The distant hills receive the passing showers and sunshine of a changeable English day, and clouds also cast intermittent shadows across the foreground, where a typical stone wall of the district is being built; people gather mushrooms in the field; a milkman passes on his donkey, and a butcher trudges uphill carrying a pig's carcase.

New housing sprawls out of the town into the countryside. The geography and economy of the place are succinctly and accurately stated in a splendidly varied and sensitive view. There is no conflict between the demands of 'science' and those of art.

The other important commission of these years was that of the engraver-publisher William Bernard Cooke, who with his brother George issued a long series of 'Picturesque Views of the Southern Coast of England' between 1814 and 1826. In this case, the plates were commissioned for their own sake, and any text that was envisaged was thought of as an accompaniment only. There were forty subjects, drawn and engraved on a small scale, but often very ambitious in their content. The view of *Falmouth Harbour*, for instance, presents a superb panorama of sea and land, with a vigorously invented foreground of carousing sailors and their Nancies which clearly relates to the theme broached by the fleet of ships at anchor in the calm waters beyond. At *Rye*, two horses drawing a cart along a causeway gallop to escape the incoming tide; at *Hythe*, a division of soldiers with its baggage waggons steadily climbs the hill out of the town, past a gun emplacement; more troops are being drilled in the parade ground below. The splendid view beyond is for our delectation, but not at the moment for theirs.

All these themes recur in the 'England and Wales' series. But there is a difference. Hitherto, Turner seems to have introduced his staffage as incidental (if important) to his designs, following the traditional topographical use of such accessories. Now he builds his whole conception of the topographical scheme around them. Some of the subjects, it is true, are similar to the 'Richmond-shire' designs; indeed one or two of them, including the views of Richmond itself (10,23), and the *Chain Bridge over the Tees* (84), might almost have been executed for the earlier project; but the first watercolour that we can confidently date in the new series, the *Saltash* (1) of 1825, announces a new mood, quite unlike that of any previous water-colours. The whole of the landscape subject has been translated into a figure composition, and the figures themselves are designed to express in the most vivid way the natural phenomena of calm sunshine and still water, airy openness and distant haze, which have become only secondary in the composition itself.

This drawing heralds a view of England and Wales as geographical entities comprising men and women, children and animals, for whom expansive skies, stormy seas, steep hills, muddy roads and calm lakes are the conditions of life. It is the 'Shakespearean' view that Turner's comprehensive sympathy compelled from him. Themes like those of *Woolverhampton* and *Falmouth* recur frequently: the country fair, the sailor ashore, the stage-coach emptying its passengers, children at play, sightseers, shopkeepers, masons, quarryers, horsedealers, bargemen, sawyers, revenue officers, haymakers, housewives, shrimpers, millers, colliers, sportsmen, soldiers, shepherds, scholars, truants, noblemen, politicians, priests, teachers, peasants, prostitutes, all inhabit these richly varied lands and enjoy their sunshine, suffer their storms, contemplate their sunsets, and shelter from their showers. These are modern 'history pictures' in which the common man is the hero.

The landscape itself is correspondingly elevated. Sometimes it is transmuted by a saturating glow of summer sunlight into a Claudian idyll: in the views of *Prudhoe* (11) and *Trematon* (98) English countrywomen assume the roles of Italian *contadine* or contemplative nymphs in blissful meditation on the loveliness of their homeland; elsewhere, in the *Richmond Hill and Bridge* (44), for instance, a formal, classical design is used as the framework for a wittily observed scene of middle-class recreation. Mighty thunderstorms burst over hurrying travellers; tremendous seas break on beaches strewn with the wreckage which is the livelihood of bands of scavangers; the whole artillery of Sublime art is marshalled to express the drama of real life in Turner's own time. This is a wealth of knowledge and understanding which is hardly, it seems, to be crammed into a few small sheets of paper!

But Turner's methods of compression and organization were, as we have seen, remarkable. More of his 'colour structures' survive for the 'England and Wales' than for any other project. These alone testify to his sense of the need to control and subdue his response to the ebullient and abounding knowledge within him. And his actual choice of subject-matter, as we should expect, is far from random. It may be that he selected his scenes more or less arbitrarily from pencil notes that he had made in his sketchbooks. But he orchestrated each with masterly precision to express the meaning inherent in the subject. For example, the view of Blenheim Palace (52), which we see from the gateway across the park shimmering magically in the distance, is a crisply framed account of the life of the place: the owner of the great house, his friends and servants, ride to hounds on the left, while a visiting group of ladies (evidently from a much lower rank of life) stand awestruck in the shadow of the gate. The two principal functions of the Palace are pithily outlined: on the one hand it is the lavishly endowed pleasure-ground of a nobleman; on the other it is a tourist attraction, no less wonderful for its sheer alien opulence than for the artistry of its landscaping or architecture.

Ruskin, while he perceived the universal vision of this series, oddly failed to grasp Turner's real point. He objected to the view of *Louth* (18), for instance, that its horse-fair (which we recognise at once as a typical subject, handled with great freshness and wit) was something Turner 'clearly felt to be objectionable, and painted, first, as a part, and a very principal part, of the English scenery he had undertaken to illustrate; and yet more, I fear, to please the publisher, ... He dwells (I think ironically) on the elaborate carving of the church spire, with which the foreground interests are so distantly and vaguely connected.' In the same way, he made even more forceful criticisms of the view of *Dockyard, Devonport* (27), going so far as to say that Turner's relish for the vulgar was 'ugly and wrong'.

This reaction of Ruskin, Turner's most ardent apologist and his supremely penetrating interpreter, illustrates how far Turner's view was removed from the critic's conception of art; how 'practical' his 'imagination' truly was, and on what a solid

foundation of compassion his work rests. Turner's acceptance is broader and more loving than Ruskin's critical approval (and occasional disapproval); it transcends criticism or cavilling, and records only what is there, because it is there, and an integral feature of the human comedy.

Turner has often been said to have had no 'school'; his art brought to an end a line of thought about landscape, consummated and concluded all that had been done before. If he was an innovator, it was not till long afterwards that men came to recognise that fact. But in one respect he taught his contemporaries and successors an important lesson: he made them understand that man is as much a phenomenon of the natural world as are mountains, fields and oceans. He painted the face of the earth as it was, inhabited by men, tended, feared, exploited and changed by men. It was a central theme of Romantic art: Samuel Palmer, a devoted admirer of Turner, summed up the idea when he wrote, 'Landscape is of little value, but as it hints or expresses the haunts and doings of man'. The sense of the immanence of man and his works in nature is as important to Romanticism as any sense of an immanent God. In the landscape art of the 1830s, '40s and '50s we can recognise the steady spread of the idea. Artists increasingly concentrated on the human element as it took its place with the natural elements. Constable himself, the antithesis of Turner in almost every way, who used figures equally appropriately to express his own types of landscape, came in his later life under the sway of the doctrine, and painted several pictures that celebrate the ubiquity and elemental presence of man: his *Opening of Waterloo Bridge* (exhibited 1832) is almost a pastiche of Turner's broad expanses filled with smoke and human activity. Frith's turbulent crowds, at Ramsgate, Paddington, or Epsom Downs, though almost entirely divorced from their landscape context, are the progeny of the same far-felt impulse. It is an irony that has rarely been appreciated, that Turner's greatness as a landscape painter was largely due to his complete assimilation of the principles of 'history' painting and his brilliant application of them to his own requirements.

AUTHOR'S PREFACE

The original watercolour drawings made by J.M.W. Turner RA for subsequent line-engraving as the 'Picturesque Views in England and Wales' are the largest related series of important pictures by any major Western artist that is still virtually unknown to the public at large. They have never been shown together, and only on two or three occasions has any moderate group of them been shown at all. Most Turner biographies barely mention them. A.J. Finberg, who wrote what remains the most exhaustive life of Turner to date, covers them in no more than two pages. Only a small percentage of them have ever been widely reproduced. It is understandable in the context of Turner's vast *oeuvre* that this series of watercolours, physically separated as it is, should have been largely overlooked in importance; yet together with the late Swiss watercolours, they are probably Turner's finest work in this medium.

Their obscurity, of course, is a result of their being separated. Turner created all of these drawings for transcription by engravers and allowed them to be sold off individually after the process was completed. He probably intended the engravings to be seen together as a series, and their subsequent neglect, and, indeed, of the whole art of line-engraving after subjects by Turner, has led in turn to a disregard of the original watercolours. In addition, their dispersal in different museums and private collections around the world has made an evaluation of them as a series virtually impossible.

The purpose of this book, therefore, is to bring together again as many of the watercolours as can be traced, or where they remain untraced, to reproduce the engravings; to relate the history of the project; to argue for a new evaluation of the drawings, both individually and within the context of Turner's *oeuvre* (in particular examining a neglected aspect of them, the significance of their symbolism); to place them within one of the most crucial periods of Turner's life; and finally and most importantly to restore as far as possible public awareness of a work that brought nineteenth-century line engraving, and indeed English watercolour drawing, to its height, a work moreover that with its variety, lyricism and unmatched powers of observation, gives us a unique survey of the Britain of Turner's age.

THE ENGRAVINGS

'... sacrificing all the picturesque to the pictorial'

SIGNAC

The British economy was booming in 1825. The end of the long Napoleonic Wars in 1815 had been followed by unemployment, inflation, economic stagnation and social unrest, and not until a series of financial reforms was instituted in 1823 was there any measurable upturn and consequent growth in the economy. By the summer of 1825, however, the effects of this change were appreciable: property had risen in value, the building trade was flourishing and other industries, such as wool and cotton manufacturing and the iron and steel trades, also seemed in a healthy state, leading in turn to a decline in agricultural distress.

However, this buoyancy was not to last. Too long unaccustomed to the perils of prosperity, by the late autumn the country was again in the throes of financial crisis. Wild speculation and over-optimism led to the inevitable 'crash', as demand for goods slackened, stocks accumulated and prices fell. On 5 December, 1825, the giant banking house of Sir Peter Pole & Co suspended payment and, as they held the accounts of forty-four country banks, the next few weeks saw no less than seventy-eight banks, including five great London banks, forced to close.

Turner was not unaffected. He mentions, in a letter to James Holworthy in May 1826 that: 'while the crash among the publishers has changed things to a standstill, and in some cases to loss, I have not escaped'.[1] This refers to the fact that during January 1826 Hurst & Robinson, Const-

able, and another publisher, Ballantyne, were all forced into bankruptcy as a consequence of the earlier crash.

This then was the inauspicious economic context within which a major print-publishing venture was launched by Charles Heath and J.M.W. Turner RA. Sometime in the summer of 1825[2] they had come to an agreement that Turner would produce a large quantity of watercolours over a number of years, from which Charles Heath would choose 120 to be line-engraved and subsequently published under the title of 'Picturesque Views in England and Wales'.

The engraving, on copper plates, was to be carried out under Heath's supervision, and financing the venture was to be the joint responsibility of Heath and the publishers, Robert Jennings & Co., a City firm of print-publishers to be responsible for their marketing and distribution. The original watercolours were to be bought from Turner by Heath who would re-sell them after they had been engraved. Accounts vary as to how much Turner was paid for them: Rawlinson[3] states that, 'Turner received sixty to seventy guineas apiece for them', but Finberg[4] considers this to have been an exaggerated guess on his part and suggests that Turner received less than half that sum, an estimate confirmed by Alaric Watts who, incidentally, verifies the dating of 1825 for the inception of the project: 'For his drawings for the 'England and Wales', he [Turner] received at so late a date as 1825 only 25 guineas (and thirty proofs).'[5] Watts also usefully tells us that, 'Mr Heath was wont to declare that in spite of his exactions, and the difficulty of bringing him to any reasonable terms, he had greater satisfaction in dealing with Turner than any other artist. When once he had pledged his word as to time and quality, he might be implicitly relied on.' There were no restrictions on the size of Turner's original watercolours, all being scaled down for the engravings, the format of which was about $6\frac{1}{2} \times 9\frac{1}{2}$in.

Heath had a great deal of experience in both print-publishing and engraving itself. He and Turner had first met when Heath engraved the figures of Turner's oil-painting *Pope's Villa at

Twickenham* (for which John Pye engraved the landscape). This plate, published in 1811, was a landmark in the history of English line-engraving, and particularly in Turner's attitude to the medium, for it was during the making of it that he became aware of the potential of line-engraving for rendering the delicacy and richness of light (so much so, that he is said to have exclaimed to Pye, upon seeing the proofs: 'You can see the lights; had I known that there was a man who could do that, I would have had it done before.')

Charles Heath was born in 1785, the youngest son of the engraver James Heath (1757–1834). As a young man he had studied with his father, quickly gaining a wide reputation, and as a result was commissioned to engrave several famous paintings: *The Portrait of Lady Peel* by Sir Thomas Lawrence; *The Infant Hercules* by Sir Joshua Reynolds; and pictures by Van Dyck, West, Dolci and others. Since *Pope's Villa,* he had engraved several pictures by Turner, but from the early 'twenties, had taken to publishing prints and supervising other engravers, a job for which his great experience well suited him. He also developed the newly imported idea of 'Picturesque Annuals' and similar kinds of literature, books that were illustrated with engravings of commissioned pictures by well-known artists of the time, Turner included, mainly aimed at the burgeoning middle-class market. The titles of some of Heath's publications from about 1825 onwards reveal their sentimental flavour: *Heath's Picturesque Annuals; The Bijou; Friendship's Offering; The Keepsake; The Amulet; Beauty's Costume; The Book of Beauty,* edited by the Countess of Blessington; *Portraits of the Children of the Nobility,* edited by the Countess of Blessington; *The Belle of a Season,* a poem by the Countess of Blessington; and *The Governess,* a tale by the Countess of Blessington. (The unfortunate Lady Blessington died in Paris, in June 1840, of 'an enlargement of the heart'!)

In his autobiography the author and journalist Henry Vizitelly records the development of such publications and also gives a valuable insight into the seemingly healthy state of Heath's finances at this time:

The rapid development of the class of gift-books known as 'Annuals' . . . with their highly finished steel engravings, had been something phenomenal. Ackermann, who kept a shop . . . in the Strand, taking the idea from Germany, started the first 'Annual', called the 'Forget me not'. Its success produced crowds of imitators, many of which speedily outstripped the original in the quality of their literary, and more especially, their pictorial contents. In their palmy days, the 'Keepsakes', 'Books of Beauty' and the like sold in their tens of thousands at high prices, and yielded royal revenues . . . For these annuals the services of the ablest artists and engravers were eagerly sought, and a hundred pounds or more were paid for a steel engraving merely a few inches in size. Although 'Annual' editors relied mainly on writers with titled names, great efforts were occasionally made to secure contributions from authors of the highest standing. Moore used to boast of having rejected an offer from Charles Heath, the engraver, of six hundred guineas for a short poem for 'The Keepsake'; whereat Lockhart contemptuously remarked that it was doubtful which was the greater fool of the two, Heath who made the offer, or Moore who rejected it.[6]

A further indication of Heath's lavish spending in the mid-twenties is given by A. Alfred Watts who relates seeing Heath in Scotland and the Lake District, sometime in 1828, inducing various authors, including Sir Walter Scott and William Wordsworth, to part with literary scraps for enormous sums of money, for publication in *The Keepsake*. Scott and Wordsworth responded with alacrity, selling him 'a pig in the poke' for that price. As Watts comments: 'The immoderate and injudicious expenditure of these considerable sums for productions, some of which, at all events, could not fail to be disappointing . . . was unsuccessful in securing in any commensurate degree the success of Mr Heath's speculation; and the work passed out of his hands into those, I believe, of his publishers.'[7]

Heath's finances were always precarious. In 1826 he began a series of ten sales by auction of the many and various properties, including pictures, that he had accumulated over the years as a result of his activities as a publisher. Over the next decade he sold in these auctions drawings by Martin, Cox, Stothard, Bonington, Prout, De Wint and Turner (a drawing of *Le Havre* engraved for *The Keepsake* in 1834) and lithographs by Géricault and Delacroix.

The first three parts of 'England and Wales' were published in 1827, each consisting of four engravings accompanied by a letterpress (i.e., descriptions of the places depicted). The only dated drawing of the entire series, *Saltash* (1), 1825, was engraved and published in Part III.[8] The prices of the prints varied, from a guinea and a half per part for proofs on India paper, to fourteen shillings per part for ordinary prints. Rawlinson was told by Henry Graves, the son of a later publisher of the series, that 'the plates were usually engraved as fast as Turner supplied the drawing, so that the date on each print always corresponds within about a year to that of the drawing',[9] but this may not always have been the case, as new evidence has been offered by Mrs Anne Tennant that Turner produced watercolour drawings many years in advance of their being engraved. This evidence does in fact concern another series of Turner watercolours and engravings—the vignettes for the *Poems* of Samuel Rogers. In a letter dated June 1831 Rogers wrote to his engraver, William Miller, '. . . I have many others [watercolours] ready for you and will send them when required.'[10] As will be seen from the *Athenaeum* review quoted below, it seems to have been Turner's practice to make large numbers of drawings well in advance of the engravers' requirements, and to allow the engravers to choose among them when required; this view is supported by Turner's known practice of producing several watercolours together during one session.

The word 'picturesque' was often used in titles by print-publishers of the day. Already in January 1825 Heath had issued a prospectus[11] for a series of engravings described as 'Picturesque Views in London and Its Environs', but this work was never realized (Ill. 2). Over the previous half century many other engraved works and series had been

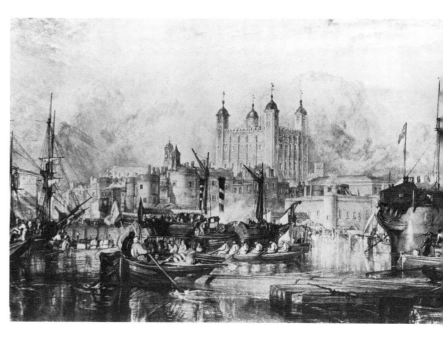

2 *The Tower of London* (306mm × 434mm, 12" × 17"), 1825, was engraved by William Miller in 1831 and is now untraced. The subject and date suggest that it was originally made for Heath's proposed series of 'Picturesque Views in London and its environs'. It demonstrates Turner's willingness to make highly-detailed drawings at this time and supports the idea of a joint Turner-Heath collaboration early in 1825.

issued with similar titles but the inclusion of the term in the title of the 'England and Wales' series does not establish any real connection between it and the body of picturesque theory of the late eighteenth century. The only connection between them lies in Turner's choice of subjects: cathedrals, abbeys and ruins were chosen by him out of a desire to explore the potential that these subjects still contained for genuine and imaginative expression. He was, by now '. . . the old painter who has seen his way to sacrificing all the picturesque to the pictorial', to quote Signac's memorable encomium of him.[12]

The engraving of the watercolours proceeded as planned. They were published at regular intervals, usually in three parts per year, and each part contained four engravings. Nineteen engravers were eventually employed on this work and some engraved as many as thirteen or fourteen of the plates, while others worked on only one. Included in the group were Miller, Willmore, Goodall, Brandard and Wallis, whom Turner considered to be the best engravers of his work (along with John Pye). The work was long and tedious, and although the engravers were paid, on average, one hundred pounds for each plate engraved, the task might take up to two years: '. . . few have lived more solitary or more laborious lives. Bending double all through a bright, sunny day, in an attic or close work-room, over a large plate, with a powerful magnifying glass in constant use; carefully picking and cutting out bits of metal from the plate, and giving the painfully formed lines the ultimate form of some of Turner's most brilliant conceptions; working for twelve or fourteen hours daily, taking exercise rarely, in early morning or late at night; "proving" a plate, only to find days of labour have been mistaken, and have to be effaced and done over again . . . such is too commonly the life of an engraver.'[13]

Overseeing everything was Turner himself. From the time he had first discovered the expressive possibilities of line-engraving he had thrown himself into the activity and in the process trained a school of line engravers who were equal to, if not better than, any of the schools trained by artists of the past. 'Probably no painter before him—unless possibly Rubens—ever so completely controlled the engraving of his own pictures, or ever set himself to educate the engravers who worked for him; certainly none ever bestowed the same infinite pains on every detail of every plate'.[14] The 'Turner School' may thus be considered the finest body of craftsmen in engraving that Britain produced in the nineteenth century—and yet the engravings have suffered neglect. Because Turner never actually worked on the plates himself (merely 'touching' the proofs—i.e., altering or correcting them) they have virtually no market value as they are considered to

be engravings *after* Turner.[15] Yet these same engravings are more Turner's original work than most prints.

Turner's relationship with his engravers is well documented, and there are many records of his concern for every minute detail in the design and execution of the plates. The engravers were much in awe of him and endeavoured to 'translate' the spirit of the original pictures to the more limited disciplines of a purely etched line with a great deal of ingenuity. One of the essential problems of line-engraving is that of converting colour into black-and-white, and this provoked considerable perplexity. Edward Goodall, who engraved four plates in this series (including the first one published, *Rivaulx Abbey*), once asked Turner how to translate a brilliant red in one of his pictures. Turner replied: 'Sometimes translate it into black, and at another time into white. If a bit of black gives the emphasis, so does red in my picture.' In the case of translating it into white, he said rather unhelpfully after a brief reflection: 'put a grinning line into it that will make it attractive'.[16] Turner was not averse to asking his engravers to invent figures either. Frederick Goodall RA, the son of Edward, tells in his *Reminiscences* how Turner once asked Edward to put two figures of his own invention into one of the engravings; when Goodall demurred the young Frederick had a very enjoyable time watching

3 Egyptian Hall, Piccadilly, the venue of the 1829 exhibition. It was demolished in 1905.

Turner paint them in himself on the original for subsequent transcription.[17]

Meanwhile, the engravings were still appearing. In early June 1829, Heath rented the Large Gallery in the Egyptian Hall, Piccadilly (Ill. 3), in order to exhibit the watercolours; he hoped to sell large numbers of the engravings as a result. Some 35 of the watercolours were displayed in a group of 41, and a handlist of the pictures exhibited has been found by John Gage amongst Ruskin's papers at Bembridge. Two of the drawings were not to be published as engravings for another three years—(*Plymouth*) and (*Richmond Hill and Bridge*)—and this confirms the view that the drawings sometimes date from long before the engravings.

Several reviews of the exhibition appeared, notably in the *Examiner* (14 June, page 373) which mentioned seventeen drawings (including the two views of Virginia Water drawn in 1827); the *Atlas* (Sunday, 7 June, page 381) which mentions nine drawings, and tells us that the engravings were also on view; and in the *Athenaeum and Literary Chronicle* which returned to the exhibition on two occasions, the 3 and the 10 June. This review (which in the newspaper custom of the time is unsigned) indicates the kind of appreciation that Turner evoked in a sympathetic viewer, and is important for the essential evidence it affords us, in its story relating to *Stonehenge,* both of Charles Heath's power of veto over drawings for the series, and of the arbitrary way that the drawings themselves were chosen in the first place. Turner certainly had a say in the matter, but this occasionally random choice explains why drawings similar in size, content and handling to 'England and Wales' subjects sometimes found their way into Heath's other contemporary publications: he presumably found it expedient to divert drawings for engraving elsewhere (i.e. to *The Keepsake,* etc.) when he deemed it necessary.[18]

The drawings are splendid specimens of taste and execution, and collected and hung together as they are here, produce an effect beyond expectation, brilliant and beautiful . . .
[10 June] We have returned to the view of this

brilliant and elegant exhibition with fresh gratification, and renewed admiration of Mr. Turner's taste and powers. . . . Yet it is objected to Mr Turner that his effects are not natural, that nothing like his colours are to be seen in nature. Without discussing the question in this place, whether the practice of an imitative art requires its follower to copy even as nearly as he can what he sees actually before him, we would refer to the two drawings of 'Windsor' and 'Twickenham Meadows',[19] and putting aside the question whether either of those delightful scenes ever appeared in reality so brilliant as Mr Turner has represented them, we would enquire if these drawings are not most delightful to the senses; whether the manner in which the scenes are treated by the pencil of Mr Turner has not even elevated and ennobled them; whether a party bent on pleasure and enjoyment would really object to have all around them as splendid, as gay as it here appears; whether our fair companions in a picnic party would not be more disposed to love than to hate the artist who should give an Oriental splendour to the groups they form, and to the spot they choose to repose in; who should make a fairy land of the scene of their elegant and innocent enjoyments. It seems to us to require very little poetry in the soul, very little reflection on the nature and province of art, to bring oneself to regard Mr Turner's style of drawing as perfectly natural. His grand and general effects, in short, are true, although his details of colour are not exactly such as are every day seen.

But to indulge the most fastidious, what have they to object to the 'Stonehenge'? Surely there is nothing unnatural in this drawing! no extravagant tints, no gold, no gorgeousness! and what a subject too! yet what a picture. The proprietor of this drawing, Mr. H. Charles Heath, relates a pleasant story respecting it. Mr Turner, he says, had a drawing of Stonehenge and asked him if he would take it for one of the views of England. 'Stonehenge! such a subject!' 'But you may as well see it.' 'It would be of no use; the subject would never do.' Other drawings were proceeded with; on the back of one of these, Mr Heath happened one day to cast his eye on the 'Stonehenge'; but he not longer objected to the subject, bad as he had deemed it. He eagerly purchased the drawing; and few, we are assured, are they who will condemn this change of resolution. The subject all will own was an ungracious one; but this very defect has served to display the talent of Mr. Turner. . . .[20]

By the summer of 1830 some thirty-six of the engravings had appeared and, according to Finberg, Turner had completed the first fifty watercolours.[21] Originally he may have decided to visit the Continent this year, as in previous years, but revolution broke out in Paris on 27 July and in Belgium (against the Dutch) on 25 August so he prudently decided to travel around the Midlands instead, probably starting out in late August, after the General Election, and returning to London sometime in October (we know that he was back in London on 1 November). He travelled extensively, visiting, among other places, Oxford, Kenilworth, Dudley, Worcester, Chatsworth and Northampton where his visit is particularly attested to by a previously unidentified sketch of the façade of All Saints Church. In all, the three sketchbooks that he brought back contain the material upon which thirteen of the 'England and Wales' series are based. (*see* Concordance pp. 155–6.)

Already there were signs that Heath was in financial trouble over the sale of the engravings. Robert Jennings, co-publisher and printseller, had found the venture a burden (having meanwhile gone into partnership with William Chaplin) and early in 1831 Jennings and Chaplin sold out their share in the venture to a larger concern, the Moon, Boys and Graves Gallery of 6 Pall Mall, (although they continued to bring out the engravings they had contracted and paid for during the next two years). The principal partner in the new publishers was Francis (later Sir Francis) Moon. Turner knew one of the other partners, Robert Graves, very well, and, according to Frederick Goodall,[22] often used to dine with him on Sundays at his home in South Lambeth. Moon, Boys and Graves undoubtedly put a considerable sum of money into the venture for there can be no doubt that Heath was finding it a strain, and it was at this time that most of Heath's other commitments were taken over by Longman, the publishers.

In order to promote the sale of the engravings, Heath displayed a selection of them, and their drawings, in January 1831, at an 'Artists' and Amateurs' Conversazione' at the Freemasons Tavern. This was described in the *Athenaeum* as 'a rich display . . . superior to any that have before appeared'[23]; but far more ambitious than this was the large exhibition of sixty-six of the original watercolours[24] at the Moon, Boys and Graves Gallery itself, in June and July 1833 (where Turner also showed twelve of the original watercolours made for engraving as illustrations to the poems of Sir Walter Scott.) The exhibition opened on 8 June and the catalogue lists the drawings with 'picturesque' descriptions of the places depicted. The show must have been a dazzling one—and indeed the largest group of 'England and Wales' watercolours ever to have been shown together. In the gallery there was an open subscription book for the engravings[25] which lists 100 subscribers (most of whom later failed to take up their subscriptions) and even Turner is among them, committing himself to purchase '2 Columbier Folios before letters', no doubt to get the ball rolling. (His name, however, is second on the list, having been beaten to first place by the collector Thomas Tomkinson, who had lent a number of watercolours to the exhibition.) Many of Turner's oldest friends and collectors are listed in the book, including Cyrus Redding, George Cooke the engraver, Thomas Griffith of Norwood (who acted as Turner's agent) and John Martin the landscape painter. All of the drawings in the show were lent by the various collectors to whom Heath had sold them after engraving (no doubt making a small profit in the process), and Heath himself also lent drawings that were being engraved at the time. Towards the end of the exhibition an informal 'conversazione' was held in the gallery, on Wednesday, 3 July, at 8.30 pm and this was described briefly in *The Times* two days later; it tells us that the rooms were brilliantly

lit and that nearly 'two hundred artists and literati' attended. Fortunately, however, we have a more detailed record of the occasion in an article by the Reverend W.H. Harrison on the painter Thomas Stothard, which appeared in May 1878:

I met this distinguished and graceful painter at a conversazione at Messrs. Boys and Graves' in Pall Mall, in July 1833, about nine months before his death. The object of the meeting was the exhibition of a very numerous and beautiful collection of Turner's drawings. Turner himself was there, his coarse, stout person, heavy look and homely manners contrasting strangely with the marvellous beauty and grace of the surrounding creations of his pencil. Stothard was in a slipshod pair of shoes, down-at-heel, and with a pair of trousers splashed with the previous week's mud. He appeared to be absorbed in the contemplation of the works around him, and scarcely exchanged a word with anyone. Etty was there; also Stanfield, Brockenden [who also had some works on show] and other distinguished painters. I also observed Lord Northwick, one of the then great patrons of art. There was also Sams, the traveller in Egypt and the Holy Land, habited like a pilgrim in a long greatcoat reaching to his toes. [Sams was showing his Egyptian collection in an exhibition in Great Queen Street at the time]. He showed us a painted portrait, doubtless of the deceased, found with a mummy, and supposed to have been executed B.C. circa 300. The colours were remarkably vivid, especially the blue, which Etty said we could not equal. He said the picture was admirably painted.[26]

The exhibition was reviewed in the press, the *Observer* (16 June) not caring for it much, mentioning the tedium of seeing too many Turners together: 'the general effect is "terribly tropical", *hot, hot, all hot* and though full of talent and fine effects, very unlike the hue and truth of nature'; but other reviews were kinder, the *Sunday Times* (23 June), the *Athenaeum* (15 June, which said of it: '. . . these drawings are of a beauty for which we can

find no parallels'), and *Arnold's Magazine* (August, 1833) all mentioning it briefly. A long, sympathetic review, appeared in *The Atlas* on Sunday, 16 June.

Despite the critical success of the exhibition, however, the engravings were by now only appearing in two parts per year and the whole business was becoming increasingly unprofitable. At the beginning of 1835, Moon, who was already financially embarrassed by the affair, split with Boys and Graves, his place being taken by Richard Hodgson. Within a few months, however, Hodgson and Graves quarrelled,[27] Graves departed and Hodgson decided to sell off his half-share in the enterprise to Messrs Longman, Rees, Orme, Brown, Green and Longman, the publishers. They noted the takeover in their commission ledgers as 'by stock from Hodgson and Co.' in May 1835.[28] Longman already had a large share in Heath's other enterprises, having, since 1831, been totally financially responsible for *The Keepsake, Turner's Annual Tours,* the *Book of Beauty* etc. It was no doubt the continuing profitability of such publications that persuaded them to take over a half-share in the 'England and Wales' series, for by now Heath was in serious financial difficulties over this and it must have been fairly evident that the project was doomed to failure. I would summarize reasons for this failure as follows.

Firstly, copper was used, on Turner's insistence, rather than the more hard-wearing steel, on account of its ability to render particularly fine lines and subtle tones. However, the softness of the copper meant that the plates were quickly worn down and had to be frequently re-worked—an expensive business. Steel plates would have been far more economical because steel is less prone to deterioration. As a result of the use of copper the engravings were over-priced.

Secondly, the public often received only the poorer, later impressions, Turner having 'creamed off' the best early proofs in large numbers.

Thirdly, there can be no doubt that the 'England and Wales' was competing in a market flooded with similar, often much cheaper publications, such as the works of Prout, Stanfield and Roberts who

were all regarded by the general public as equal to, if not better than Turner. '. . . the public became surfeited and, by the time of Queen Victoria's accession [1837], the fashion for landscape illustrations had almost worn itself out.'[29]

By 1838 Turner had produced more than a hundred 'England and Wales' drawings, and ninety-six of them had been engraved. It is impossible to know for certain which drawings were originally intended for the series and never engraved, but their size and detail would suggest that drawings like *Merton College, Oxford* and *Northampton* (which, Finberg says, was definitely intended for engraving and which, indeed, was shown in the 1833 exhibition[30]) were intended for the series and they are, accordingly, reproduced in this book along with one or two others. Longman, however, had not given up. In 1832 Moon had collected the first sixty engravings together (i.e., the projected first half) in book form and issued them with their letterpress which had been penned by one Hannibal Evans Lloyd, a prolific writer and translator of the time who also wrote the catalogue entries for the 1833 exhibition.[31] The prices varied, depending on the size and state of the engravings, and ranged from '£48 per volume, for India proofs, before letters, Columbier folio, with the etchings', down to '£10.10s. for prints, Royal Quarto'. Longman, therefore, made the decision in 1837 to terminate the series, and in 1838 had the ninety-six engravings bound into two volumes of forty-eight plates, with the additional letterpress by Lloyd, and re-issued them at the same prices as before.

Again the response was negligible and this was finally the end of the 'Picturesque Views in England and Wales'. Heath was by now financially ruined, although he was never officially declared bankrupt,[32] and probably came to an 'agreement with creditors' whereby voluntarily, and without resort to court proceedings, he offered to clear his debts. Longman, his principal creditor, were very tolerant towards him, probably because his other publications on their behalf, i.e., *The Keepsake,* etc., were still highly profitable. Unfortunately, all the correspondence relating to the 'England and Wales' series in the Longman archives was destroyed

during the Second World War, but their commission ledger books relating to it have survived in the archives of the University of Reading. Any interpretation of them without corroborative material (in the form of letters, etc.) is necessarily incomplete, but it does appear that Longman took over Heath's affairs and supported him for some time while his debts were paid off; there are entries in the ledgers recording the quarterly (and later more frequent) payments to Heath of £50, and he went on working for them almost up until his death in 1848. In April 1840, Heath himself sold off his sets of proofs of the engravings at Sotheby's, and his presentation set of these is now in the Boston Museum of Fine Arts.

As a result of the failure, and in order to recoup their losses, Longman decided to try and sell the entire property to H. G. Bohn, a dealer in publisher's remainders and cheap reprints, for £3,000. He offered only £2,800 which Longman declined, and they put the stock up for auction which took place on Tuesday, 18 June, 1839, at the premises of Messrs Southgate and Company, 22 Fleet Street. At this auction, Longman also put up two other publications, the remaining stock of *The Literary Souvenir* and *Select Views in Greece* (for which they received £707/8s) and they advertised in the catalogue the entire stock of the 'Picturesque Views in England and Wales', consisting of several hundred copies of the two bound volumes, plus many odd engravings and proofs and, most important of all, the ninety-six copperplates.

. . . after extensive advertising, the day and hour of sale arrived, when, just at the moment the auctioneer was about to mount the rostrum, Turner stepped in and bought it privately at the reserved price of three thousand pounds,[33] much to the vexation of many who had come prepared to buy portions of it. Immediately after the purchase, Mr Turner walked up to Bohn, with whom he was very well acquainted, and said to him: 'So, sir, you were going to buy my 'England and Wales', to sell cheap, I suppose—make umbrella prints of them, eh?—but I have taken care of that. No more of my plates shall be worn to shadows.' Upon Mr Bohn's replying that his object was the printed stock (which was very large) rather than the copper plates, he said: 'O! Very well, I don't want the stock. I only want to keep the coppers out of your clutches. So if you like to buy the stock, come and breakfast with me tomorrow, and we will see if we can deal.'

When Mr Bohn presented himself at nine o'clock the next morning, the artist, giving no thought to the breakfast to which he had invited, unceremoniously enquired: 'Well, sir, what have you to say?'

'I have come to treat with you for the stock of your "England and Wales"', was the answer.

'Well, what will you give?' was the sternly definite demand. It was then explained that in the course of the previous negotiation the coppers and copyright had been valued at £500; so that £2500, the balance remaining after deduction of that sum, would be the amount to be handed over to the painter. 'Pooh,' was the contemptuous reply; 'I must have £3000 and keep my coppers; else good morning to you'; and thus the interview closed.[34]

The total cost of the venture may be estimated to have been somewhere in the order of between £14,000–18,000.[35] No figures are available as to what it recouped but it seems unlikely that it broke even.[36] Turner himself may have lost up to £700 in the process, the £2,400–£2,900 that he had been paid over the years for the drawings being swallowed up by the £3,000 paid to buy back the prints and plates at auction.

The engravings and plates themselves were removed to Turner's house in Queen Anne Street where they mouldered. Alaric Watts commented: 'The stock, or the greater part of it, is still lying in Queen Anne Street, of course not improved by keeping and having, in the course of the 14 years which have since elapsed, swallowed up another £3000, reckoning compound interest at five per cent per annum.' Eventually, after Turner's death, as a result of the dispute over his will, the entire stock of engravings was auctioned off at Christies, on 24 May, 1874, and the copperplates were destroyed to preserve the market value of the prints.

Turner had obviously bought all the stock to prevent the copperplates being further printed until they were 'worn to shadows'. However, as C. F. Bell has written:

His solicitude on this account would seem odd enough regarded only in relation to the pains he took ... to deprive the public of as many as possible of the choice impressions. But it becomes even more astounding when the plates themselves are brought under consideration. For it is not too much to say that many of them never had any youthful freshness to lose; while in almost all the tenuity of the original work, rendered yet more delicate by the copious use of the burnisher for finishing touches could, even before it wore down, as it speedily did, yield its charm only under the most careful printing. The extraordinary subtle tones of such plates as the 'Richmond from the Moors' and 'Llanthony Abbey', (both engraved by J. T. Willmore) are only to be appreciated in the engravers' proofs, while it is rare to find two even of these perfect in every particular.[37]

Thus ended Turner's most ambitious and essentially his last attempt to disseminate his work in such a comprehensive way. Like every other of his ambitious engraving projects, from the 'Liber Studiorum' to the 'Southern Coast', it had ended in financial disaster for its publisher. But if the 'Picturesque Views in England and Wales' was a commercial failure, it must be considered a success in all other terms, for in the process it brought into being not only a series of landscape engravings that have no equal, but also a group of watercolours that are unsurpassed in their range and power.

THE WATERCOLOURS

'... the great human truth visible to him.'

RUSKIN

The dispersal of the original watercolours by Heath came to an end with the abrupt termination of the 'Picturesque Views in England and Wales' in 1837. We know from the catalogue of the 1833 exhibition that the drawings had passed into only a small number of collections by that date, and there, for the most part, they stayed for the rest of Turner's lifetime. Ruskin, of course, bought several (he eventually owned thirteen) and the series was gradually dispersed, about two thirds of the drawings passing from private to public collections over the following century and a half. The largest single collection today (fifteen in all) is owned by the British Museum in London, the result of two individual bequests. After that the number in a single collection drops to seven in the Manchester City Art Gallery and then to three each in the respective collections of the Lady Lever Art Gallery, Port Sunlight, and the Yale Center for British Art. Thereafter they are usually found individually, or occasionally in pairs, in various private and public collections. Seven of the ninety-six have now vanished altogether, and two more, alas, were lost in separate fires, one in 1955, the other in 1962.

It was perhaps the magnitude of the project that led Turner to sell off the drawings to Heath in the first place, rather than to hire them out as he had done with the drawings for 'The Rivers of England' in 1823–7, or as he was to do, as a result of financial considerations, with the vignette illus-trations for Rogers' 'Italy'. No doubt he would have had some problems in keeping track of so many and in 1825 he had not fully developed the notion of keeping most of his works together for posterity. In any event there is another important reason for the dissemination of these drawings and this is his lifelong involvement with engraving.

Turner spent an immense amount of time and energy in producing works for subsequent engraving, going to unusual lengths to ensure that the standard of the engravings matched the quality of his works. The fruits of this involvement already ran into hundreds of prints and no doubt Turner felt that their quantity gave the works more chance of survival than the individual oil-paintings and watercolours upon which he lavished his fullest powers. This would certainly explain his involvement with engraving which was as important to him as the income that accrued from them. As we shall see, it also partly explains why he felt the need to bring his work together in such a format as the 'England and Wales'.

A possible factor in the germination of this series lies in his childhood. After the death of his only sister when he was eight, and the mental illness of his mother a year later, he was sent to stay with an uncle at Brentford, a small market town near London, where he stayed for some years. There he was paid twopence a time by a distillery foreman, John Lees, to colour the engraved plates in a massive topographic work entitled *Picturesque Views of the Antiquities of England and Wales* by Henry Boswell. This book,[1] published in 1786, contained a letterpress and a large number of engravings, by various artists, of 'picturesque' scenes, seventy of which were hand-tinted by Turner, often with imaginative handling, especially of the skies. Fifty-eight are of *exactly* the same subjects as Turner's own later 'Picturesque Views in England and Wales' and the similarity in the two titles is obvious. This book evidently made a profound impression on the young Turner, not only opening up imaginative horizons in its literary letterpress, but also awakening his latent sense of history and romantic imagery through its pictorial stimulus. Turner knew a great deal about the historic background of the places he depicted and he often related his figuration to it, as for instance in the drawing of *Castle Upnor* (56). He had a phenomenal memory and it seems natural to assume that he would have remembered the Boswell when a scheme for producing a large number of engravings from his own works was first suggested in 1825. The series gave him the chance to renew creatively the images and scenes that had so decisively affected him as a child, and also allowed him to produce a lasting body of engravings as the summary of his work. This attitude to the engravings, seeing *them* as the final vehicle for the images themselves, may explain his apparent disinterest in keeping the watercolours together as a group.

With this uncompleted series Turner came closer than at any other time to realizing his lifelong urge to coalesce the divergent and varied strands of his art into a unified system. That he should have wanted to do so speaks much of his need to achieve psychological completeness through his art, and to impose through it, in turn, some sense of order upon the world. He had already attempted to do this with the 'Liber Studiorum', whose categories of landscape (i.e., historical, mountainous, pastoral, marine and architectural) were clearly defined and worked to, sometimes with unconvincing results; but while the 'England and Wales' series lacks those precisely defined categories, it does display the same subconscious desire as the earlier work to achieve integration, a trait noticed by Ruskin: 'Among the many peculiarities of the late J. M. W. Turner ... were his earnest desire to arrange his works in connected groups, and his evident intention with respect to each drawing that it should be considered as expressing part of a continuous system of thought. The practical result of this feeling was that he commenced many series of drawings—and if any accident interfered with the continuation of the work, hastily concluded them—under titles representing rather the relation which the executed designs bore to the materials accumulated in his own mind, than the position which they could justifiably claim when contemplated by others.'[2]

Indeed, the 'England and Wales' has been

criticized for bearing more relationship to the 'materials accumulated' in Turner's mind than for being a systematic exploration of its subject,[3] and it would be difficult to establish the kinds of categories encountered in the 'Liber Studiorum' in this work; the arbitrary way in which the subjects were chosen for engraving by Charles Heath really precluded that kind of systemization. In a larger sense, however, there is a profound connection between these works which lies not only in their stylistic character (markedly different from all the other series of Turner's watercolours) but also in the outlook that engendered them. For this reason it is important to consider the phase of Turner's life during which they were created.

Turner was undoubtedly at the height of his mature creative powers during the years of this series. Between 1825 and 1838 he was to exhibit publicly seventy-four oil-paintings (including such masterpieces as *Ulysses Deriding Polyphemus* and the two paintings of *The Burning of the Houses of Parliament*) and 130 watercolours (including those of this series) and this by no means represents his total output during the period. However, these years also saw great personal unhappiness. The series itself got off to a very positive start: *Saltash* (1), the radiant *Prudhoe Castle* (11) and *Richmond Castle and Town, Yorkshire* (10) all reveal Turner's optimism during the summer of 1825 (when they were almost certainly created), but this mood was to be abruptly shattered. On 25 October, 1825, Turner lost his closest friend, Walter Ramsden Fawkes, who died at his home, Farnley Hall, near Bradford. Yorkshire. It was at Farnley that Turner had enjoyed, from 1810 onwards, the friendly and familiar company of a sensitive patron and his family in an environment where he could relax his emotional defences. There he went fishing (his favourite pastime) and also worked, producing, for instance, a highly elaborate watercolour, *A First-rate Taking in Stores*, the creation of which, between breakfast and lunch, was witnessed by Fawkes's son whose story of it has survived in family memory, giving us a valuable insight into Turner's fast working processes, incredible virtuosity and his mastery of technique.[1] Turner never

revisited Farnley after Fawkes's death and later even gave away the sketchbook that he had used on his last stay there, one of the only times he is known to have done so.

The death of Fawkes shook Turner deeply. He was only six years Fawkes's junior and could not know that he was to live for another twenty-six years. It must have seemed the beginning of the end for him. He wrote shortly afterwards to James Holworthy, in January 1826 '. . . alas! My good Auld lang sine is gone . . . and I must follow; indeed, I feel, as you say, nearer a million times the brink of eternity. With me Daddy only steps between us'.[5]

This event marked a turning point in Turner's outlook which is reflected in a change in the mood of some of the 'England and Wales' drawings. While there is no change of style, there is an intensification of Turner's awareness of life and death, a change that is especially displayed in the series by a frequently manifested pessimism, a contrast between the ruined aspirations of man and the beauty and renewal of nature.

Ruskin, writing in 1878, perceived this subtle alteration in Turner and expressed it with poetic insight:

But a time has now come when he recognizes that all is not right with the world—a discovery contemporary, probably, with the more grave one that all was not right within himself. Howsoever it came to pass, a strange, and in many respects grievous metamorphosis takes place upon him, about the year 1825. Thenceforward he shows clearly the sense of a terrific wrongness and sadness, mingled in the beautiful order of the earth; his work becomes partly satirical, partly reckless, partly—and in its greatest and noblest features—tragic . . . and with this change of feeling came a twofold change of technical method. He had no patience with his vulgar subjects, and dashed them in with violent pencilling and often crude and coarse colour, to the general hurting of his sensitiveness in many ways; and, perhaps, the slight loss of defining power in the hand. For his beautiful

subjects, he sought now the complete truth of their colour but as a part of their melancholy sentiment; and thus it came to pass that the loveliest hues, which in the hands of every other great painter express nothing but delight and purity, are with Turner wrought most richly when they are pensive; and wear with their dearest beauty the shadows of death.[6]

The period between 1825 and 1838 was greatly marked by a number of deaths among Turner's closest circle, and of all of these deaths that of his father, in September 1829, was the most terrible for him. They had been very close, drawn together especially during the long mental illness of Turner's mother who had died in the Bedlam Mental Hospital in 1804. The old man was extraordinarily proud of his son and had played a crucial role in his life over the years, acting as general factotum and housekeeper. In the days between his father's death and funeral Turner drew up the first draft of the will which, eventually, after many revisions, was to become the grandiose (and ultimately confounded) Turner Bequest. Other deaths followed over the course of those years, including that of Sir Thomas Lawrence, President of the Royal Academy; W. F. Wells, who had been instrumental in the genesis of the 'Liber Studiorum'; and, in 1837, Lord Egremont, another of Turner's great patrons who, from 1827 onwards, had given Turner a substitute for Farnley at his great house at Petworth in Sussex. There during the late 'twenties and early 'thirties he had painted some of his greatest interiors, marvellously intimate and atmospheric studies of a great English country house with its eccentric owner and constant activity. The closeness of death during this period makes its appearance in his work in such exhibited pictures as a watercolour of Lawrence's funeral, the oil-painting (also shown in 1830) of *Calais Sands* (which Finberg suggests Turner painted as an expression of his grief at the loss of his father),[7] and *Caligula's Palace and Bridge*, exhibited in 1831. Perhaps most startling of all, however, is the macabre *Death on a Pale Horse* which was never exhibited (perhaps because it was too private for him) and which was also probably painted at

the time of his father's death. Drawings in this series also reflect the fear or actuality of death: works such as *Stonehenge* (25), *Powis Castle* (69), *Leicester Abbey* (100) and the *Chain Bridge Over the River Tees* (84).

Yet one should not imagine that Turner dwelt exclusively on death at this time. Although Alaric Watts tells us that as he advanced in years he often shed tears at the thought that his end was near, these forebodings were often sublimated in his work, his bleak pessimism also enacting a concomitant joy in life and nature, exemplified in paintings of the period such as the two Mortlake pictures, *Childe Harold*, the several Venetian pictures exhibited between 1833 and 1835 and, above all, in the *Ulysses* of 1829 which Ruskin saw as the 'central' painting in Turner's development. Amongst the drawings of this series such feelings are manifested in the marvellous *Kidwelly Castle* (78) and in *Worcester* (70), *Flint Castle* (89), and *Plymouth Cove* (46).

The realization of his own mortality also engendered a far greater awareness of contemporary life. Turner had always used his art to document the passing scene and this period of personal isolation was to coincide with one of intense political and social change in Britain. This is reflected in the series which, as a cultural record, confirms Turner as the foremost pictorial historian of the nineteenth century. Every aspect of the technological and social advance of his epoch, with the exception of the railways, is expressed here: the increase of urban growth and its encroachment upon the countryside; the decline of established institutions such as the Church and the power of the landed aristocracy; the pressure for political change during the crisis years of 1829–32, the period of Reform and its successful outcome; the rise of industry and the decline of agriculture; the movement for religious tolerance and education, exemplified in depictions of schools and universities; the establishment of the regular army, coastguard and navy; hunting, shooting and fishing (both as recreation and industry); the country market and fair; the canal, the stagecoach, river traffic and sea shipping; smuggling and

coastal plunder; and always wreck and ruin and the vain attempt of man to achieve some measure of permanence in a beautiful but indifferent universe.

This range gives us the vital clue to the unity of the series; it lies not in the survey of topography or monuments but in its systematic exploration of human beings. Man is Turner's real subject throughout the 'Picturesque Views in England and Wales', man in all his diverse cultural and social complexity. Moreover, the study of man and his achievements was as essential to him as was the celebration of nature. He very rarely painted a landscape devoid of men (or their works) and the study of nature in isolation was for him an unsatisfying activity. For Turner man is the sounding board of all things, and the drawings reflect this, even to the extent (as in *Northampton* —53, or *St Catherine's Hill*—48) that nature is sometimes almost excluded. As Ruskin explained:

He must be a painter of the strength of nature, there was no beauty elsewhere than in that; he must paint also the labour and sorrow and passing away of men: this was the great human truth visible to him. Their labour, their sorrow, and their death. Mark the three. Labour; by sea and land, in field and city, at forge and furnace, helm and plough. No pastoral indolence nor classic pride shall stand between him and the troubling of the world; still less between him and the toil of his country—blind, tormented, unwearied, marvellous England. Also their sorrow; Ruin of all their glorious work, passing away of their thoughts and their honour, mirage of pleasure, FALLACY OF HOPE . . . and their Death. That old Greek question again;—yet unanswered.[8]

This surely is the 'continuous system of thought' that connects these works; Turner's love of nature here fuses with his love of humanity: our labour, sorrow and death. Rawlinson is quite wrong in writing that the figures were only added 'at the last'.[9] Their integration is complete because they are the central subjects of each work. Man's labour is expressed in a whole range of the drawings, from

the bleak *Lowestoffe* (76) to the darkly elegaic *Dudley* (66), from the quietly poetic *Beaumaris* (72) to the joyous *Worcester* (70); his sorrow (perhaps the predominant theme of the series) expressed in the conjunction of ruins with the vanities of man: self-absorption, as in *Llanberris* (64), vulnerability as in *Llanthony Abbey* (71), or transience contrasted with the eternal resurgence of nature as in *Brinkburn Priory* (49); and finally our death, expressed either indirectly as in the *Chain Bridge over the River Tees* (84) or directly as in *Stonehenge* (25) and the *Longships Lighthouse* (73). As Ruskin remarks in a footnote to the passage quoted above: 'There is no form of violent death which he has not painted. Pre-eminent in so many other things, he is pre-eminent also in this . . . Flood, and fire, and wreck, and battle, and pestilence, and solitary death, more fearful still.'[10] A comparison of this series with the earlier engraved series of watercolours, such as the 'Richmondshire' drawings, or the 'Rivers of England', demonstrates instantly just how far Turner had chosen to go here in his depiction of man 'as the measure of all things'.

The centrality of man in nature is shared by Turner with many other landscape painters, from Bruegel to Millet; but rarely has anyone else painted it with such a fusion of figures and landscape both on a formal and a metaphorical level. Even the figures themselves, which may superficially seem 'banal and ill-drawn', to quote Rawlinson again,[11] can only do so to those whose expectations of them are based solely on the criteria of naturalism. As Ruskin points out in *Modern Painters*[12], were they to be over-painted by some more precisely naturalistic and 'better-drawn' figures, the effect would be both ridiculous and futile, destroying their spatial relationship to their context. In this series Turner's figures are always masterly in their social observation and dramatic grouping and crucial to the overall structure and meaning of the works themselves. This can be seen throughout the series, from the *Fall of the Tees* (7) where the solitary figure gives scale to the immense space and distance (and equally to its mood of lonely silence), to, at the other extreme, the crowded *Louth* (18), where the complexity of the

scene is structured through the concise and subtle demarcation of the figures from their surroundings. This picture serves too as an admirable demonstration of Turner's powers of social differentiation in his figures. The farmers, peasants and market-town inhabitants are all clearly identified, and their role in the picture equally so. Certainly they are idiosyncratic in form but it is naive to expect from Turner (as did Edwardian writers such as Rawlinson and Francis Bullard) a set of more precise naturalistic conventions in rendering his figures. Influenced as he was, by Hogarth, Rowlandson and Gillray, he evolved his figures exactly as he had evolved all his other forms: their seeming vacancy and doll-like features are not supplied by any human or painterly deficiency on his part, but by a deep desire to create a figurative metaphor for human vanity and for the rudimentary, unsophisticated personality of the great mass of mankind in the early nineteenth century. These people were often uneducated, crude, sensuous, ignorant or maltreated individuals and he represents them as such. If they are more 'civilised' however, as are the middle-class figures of *Richmond Hill and Bridge* (44) with its picnic party, he still regards their behaviour as a state of vanity, a 'mirage of pleasure' and depicts them accordingly. When he wants true nobility of humanity, as in the two Yorkshire *Richmonds* (10, 23), or *Kilgarren Castle* (21), with its Gainsborough-like figures, he easily attains it with more idealized figures. Turner's figures do not merely 'swell a progress, start a scene or two', nor are they mere ciphers. He always gives us their feelings and their human motivations—they show 'real cause'.

The figures are thus completely integrated into the linear structures of the works themselves. In the 'England and Wales' series Turner develops to an extraordinary degree the complexities of his formal designs, often the result of his desire to create a metaphor or allegory for the subject itself—for example, *Eton College* (41). Many of his works have this symbolic level (as I shall demonstrate in the Commentaries) and often it is fused with the compositional structure, as in *Eton* or *Brinkburn*

Priory (49). All the drawings display unifying linear structures which range from the much-used compositional device of a unifying V-line (*see Longships Lighthouse* (73), or *Prudhoe Castle* (11) with its overlapping inverted repetition of them) to a whole variety of these forms: an equally frequently encountered X-device (*Barnard Castle* (8), *Dartmouth Cove* (4) or *Eton* (41); a hairpin-like structure formed by two intersecting diagonal lines which we can see underlying many of the drawings, for instance *Walton Bridge* (36) or *Tamworth Castle* (55); and the curvilinear form of the type that gives structure to *Launceston* (9) where our sense of the immense central void of the picture is clearly created by it. I shall explore the diversity of these structural forms in connection with the individual works, but we can see easily how they must have emerged for Turner both as a result of the methods by which he obtained the basic material for the drawings and equally by the way that he then proceeded to elaborate it in and through the medium of watercolour itself.

His obvious starting point was his sketchbooks. These were kept throughout his life as a private reference library and form a large part of the Bequest that he left to the nation upon his death in 1851. They are now in the British Museum—more than 365 of them—containing something in the region of 19,000 assorted pencil sketches, rough colour studies and finished watercolours. To say that Turner's visual curiosity was voracious is an understatement. Practically no other painter in the history of the art has brought such ruthless industry to the pursuit of knowledge, and the multitude of his studies are proof of this. The American painter Jim Dine recently remarked: 'For an artist, drawing is the way one learns to see . . . you learn to see by looking. Drawing insists that you look'[13]: for Turner the act of drawing was an essential element in learning through looking. The acquisition of knowledge was, for him, a lifelong activity and enabled him to display his unrivalled and, above all *assimilated,* knowledge of natural forms and phenomena. The sketchbooks furthered this purpose in two essential ways: by building up a huge store of referential information; and in the

process of building that store, by enforcing the most intense acts of looking and learning. As a result of this Turner could draw upon a vast fund of knowledge, to supply at will (and *without* reference to the sketchbooks) details of light, flora and fauna, weather, geology, human incident, colour and, above all, those most transitory of effects in the pre-photographic age, the dynamics of physical movement. The knowledge passed *through* the sketchbooks, leaving them repositories of information regarding landscape and human topography— details of dress etc. Very rarely are the studies of figures in the sketchbooks related on the page to

4 *Sketch from the 'Gravesend and Margate' sketchbook upon which **Chatham** was based.*

particular landscapes; and, in reverse, the landscapes drawn in great detail rarely, if ever, have figures in them. At best they are merely indicated, as for instance in the sketch (Ill. 4) upon which *Chatham* (94) is based; the marines are literally represented only by Xs indicating their uniform webbing. Furthermore, in the British sketchbooks at least, Turner devotes little space to actually studying his figures; the vast majority of the sketches are of landscapes. Turner's great accuracy as regards dress (testified to in his memories of military uniform often used years after being seen) is evidence, yet again, of his total visual recall.[14]

Turner's working procedure was to take a bare outline sketch (sometimes made decades before) and, using it like a stage set, to fill it with figures and events, relating these to the 'inner' meaning of the subject and simultaneously exploring through it the

act of creation, subordinating everything to the dictates of his mood. The sketch which Turner used as the basis for his drawing of *Louth, Lincolnshire* (18), a drawing that dates from sometime in 1827–8, was made thirty years earlier, in 1797 (Ill. 5). As can be seen, this is a detailed line-drawing, painstaking in its accumulation and observation of precise architectural detail. In 1827 Turner filled this dry and purposely empty outline with the 'horse-fair' scene he may have witnessed in 1797, but which he never drew in his sketchbooks. It is all orchestrated from memory and imagination, the figures, animals, architecture, light and effects of weather evolving into a rich and complex symphony.

Most of the 'basis' sketches for the 'England and Wales' drawings are used in exactly the same way, almost all of them being devoid of anything but dry topographical information. Turner had a dislike of topography in 'finished' works; he called it 'mapping' and always attempted to avoid its limitations, allowing himself perfect freedom to raise, lower, or in any other way alter buildings, mountains, rivers, and similar topographical details.

Many of these 'basis' sketches inhabit the same sketchbooks (*see* Concordance, pp. 155–6) and by direct comparison with 'finished' works, they tell us (by their reticence) an immense amount about Turner's working and imaginative processes. He must have had an extraordinary power to form an advance mental 'picture' of an uncreated work, a power illustrated by the following story. Travelling in Italy in 1819 Turner was accompanied by R. G. Graves, an amateur artist:

When they had fixed upon a point of view . . . Turner would content himself with making one careful outline of the scene, and then, while Graves worked on, Turner would remain, apparently doing nothing, till, at some particular moment, perhaps on the third day, he would exclaim: 'There it is', and seizing his colours, work rapidly until he had noted down the particular effect he wished to fix in his memory.[15]

Turner worked only rarely from nature on his finished works; he was very much a studio artist

and, again, we can easily infer his studio working methods from the sketchbooks. No doubt he would leaf through such a sketchbook as the 'North of England' book from years before, and, in the event of a sketch or sketches sparking off an imaginative response, carefully and delicately indicate the topography from them on several sheets of prepared paper and begin work:

There were four drawing boards, each of which had a handle screwed to the back. Turner, after sketching in his subject in a fluent manner, grasped the handle and plunged the whole drawing into a pail of water by his side. Then quickly he washed in the principal hues that he required, flowing tint into tint, until this stage of the work was complete. Leaving this drawing to dry, he took a second board and repeated the operation. By the time the fourth drawing was laid in, the first would be ready for the finishing touches[16]

James Orrock, the painter and collector, gives us a similar observation of Turner at work (from the same witness as above, W. L. Leitch):

I have been informed, on unimpeachable authority, that each of the matchless drawings which were painted for Mr Windus of Tottenham [a retired coach-maker who had thirty-six of the 'England and Wales' drawings in his collection[17] of no less than 181 Turner watercolours by 1840] . . . was executed there in a day. Turner's method was to float in his broken colours, while the paper was wet and my late master [W.L. Leitch] . . . told me that he once saw Turner working, and this was on watercolour drawings, several of which were in progress at the same time! Mr Leitch said he stretched the paper on boards and after plunging them into water, he dropped the colours onto the paper while it was wet, making *marblings* and gradations throughout the work. His completing process was marvellously rapid, for he indicated his masses and incidents, took out half-lights, scraped out highlights and dragged, hatched and stippled until the design

was finished. This swiftness, grounded on the scale practice in early life, enabled Turner to preserve the purity and luminosity of his work, and to paint at a prodigiously rapid rate.[18]

Leitch also recorded elsewhere that the daughters of Walter Fawkes told him they had seen cords spread across Turner's bedroom at Farnley Hall with 'papers tinted with pink and blue and yellow hanging on them to dry'.[19]

This serial technique of Turner's throws some light, through the sketchbooks, upon the dating of the works themselves. The accepted dating of them is at present posited upon the year of the production of engravings from them. But, as we have seen in the previous chapter, this date-relationship is now untenable. The sketchbooks, and the location in them of several 'basis' drawings, do suggest alternatives (though still not precise ones), it seeming extremely unlikely that if a sketchbook contains eight different 'basis' sketches as does the 1797 'North of England' book, that this necessarily proves that it was referred to on eight separate occasions; a far greater likelihood is that Turner would have made all the drawings serially in one session and kept them back for later use by the engraver. However, it does not appear possible to advance more precise datings any further than that, save through scientific analysis of the drawings and a close study of the watermarks of the paper on which they are drawn. These datings are further complicated by the exhibition history of the pictures in 1829 and 1833. Only in a few instances, therefore, have I suggested the re-datings of works but I have, in the Concordance, given the date of the earliest drawings made from each sketchbook, and the others made from them may also belong to the same year.

From these descriptions of Turner's watercolour methods we can also see quite easily how the unifying design structures emerged in the initial stages of each drawing, being 'blocked in' to the wet paper. An example that affords us a clear indication of this is *Dudley, Worcestershire* (66). Here we can see exactly where Turner has washed in the three constituent colour elements that make up the

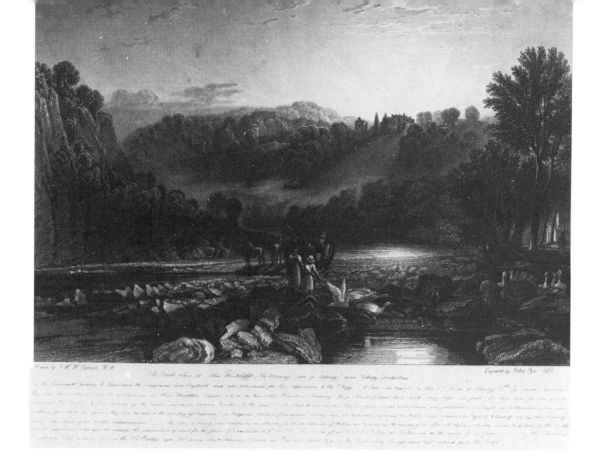

6 *John Pye's 1823 engraving of Turner's* **Wycliffe, near Rokeby** *for the 'Richmondshire' series. A long inscription by Turner recounts the history of the struggle for the translation of the Bible into English. The inscription was etched onto the original plate and only three or four copies of the impression were printed. According to Dr John Percy, all of them were for presentation.*

composition of the picture. The red, grey and pale mauve dramatically contrast the industrial fire and filth on the one hand, and, on the other, the pathetic remains of the ancient castle and priory catching the dying rays of setting sun.

These colour substructures always unify the drawings and contribute to their meaning, which is very often increased by a subtle and purposeful use of allegorical symbolism (the creation of levels of meaning *behind* ostensible images). Turner was a painter for whom art was much more explicit than words in its power to communicate specific ideas, and although he occasionally used words to clarify that meaning in his exhibited works, the results were usually counter-productive. More often than not he would resort to allegory, a frequent device in contemporary landscape painting which was to be further developed by the Pre-Raphaelites. Turner undoubtedly had what John Gage has perceptively called 'an almost obsessive readiness to associate ideas'[20] and this readiness is manifest in his use of symbolism. Fortunately we have evidence of this in the story of the engraving (Ill. 6) by John Pye of Turner's watercolour (for the 1818–23 'Richmondshire' series) of *Wycliffe, near Rokeby*, the conjectural birthplace of the fourteenth-century religious reformer, John Wycliffe: 'Mr Pye remarked to Turner that "the

geese are large". Turner replied, "They are not geese, but overfed priests." Turner told Pye that the light over Wycliffe's house indicated the symbolic light of the Reformation. Wycliffe's followers are driving away the geese-priests.'[21]

Rawlinson gives another version of the same story: 'Pye . . . stated that Turner, when "touching" the Proof, introduced a burst of light (the rays seen above the Hall) which was not in the Drawing. On being asked his reason he replied:—"that is the place where Wickcliffe [sic] was born and the light of the glorious Reformation." "Well," said Pye, satisfied, "but what do you mean by these large geese?" "Oh, they are the old superstitions which the genius of the Reformation is driving away!" '[22]

This story is a vital key to our understanding of Turner's intellectual processes. Similar allegorical levels of meaning are frequently introduced into the 'England and Wales' drawings: the *Eton* (41) already mentioned, or *Salisbury* (24) where, in an allegory of religious faith, the distant edifice surrounded by a thunderstorm is juxtaposed both with a widely scattered flock of sheep and a shepherd who affords some children shelter under his cloak, an image that obviously refers (in its use of the old symbol of Christ's ministry) to the purpose of the cathedral. Another drawing, *Ely Cathedral* (54), works on three levels: primarily it is, of course, a monumental study of a great cathedral with some children playing in the foreground; on the second level, the children relate the architectural history of the building (i.e., their stone-throwing symbolizes the collapse of the building fabric in 1322, a fact known to Turner); and on the final level this event is used to suggest the feared collapse of the Church itself, a relevant issue in 1831–2, the year of the creation of this work. There is a wealth of symbolic meaning in the 'England and Wales' series, ranging from the faith implicit in *Salisbury* (24) to the total nihilism of *Stonehenge* (25); *Dudley* (66) which associates ruins with a sense of loss; *Brinkburn Priory* (49) confronting the vanity of man with the renewal of nature; *Tynemouth* (90) discoursing on the futility of all human endeavours; *Dock Yard, Devonport* (27) using nature to suggest the end to war, and *Great Yarmouth* (26) using it to suggest the end to

peace. Others are more locally specific: *Stoneyhurst College* (35) is a very clear allegory of Catholic emancipation; *Richmond Terrace* (85) a survey of Britain's class system.

This use of allegorical symbolism derived from Turner's interest in the history of the places he depicted. His knowledge of history was extensive; he was, after all, considered by himself and others to be as much a 'history' as he was a 'landscape' painter. Since childhood he had shown a great interest in the subject and he was no doubt helped in that respect by reading the Boswell *Antiquities*. The notes in his sketchbooks demonstrate that he always took as much interest in the human associations of the places he studied (and later depicted) as he did in their natural attributes. He had, moreover, attempted to accompany his works with specific indications of that knowledge: for his earlier 'Southern Coast' series he had written a literary and historical letterpress that was eventually suppressed by the publisher on account of its incomprehensibility. The long inscription to *Wycliffe* also indicates this preoccupation. To what extent he collaborated or contributed to the 'England and Wales' letterpress is unclear but inclusion of historical descriptions in the 1833 exhibition catalogue would only have been undertaken with his permission, a fact that suggests he must have known something of their content. Most probably he discussed the topics for coverage both in the letterpress and the catalogue with H. E. Lloyd, a supposition strongly supported by the evidence of the drawings themselves. Works such as *Castle Upnor* (56), *Ely Cathedral* (54) and *Leicester Abbey* (100) show such clear symbolic allusions to these texts that it is difficult not to believe a strong correlation exists between them.

Turner's use of symbolism is not only attested to by the story of *Wycliffe*: its potential for expression is explored in many of his specifically historical and mythological subjects. This aspect of his work was accepted without reservation by Ruskin who devoted important passages in *Modern Painters* to its analysis. Turner's meanings can be understood when one grasps the way that he repeatedly uses symbolic juxtapositions of images, or fixed sym-

bols, such as a milkmaid to represent refreshment, barking dogs as dispute and a hoop to represent accord. Turner used painting to communicate; and symbolism was an important element of his art.

It was a prerequisite for successful print-publication at this time that line-engravings should exhibit much detail, a requirement well suited to the characteristics of the medium. To this end, of course, a specific, though unstated, demand was made of Turner in the degree of 'Flemish finish' contained in the watercolours; and it is indicative of his painterly confidence that he could handle that requirement with ease and, indeed, even turn it to good use. The increasingly insubstantial forms that we see in Turner's oil-paintings (but not in his watercolours) from the late 'thirties onwards would, in any event, have been of little use to an engraver, and so he elaborates. The jewel-like precision of many of these drawings again foreshadow the Pre-Raphaelites and will surprise those who think of him mainly as an early abstract expressionist.

Turner also explores the expressive potential of colour in this series, often experimenting with new pigments: many of the drawings use emerald green, 'Schweinfurt green' named after its place of invention in 1814, a colour that came on the market in the 1820s, as did both French ultramarine and a whole range of madder lakes—rose, carmine and alizarin (only isolated in 1826). Mixtures of these colours give the delicate purples seen in drawings dating from the 1830s, *Ullswater* (68), *Boston* (67) and *Blenheim House* (52). Throughout all the drawings Turner uses his colours to obtain effects of the utmost brilliance and transparency; pure blues and creams (*Bolton Abbey*—5, *Richmond Hill and Bridge*—44); brilliant greens (*Worcester*—90, *Richmond Terrace*—85); gleaming golds and reds (*Saltash*—1); glaring reds (*Dudley*—66); electric blues (*Stonehenge*—25); dark blues (*Alnwick*—32); variations of grey (*Longships Lighthouse*—73, *Lowestoffe*—76); intensities of black (*Winchelsea*—34).

By this time (as Ruskin comments in his 1851 essay 'Pre-Raphaelitism') Turner primarily conceived his work in terms of its colour, and the fruitful results of this can be seen in the drawings of

this series which have miraculously survived the years to remain some of the best examples of his power as a colourist—e.g., *Kidwelly Castle* (78) in which the colours have an unearthly beauty, or *Dudley* (66), in which he intentionally conjures up a meditative ugliness. He revels, too, in the expressive ranges of tone in those colours, exemplified at its extremes from an almost imperceptible subtlety, as in the rendering of falling water in *Fall of the Tees* (7), to breathtaking shifts from dark to light as in the centre of *Brinkburn Priory* (47). The harmony and intensity of colour displayed in all these drawings add yet another dimension to our understanding of Turner as a colourist; their certainty and mastery of technique give a renewed awareness of his abilities as a painter. Wherever we look amongst them we can see, in their fluent ranges of formal and poetic invention, a more perfect equilibrium between exquisite delicacy and tempestuous energy, a new fusion of thought and feeling.

Here, then, is a neglected series of watercolours. They combine to give a unique document of a nation and an age, demonstrating a great painter's pride in his country, his love of its beauty, humanity and history, and his understanding of its climate and landscape, all permeated by a sense of perpetual transience and loss. They can be considered the most extensive corporate work of one of the finest painters of the natural world, an artist whom one can quite justifiably compare with Shakespeare for the magnitude of his genius and the comprehensiveness of his art. He was, for all his success, a contradictory, solitary and lonely man whose immense vision is still imperfectly understood. Let Ruskin have the final word:

> And, instead of Cathedrals, Castles or Abbeys, the Hotel, the Restaurant, the Station, and the Manufactory must, in days to come, be the objects of her artist's worship. In the future England and Wales series, the Salisbury Terminus, the Carnarvon Buffet, the Grand Okehampton Hotel, and the United Bolton Mills will be the only objects thought deserving of portraiture. But the future England and Wales will never be painted by a Turner.[23]

COMMENTARIES ON THE WATERCOLOURS

In what follows I quote liberally from the works of John Ruskin. *Modern Painters* and his lesser writings on Turner are little read today and those who have read them can never have had much chance to see the pictures in this series; and so I reunite brief passages from them.

I have maintained all the original spellings of titles (i.e., *Lowestoffe, Winander-mere, Crickieth,* etc) and I have also attempted to correct errors in titling that have come about over the years. In these instances I consider the titles of the works in the 1829 or 1833 exhibitions to be authentic. In the case of the two Richmond, Yorkshire, drawings I have deleted 'from the Moors' from one of them and reverted to *Richmond Castle and Town, Yorkshire* for the other as it was listed this way in the 1833 exhibition catalogue and the distinction is obviously a useful one.

All the datings are provisional with the exception of *Saltash.* Certain drawings can, however, be fairly accurately dated by their content and in a few instances I have thus suggested datings. The sequence closely corresponds to the original published order of the engravings but certain changes have been made. The *Saltash* has been put at the beginning and I have brought together obvious pendants such as *Yarmouth* and *Devonport.* I have also taken the opportunity to separate works that would have been juxtaposed to the detriment of their dramatic effect—works of similar subjects (i.e., storm scenes) such as *White-*

haven and *Crickieth.* Further alterations have been enforced by the destruction or disappearance of pictures or because it was not possible to obtain colour transparencies. These now appear together as a group represented either by black-and-white photographs or by their engravings. A list of the engravings in their order of publication is appended after these commentaries with a list of the drawings exhibited during Turner's lifetime and their original catalogue numbers. I have also compiled a Concordance between the drawings in this series and the sketches upon which they were based.

The timings given to the works by Ruskin are those accorded to the drawings in Volume I, Section III of *Modern Painters.* The descriptive notices are from the 1833 Moon, Boys and Graves (MBG) exhibition catalogue and the number of each commentary corresponds to the plate.

1 SALTASH, CORNWALL

27 × 41cm (10¾ × 16in) Signed and dated 1825

This is the only drawing in the series to have been dated, which suggests that it was intended to begin the project. Its size, structural complexity and wealth of detail all indicate Turner's desire to explore new areas. Unlike its engraving (which did not appear until the *third* published set of engravings), the rich colour and subject matter make for a more original start to the series than the work which appeared as the first engraving, *Rivaulx Abbey* (2).

The series thus begins as it is to continue—with man as the theme. A party of marines celebrates with their women and children. The frequent use of reds and golds enhances the sense of pleasure and also throws into relief the mistiness of the distant town in the afternoon sunshine. This was characterized by Ruskin as 'very clear, after rain. A few clouds still on horizon. Dead calm'. Ruskin also praised the drawing in Volume I of *Modern Painters* for the truthful indistinctness of its reflections upon water.

Saltash itself (which the letterpress described unenthusiastically as 'narrow and indifferent') appears only in the background, although its pyramid shape, topped by the tower of St Nicholas's chapel, contributes essentially to the structure of the work. This design is unified by a line running up the oars in the centre and down the contour of the town's skyline, and the cross-webbings of the marines' uniforms are echoed in a multitude of repetitions which culminate in the triangle of Saltash itself. The town also stands at the apex of a greater triangle that runs down into the bottom corners of the picture.

2 RIVAULX ABBEY, YORKSHIRE

28 × 40cm (11 × 15¾in) *c.* 1825

This is a drawing remarkable for its misty dawn light. The ruined Cistercian abbey stands under the steep wooded banks and moors of Ryedale which contribute, along with the many figures, to a sense of claustrophobia. The morning mists swirl in great arcs around the landscape rising behind the abbey, and the richness of the foliage on the sides of the valley is described by differentiations between shadow and sunlight that impart a moist coolness to the early morning air.

The framework of the drawing is provided by the basic X-line of the hillsides and the river. Note the foreground fisherman, tying on a fly, who inspired Rawlinson to write: 'only a fisherman could have drawn [the scene] . . . the long slender tapering line of the rod is of the greatest value to the composition, as may be seen by covering it up'.[1] High up on the right the classical temple built in 1758 by Thomas Duncombe adds to the picturesque charms of the site.

There is a rather artificial engraving of Rivaulx Abbey in the 'Liber Studiorum' (No 51) and another, later and very similar watercolour of the scene which dates from the mid-1830s (Tate Gallery London).

3 LANCASTER, FROM THE AQUEDUCT BRIDGE

28 × 39cm (11 × 15½in) *c.* 1825

The large wave of canal-building that followed the opening of the Bridgewater Canal in 1761 greatly speeded up the movement of bulk goods in Britain, and this system of transport reached its heyday during Turner's lifetime.

The view is from the Lancaster Canal (linking Stainton to Preston) as it passes over the river Lune on an aqueduct. The crowded canal frames the huge expanse of country that curves around the line of the river to the town. The busy canal is deliberately contrasted with the pre-industrial agricultural countryside beneath it. This also provides a compositional contrast that increases the sense of space beyond. The colour furthers this purpose, the gold-greens of the fields below being intensified by their juxtaposition with the greys and umbers of the architecture before us, while the delicate blues distributed throughout also emphasize the warmth of light. Note the helpfully titled barge on the right; the munching barge-horse and travellers seated before it (tow-paths also served as roads); the fishing figure on the left, ostensibly hanging from the barge; the tiny reaping figures in the fields below; the detailed shadows of the balustrade on the right; and the subtle use of verticals which give variety to the principally horizontal stresses of the landscape. In the sky Turner creates a sense of movement from the left which culminates in the soft yellow space and towering cloud above the castle.

4 DARTMOUTH COVE, WITH SAILOR'S WEDDING

28 × 40cm (11 × 15¾in) *c.* 1825–6

Often after lengthy voyages, and especially during the Napoleonic Wars when shore leave was rarely granted for fear of desertion, the ensuing landfalls would be celebrated with mass marriages, as many

as two or three hundred occurring in a single week. They were usually occasions for licensed debauches, and Turner's uncensorious rendering of the scene gives us insight into his lack of inhibition and his uncondescending sympathy with the needs of humanity.

The forms of the trio of women in the foreground are echoed by the equally feminine lines of the trees on the left, one of which stands out, dark and suggestively phallic, from its companions. In this way it symbolizes the human motives of the picture. Its shape also summarises all the waving gestures of the figures.

The structure of the composition is masterly: the line of the overturned table in the foreground carries through to the line of the cove on the right, and the opposite diagonal of the river bank carries on up to the left, the central tree growing out of the point of bisection. To this structure Turner counterpoints two semi-circles: the left-hand one runs up the sailor with the raised arms on the left and through the flag down to the side of the woman with the raised handkerchief on the right; the other runs through the shape of the cove on the right from the left side of the woman's companion. Note the straw hats, indicating a return from a foreign station, and the tiny detail of the horse and cart ascending the opposite hill across the river.

5 BOLTON ABBEY, YORKSHIRE

Signed but not dated *c.* 1825
29 × 39cm (11½ × 15½in)

'. . . those shores of Wharfe which, I believe, he [Turner] could never revisit without tears; nay, which for all the latter part of his life, he could never even speak of, but his voice faltered'

(Ruskin, on this drawing in *Modern Painters* Vol IV, Part V)

All the elements of Yorkshire scenery that Turner valued so highly are to be seen here: the richness of form, colour and light and above all the immensity of scale. He had felt the impact of all of these years

before, but his associations of place were fixed and lifelong, a formative influence that was described by Ruskin who owned this picture at the time that he wrote of it:

And at last fortune wills that the lad's true life shall begin; and one summer's evening . . . he finds himself sitting alone amongst the Yorkshire hills. For the first time, the silence of Nature round him, her freedom sealed to him, her glory opened to him. Peace at last; no roll of cartwheel, nor mutter of sullen voices in the back shop; but curlew-cry in space of heaven, and welling of bell-toned streamlet by its shadowy rock. Freedom at last. Dead wall, dark railing, fenced field, gated garden, all passed away like the dream of a prisoner; and behold, far as foot or eye can race or range, the moor, and cloud. Loveliness at last. It is here then, among these deserted vales! Not among men. Those pale, poverty-struck, or cruel faces;—that multitudinous, marred humanity—are not the only things that God has made. Here is something He has made which no one has marred. Pride of purple rocks, and river pools of blue, and tender wilderness of glittering trees, and misty lights of evening on immeasurable hills. Beauty, and freedom, and peace . . .[2]

The ruined abbey, an Augustinian foundation dating from 1120, stands tranquilly in the early sunlight and Turner expresses the serene mood in his handling of the foreground trees which dominate the picture. Their disappearance at its top seems to increase the height of the landscape and to emphasize the sense of solitude. Turner not only depicts their outward forms but also suggests their growth. To quote Ruskin, they are '. . . seen to be all tremulous, perpetually waving along every edge into endless melody of change. This is finish in line, in exactly the same sense that a fine melody is finished in the association of its notes . . . Texture of bark, anatomy of muscle beneath, reflected lights in recessed hollows, stains of dark moss, and flickering shadows from the foliage above, all are there, as clearly as the human hand can mark them.'[3]

6 COLCHESTER, ESSEX

28 × 40cm (11⅙ × 15-9/10in) *c. 1825–6*

The pursuit of a hare is an image used elsewhere by Turner. It appeared in an earlier drawing of the site of the Battle of Hastings (*Battle Abbey*, now untraced) where the hare's pursuit by a dog symbolizes the impending defeat of King Harold (or 'Arold 'Arefoot' as Turner described him to a contemporary); in 1837 he was to use its chase by a hound to represent the pursuit of love in his painting *Apollo and Daphne*; and finally the poor animal was to appear in *Rain, Steam and Speed* as an emblem of speed running before the advancing locomotive. Here its rush injects both speed and fear into an otherwise peaceful scene and Turner uses it to comment upon the uneasy relationship of nature to the growing towns of the nineteenth century.

The handling is enormously confident, Turner strewing his highlights and shadows with seeming abandon. The immaterial quality of the shimmering roofs on the right is heightened by the solidity of the hillside on the left. The colouring is warm and soft, but the drawing's exact timing has presented some problems: Finberg[4] characterizes it as late afternoon, a view shared by Rawlinson, who also suggests[5] however, that it may depict moonlight (although a comparison with *Alnwick* (32) suggests not). The view itself looks due south and it therefore cannot realistically be a sunset. Turner has most probably lit the scene from his imagination or merely lowered the late afternoon sun. Middle Mill (on the right) is still standing, although much altered. Note how Turner repeats the gestures of the figures in the shape of the willow trees on the right of the pond.

7 FALL OF THE TEES, YORKSHIRE

28 × 39cm (11 × 15½in) *c. 1825–6*

A vision of solitude, in which the single, focal figure, who looks as if he were sketching, might even be Turner himself. He had in fact sketched High Force waterfall from that exact spot in 1816 and used the sketch as the basis for a drawing in the 'Richmondshire' series.

Ruskin praises this drawing at much length for its observation of rock formations, so accurate, he suggests, as to be capable of forming a geological lecture in themselves: 'In fact, the great quality about Turner's drawings . . . is the capability they afford us of reasoning on past and future phenomena, just as if we had the actual rocks before us; for this indicates not that one truth is given, or another, not that a pretty or interesting morsel has been selected here and there, but that the whole truth has been given, with all the relations of its parts; so that we can pick and choose our points of pleasure or of thought for ourselves, and reason upon the whole with the same certainty which we should after having climbed and hammered over the rocks bit by bit'.[6]

Ruskin also praises Turner's especial accuracy in the rendering of the concentric waves of falling water, not merely drawing it as an unbroken fall, but as wave upon wave. These same waves in the engraving (Ill. 7) were worked with less subtlety and more obvious dramatic contrast to compensate for the absence of the drawing's warm colour.

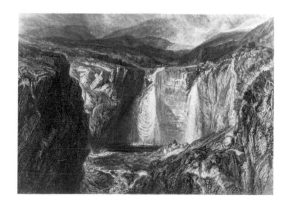

*7 Engraving of **Fall of the Tees, Yorkshire** by Edward Goodall.*

8 BARNARD CASTLE, DURHAM

29 × 41cm (11⅝ × 16¼in) *c.* 1826

The luxuriant vitality of nature is strongly contrasted with the austere shell of the ruined castle, proudly dominant in the sharp, early sunshine. Turner evinces the maximum brilliancy from the sparkling highlights that animate the surface. The compositional structure consists of a X-line that crosses on the water immediately beneath the sun. A large curve led by the bank of shingle on the river repeats the double curve of the bridge-spans. In addition, a parallelogram is created by the man binding wood on the shingle, the fisherman standing at the end of it, the tiny distant figure immediately under the sun, and the reflected highlight at the right-hand end of the bridge.

Into this harmony of light and nature Turner introduces a single ominous note: at the river's edge below us there are two women happily fishing; immediately above them is the sinister figure of an approaching woodcutter, his scythe raised in a threatening gesture.

This detail suggests that it was made soon after the death of Fawkes. The light patches around the castle and sun are probably the results of a later attempt to bleach out a stain. There is a colour-study for this work in the Turner Bequest (CCLXIII–323).

9 LAUNCESTON, CORNWALL

27 × 39cm (10¾ × 15½in) *c.* 1825

The silent and foreboding mood of this picture is heightened by the solitary figure in the centre, a device that also contributes to the grandeur of the landscape. Unfortunately the drawing (especially in the greens) has faded much since it was last reproduced in colour as Plate XV in *The Water-colours of J. M. W. Turner* by W. G. Rawlinson and A. J. Finberg (London, 1909), but the powerful composition remains. Over the two massive diagonals that meet on the right, a sinuous line is apparent from the initial colour-beginning. It runs from the top of the hillside on the left, curves down through the line of foreground trees in the centre, runs under the figure, turns up the tree on the right (having created *en route* an enormous void in the centre) and finally arrives at the castle.

10 RICHMOND CASTLE AND TOWN, YORKSHIRE

27 × 40cm (10¹³⁄₁₆ × 15⅝in) *c.* 1825

Turner here draws upon ranges of colour that were especially reserved for his beloved Yorkshire subjects: richly autumnal, the mood even extends into the sky, with its touches of pink in the clouds, and the total effect is one of gold and silver alternations of warmth and coolness.

The splendour of the castle and town in the early morning light is celebrated with an astonishing virtuosity based upon minute observation, and the sharp clarity of the architecture and of the dense and verdant natural forms throughout are all intensified by the central vagueness of the rubbed-out haze above the river. The tones transform radiant lightness into utmost darkness within inches and without any sense of artificiality. This can be seen especially at the lower left-hand corner. The drawing is structured by a shallow pyramid at whose apex stands the castle's tower, and by two diagonals that meet on the left; the curves of the bridge are repeated in the shape of the hillock before it and magnified by the recession of moors beyond.

The girl with a dog (or dogs) appears in all four of Turner's views of the town (the other two being in the series of drawings that he made for subsequent engraving in Whitaker's *History of Richmondshire*). Turner no doubt once observed a girl with a dog there. Here, however, the dogs, who later appear as symbols of aggression or dispute, are playful and the general happiness of the work certainly suggests that it was created before the death of Fawkes.

11 PRUDHOE CASTLE, NORTHUMBERLAND

29 × 41cm (11½ × 16¼in) Summer 1825

In this work Turner appropriates Claudian pictorial composition and develops it to new ends. With extraordinary virtuosity he creates a complex of rhythmic and tonal vortices that spin from the centre of the drawing, not only intensifying the light but also creating an infinity of recessions in the distance. To these circular movements are counterpoised three overlapping triangles in the lower half of the picture, of which the left two balance the third triangle of the receding road on the right, and also divide the river 'into two channels, the right hand one being that which it usually takes, but the left [being] also filled in a flood'.[7] All of these structures are subordinate to the overall triangle that leads up to the castle.

The tonal range is greatly varied: around the sun Turner juxtaposes maximum intensities of black, white, yellow and blue to give richness to the lush greens and gold-umbers of the foreground and the pale blues of the sky. The diversity of movement is augmented by the figures and by the distribution of debris that also serves to fix the association of ruin.

Turner has taken his usual liberties with the landscape, most especially in the raising of the castle to almost Rhenish heights. Otherwise the scene is recognizable today, with the town of Prudhoe standing high on the moors at about the height of the castle and the whole far bank of the Tyne a depressing conglomeration of railway yards and factories. Rawlinson relates that the drawing's first owner, the Reverend Kingsley, told him 'the drawing was afterwards damaged in the centre of the sun's reflection in the water, and on Turner's coming to see it, he said: "I won't have that tampered with". He moistened his finger with saliva, rubbed the colour off, and then touched it in

again. It is now impossible to see the repair.' (At the same time he scratched his name in the left corner of the drawing which had previously been unsigned). Some doubt exists as to the exact genesis of this work: Rawlinson records that Kingsley also told him it was: 'made by Turner from memory, he having been struck by the view as he was being driven past, whilst on a visit to the Swinburne family [in August 1825?]. He wanted to stop the carriage and make a sketch, but time would not permit'. As Andrew Wilton has pointed out, however, the finished drawing is so close in its formal configuration to sketches made much earlier that 'it is difficult to believe that they were not adhered to'.[8] These sketches are contained on pages 78–77a of the 'Durham, North Shore' sketchbook (TB CLVII) used on a tour of Northumberland in 1817.

12 ALDBOROUGII, SUFFOLK

28 × 40cm (11 × 15¾in) *c. 1825–6*

This is a dawn scene in summer, the day already hot and displaying a rich light. The buildings shimmer in the early warmth, and the sun emerges from behind the Martello tower on the right with a brilliance intensified by the texture of the rubbed paper. Turner minutely observes the shadow of the tower as it falls across the sail of the boat in front of it, another detail supplied from memory, there being no record of it in the sketch.

The composition is structured by two diagonals that meet midway on the right, running up the mast in the foreground, and along the line of the shore to the town. Aldeburgh was already becoming a fashionable holiday resort, and the letterpress by H. E. Lloyd tells us that 'for the mean clay-built cottages of the poor, the appearance of which too forcibly announced the dirt and misery that prevails within, we now find many neat and comfortable dwellings belonging to persons of rank and fortune, who occasionally reside in them. It is pleasing to be able to add that the morals of the lower classes are much improved.'

13 ORFORD, SUFFOLK

28 × 40cm (11 × 15⅞in) *c. 1825–6*

This is a companion piece to *Aldborough, Suffolk* (which it follows in the order of engraving). Both drawings show the same early time of day and summer air, the gentle Suffolk morning mists here seen blowing away across to the right below the town. The picture also contains one of Turner's visual jokes: the crab fishermen on the left are unaware of the 'one that got away' (i.e., the crab floating across the water on the right). Turner has again distorted the topography by raising the height of the castle and his drawing of it makes it particularly dream-like. An almost hidden diagonal links the bird in the top left, the bird beneath it, the top of the castle, the ship's mast, the seagull and finally the crab; and the merging of gold into blue on the right is achieved both with ease and without a trace of muddy green.

14 VALLE CRUCIS ABBEY, DENBIGHSHIRE

29 × 41cm (11¼ × 16⅛in) *c. 1825–6*

'Formerly a House of Cistercians, founded in the year 1200, and dedicated to the Virgin Mary: the ruins of the abbey still afford some fine specimens of the pointed style of architecture. The ruins of the conical mountain in the background of the view are those of the once impregnable castle of Dinas Bran'.
(From the 1833 MBG Gallery exhibition catalogue)

The abbey stands in the sunshine with Eglwyseg mountain receding in shimmering waves beyond, and the long, early shadows both structure the drawing and intensify the movement of the industrious labourers below. The shepherdess returning two strays to the fold adds both a rustic innocence and a hint of religious symbolism to the scene, but the drawing's ultimate intent is not allegorical, merely exploring the light on the upper and lower ruins and the fertile panorama. There is

extensive scraping out, especially of the fleece on the right and in the corn on the left.

The sketch upon which this drawing is based is contained on page 13 of the 1808 'Tabley No 1' sketchbook (TB CII) and on it Turner writes the words 'road' and 'corn' to signify their whereabouts. A similar view to this was hand-tinted in Boswell's *Antiquities*.

15 BUCKFASTLEIGH ABBEY, DEVONSHIRE

27 × 39cm (10¾ × 15½in) *c. 1825–7*

A sunlit autumn morning in which Turner exactly describes the alternate warmth and coolness of the temperature and the turning colours of the foliage.

The boys on the left attempting to retrieve their kite establish a necessary vertical element which offsets the horizontal emphasis of the vista. The drawing is structured by various repetitions of the curve of the river, and these can be seen in the shapes of the moors, the rounded form of the tree on the left, and most clearly in the line of the road at the bottom centre. The colouring is rich and the haze of distance has a perfect tonal subtlety, especially at the skyline to the right and on Dartmoor, where Turner places the early mists with impetuous ease.

The spots discernible in the blue sky to the left are present in the original and are almost certainly the result of nineteenth-century restoration.

16 LANCASTER SANDS

28 × 40cm (11 × 15⅞in) *c. 1825–7*

Morecambe Bay, of which Lancaster Sands are a part, was fordable at low tides, there being traditional guides (called 'Carters') who would lead travellers across. They were necessary, as sudden fogs, unexpected tides and quicksands were an

ever-present hazard. Here a straggling line of pathetic figures hurry to cross before nightfall and they are necessarily pre-occupied and oblivious to the glorious scene around them. The rising tide is clearly depicted and the sense of danger is intensified by the compositionally important diagonal lines that meet at the straining horses on the right, by the gesticulating figures, and by the confrontation between two dogs and a seagull on the left. Turner varies the depth of the water that the various figures are walking through, and in the distance a cart and horses are being overtaken by the sea.

Ruskin wrote of this work: 'It is of an evening in spring, when the south rain has ceased at sunset; and, through the lulled and golden air, the confused and fantastic mists float up along the hollows of the mountains, white and pure, the resurrection in spirit of the new fallen rain, catching shadows from the precipices, and mocking the dark peaks with their own mountain-like but melting forms till the solid mountains seem in motion like those waves of cloud, emerging and vanishing as the weak wind passes by their summits; while the blue level night advances along the sea, and the surging breakers leap up to catch the last light from the path of the sunset.'[9]

17 OKEHAMPTON, DEVONSHIRE

29 × 40cm (11 3/16 × 16 3/16 in) *c. 1826*

Turner effectively contrasts the ruined castle and the death of the rabbits with the abundance of nature but the work lacks the more serious symbolic undertones found in another hunting scene, the later *Powis Castle* (69). He perfectly captures the morning light of an early autumn day and likewise demonstrates an effortless virtuosity: 'The winding valley in the left-hand distance, painted with little more than a single wash and scratch of light through it, may be taken for an example of the painter's loveliest work at speed.'[10] The framework of the composition is a large

triangle which culminates at the conical hill of the castle. This is opposed by the wide semi-circle of the descending foreground; and both of these shapes are repeated and intensified by the opposing curves of the rabbits.

There is another drawing of this castle (from a lower viewpoint) made for the 'Rivers of England' series. It was mezzotint-engraved in 1825 and is now in the British Museum. The 'England and Wales' drawing was engraved in 1828 by J. T. Willmore and he also reproduced it separately in another much smaller engraving at a later unknown date. (Rawlinson No. 647).

18 LOUTH, LINCOLNSHIRE

29 × 42cm (11 1/4 × 16 1/2 in) *c. 1827–8*

Ruskin, who owned this drawing, thought that Turner had done it as a sop to the publisher. Rawlinson on the other hand wrote that, 'homely subjects were by no means uncongenial to [Turner] and he would probably have thoroughly enjoyed the sights and sounds of a country fair.'[11] This enjoyment is evident throughout the picture, and Turner gives us a wonderful survey of a nineteenth-century horse-fair (for once his horses are almost to the right scale), the whole scene lively and animated, with the social distinctions finely observed between simple rustics on the left and horse-dealers, farmers and buyers on the right. These distinctions are emphasized by the wide space that forms an important part of the drawing's structure, all the figures standing outside its shallow inverted V-line. This is counterpointed by the basic X-line of the surrounding buildings on either side of the square.

The warmth of light and the contrast of the town's rustic architecture with the majestic splendour of the medieval church of St James's complements the magnificently stormy sky. The spontaneous rendering of the shadows across the sunlit buildings on the left is particularly striking.

19 KNARESBOROUGH, YORKSHIRE

29 × 41cm (11 3/8 × 16 1/4 in) *c. 1825–7*

Another drawing whose richness of colour grows out of Turner's response to a particular area of England. As Rawlinson says: 'This could have been drawn only in Yorkshire.'[12] Its structure is remarkably similar to that of *Kilgarren Castle* (21), but here it is even more complex: the basic linear structure is a shape in which we follow the gesture of the girl's arm (repeated by the bough of the near tree) up the line of approaching cows to the waving herdsman and then turn left up the further line of animals to the town, so becoming gradually involved in an inextricable mesh of interrelated diagonals that create an infinity of unifying parallel relationships. The foliage in the foreground heightens the sense of the castle's decay and the dark tones on the left, by contrast, make the light of the hillside on the right appear even more transparent. There is extensive scraping out at the bottom right and in the foliage at the centre.

20 MALMSBURY ABBEY, WILTSHIRE

29 × 42cm (11 3/8 × 16 3/8 in) *c. 1825–8*

'The tragedy in progress here is amusing—the milkmaid is evidently—and not unnaturally?—declining the attentions of the elderly and most unattractive swain, whilst the proceedings are being watched from behind the hedge, apparently by a youthful sister and brother. Doubtless Turner had witnessed the scene.'

W. G. Rawlinson[13]

Turner knew Malmesbury from the Boswell *Antiquities*. He actually visited it in 1791 at the age of sixteen and drew it in watercolour several times in the 'Bristol and Malmsbury' sketchbook used on that trip. He also exhibited a watercolour of the subject at the Royal Academy in 1792 (Castle Museum, Norwich).

Turner further develops this familiar scene with the richness of mature colour. The blue shadows

upon the abbey and in the mist behind the line of trees are spectacular and convincing and their intensity is heightened by the gold-greens sandwiched between them. The cows and foliage are re-created from the early sketches, but by now Turner's understanding of animal and botanic anatomy is as mature as his colour and the differentiation between sunlight and soft shadow upon the foliage on the right is particularly effective. The structure of the drawing is formed by the embracing curve that runs right across the picture through the line of treetops, and this line mirrors the arch of the abbey standing stark against the sky.

21 KILGARREN CASTLE, PEMBROKESHIRE

28 × 41cm (11¼ × 16¼in) *c.* 1825–8

Turner made four oil-paintings of this subject around the turn of the century. He had also developed the subject earlier in watercolour in a group still contained in the 'Hereford Court' sketchbook (now in the Turner Bequest) and in a separate watercolour (now in the Manchester City Art Gallery). These are all in his early, rather gloomy Wilsonian manner.

In this work he once more recreates that long-remembered dawn, but instead of giving us a dark somnolence he offers brilliant sunlight bursting from behind the castle and cascading over the high, lush banks of the Teifi and Plysgog rivers. On the water itself the bathing naiads of the early paintings have made way for more convincing boatmen. Turner has rubbed the paper in the area beneath the castle to give the texture of the mist, and the Gainsborough-like woman and child in the foreground are proof of his excellent ability to draw figures. Their hoop is a recurring symbol of accord.

22 EXETER

29 × 42cm (11⅝ × 16⅝in) *c.* 1825–9

The cathedral is partially obscured by Colleton Crescent, and this conjunction emphasises the diminution of the importance of ecclesiastical architecture in the growing towns of the early nineteenth century. This statement is heightened by the busy activity on the river and by the sunset.

That Turner used gum with his watercolour in this drawing is very apparent in the distant blue of the river to the left. He also displays a slightly careless use of perspective, for the line of houses at the riverside on the right appear to sink into the water. The drawing is generally in a fine condition although the sky has yellowed slightly. The greens still appear very fresh and the handling of reflection on the water is adroit and finely observed, with touches of mauve in the shadows serving to complement the warmth of the light.

23 RICHMOND, YORKSHIRE

28 × 40cm (11 × 15¹¹⁄₃₂in) *c.* 1825–8

The view is from Swaledale (above Whitcliffe) towards the south-east, with the same girl and dog that appear in the other 'England and Wales' view of the town (10). This is one of the most extensive panoramas that Turner ever drew of England and he unifies it with great economy: an X-structure is disguised in a line running down from the distant rain above the river to the shadow inside the bridge in the bottom left-hand corner, and this is crossed by the line of the moors running down to the right, bisecting the river *en route*. In Volume V of *Modern Painters* Ruskin praises the accuracy of Turner's rendering of foliage in the foreground, and once again the solitary figure and her dog (rendered, as always, with insight into the behaviour of children and animals) serve to lend distance to the moors beyond. The passage of shadows over ground is handled with complete technical assurance and

with a knowledge of the modelled form beneath. The contrast between the dark and rich red-browns in the foreground and the soft, warm greens beyond serve to lead the eye towards to the castle whose vertical lines dominate the landscape.

24 SALISBURY, FROM OLD SARUM INTRENCHMENT

28 × 41cm (10⅞ × 16¼in) *c.* 1828–9

'This drawing is of unsurpassable beauty in its sky, and effect of fast-flying storm and following sun-beams . . . No more lovely or skilful work in water-colour exists than the execution of the distance in this drawing'
Ruskin (Notes '1878' pp. 40–41)

Ruskin characterized this drawing as 'Turner's great sermon on Salisbury Plain', and he particularly appreciated its symbolism. The cathedral is combined with the old Christian symbol of a shepherd and his flock, and the landscape is widely varied in its range of colour, from cool to brilliant greens and deep blues to Venetian reds. The passage of shadows over the ground is finely observed and the washes are laid on with enormous confidence.

Ruskin saw the connection between this drawing and *Stonehenge* (25) and he wrote of them:

On that plain of Salisbury, he [Turner] had been struck first by its widely-spacious pastoral life; and secondly by its monument of the two great religions of England—Druidical and Christian. He was not a man to miss the possible connection of these impressions. He treats the shepherd life as a type of ecclesiastical; and composes his two drawings so as to illustrate both.
In the drawing of Salisbury . . . the Cathedral occupies the centre of the picture, towering high over the city, of which the houses (made on purpose smaller than they really are) are scattered about it like a flock of sheep. The Cathedral

is surrounded by a great light. The storm gives way at first in a subdued gleam over a distant parish church, then bursts down again, breaks away into full light about the Cathedral, and passes over the city, in various sun and shade . . . The rain-clouds in this picture are wrought with a care I have never seen equalled in any other sky of the same kind. It is the rain of blessing—abundant but full of brightness; golden gleams are flying across the wet grass, and fall softly on the lines of willows in the valley—willows by the watercourses; the little brooks flash out here and there between them and the fields. Turn now to the Stonehenge. That also stands in a great light; but it is the Gorgon light—the sword of Chrysaor is bared against it. The cloud of judgement hangs above. The rock pillars seem to reel before its slope, pale beneath the lightning. And nearer in the darkness, the shepherd lies dead, his flock scattered.[14]

25 STONEHENGE

28 × 41cm (11 × 16in) c. 1825–8

A drawing of brutal grandeur. The shepherd and sheep in the foreground have just been struck by lightning, whose precise path we can gauge, and their annihilation is deliberately juxtaposed with the ruins of a dead religion. The drawing articulates Turner's pessimistic view that mankind and civilization would end in extinction and that all religious faith is a 'fallacy of hope'.

The sharp colours in the drawing have a chilling intensity like those of the electrical forces depicted, most especially in the brilliant blue of the dead shepherd's jacket. Ruskin called it:

. . . the standard of storm drawing, both for the overwhelming power and gigantic proportions and spaces of its cloud forms, and for the tremendous qualities of lurid and sulphurous colours which are gained in them. All its forms are marked with violent angles, as if the whole muscular energy, so to speak, of the cloud were

writhing in every fold: and their fantastic and fiery volumes have a peculiar horror, an awful life, shadowed out in their strange, swift, fearful outlines which oppress the mind more than even the threatening of their gigantic gloom. The white lightning, not as it is drawn by less observant or less capable painters, in zigzag fortifications, but in its own dreadful irregularity of streaming fire, is brought down, not merely over the dark clouds, but through the full light of an illuminated opening to the blue, which yet cannot abate the brilliancy of its white line; and the track of the last flash along the ground is fearfully marked by the dog howling over the fallen shepherd and the ewe pressing her head upon the body of her dead lamb.[15]

Turner's most comprehensive group of sketches of Stonehenge occur in a sketchbook of 1811–15 (TB Add CXXV B) in which he draws the scene several times, but nowhere exactly like this. As Louis Hawes has pointed out: 'From no viewpoint does the ruin appear as we find it here. He [Turner] increases the number of supported lintels and treats the central area in a way that bears little resemblance to its actual disposition.'[16]

26 GREAT YARMOUTH, NORFOLK

28 × 39cm (11 × 15½in) c. 1825–8

This drawing symbolizes the advent of war and is a natural pendant to *Devonport* (27) which represents the coming of peace. The view is from Gorleston, with Gorleston Pier on the right.

In the foreground a washerwoman represents Britain's citizenry taking shelter behind its military power. After laying her washing and fish to dry in the peaceful sun, she sees her bonnet, basket and items of wet clothing blow away in a sudden and fierce wind. Beyond her ranges the vast space of Yarmouth Sands with the naval hospital and the parish church of St Nicholas to the left, and at the centre the 144-foot high monument erected in 1817 to honour the memory of Nelson. Behind its stark

vertical (topped by a statue of Britannia) lies a wall of ships, the Yarmouth-based North Sea fleet lying at anchor beneath a sky whose ominous clouds merge rain with sea on the horizon.

By this means the change from peace to the promise of coming storm is suggested. The transformation is intensified by the sea in the bottom right-hand corner where the tide is clearly on the turn, and by the inclusion, far below on the sands (to the right of the washerwoman), of the two dogs, one white and one black, that are frequently used by Turner to symbolize dispute and aggression (*see also* 31).

Note the two herrings lying side by side in the foreground, a reminder of the town's main industry; the cap, blurred in its flurry of movement; the wheeling seagulls, tiny in the distance; and the surges and eddies of the sea at the bottom right-hand corner. Ruskin remarked of this sea that it should be 'noticed for its expression of water under a fresh gale, seen in enormous extent from a great elevation; there is almost every form of sea in it: rolling waves dashing on the pier; successive breakers rolling to the shore; a vast horizon of multitudinous waves; and winding canals of calm water along the sands, bringing fragments of bright sky down into their yellow waste'.[17]

The sudden jump from foreground to background and the sheer drop on the right force the eye to the middle distance. The contrast between the active foreground and the solitary stability of the distant column with its associated fleet suggests Nelson's steadfast determination to protect England.

27 DOCKYARD, DEVONPORT, SHIPS BEING PAID OFF

27 × 43cm (10⅗ × 16⅘in) c. 1825–9

The drawing was probably intended as a pendant to *Great Yarmouth* (26) which was published as an engraving in the same year. It is an allegory of peace whose meaning is not only suggested by the title, but by the symbolism of the

sky, in which dark storm-clouds pass away to reveal a beneficent calm.

The work was in Ruskin's possession when he wrote of it in 1878:

... it will be seen that much of what the public were most pained by in Turner's figure drawing arose from what Turner himself had been chiefly pained by in the public. He saw, and more clearly than he knew himself, the especial forte of England in 'vulgarity'. I cannot better explain the word than by pointing to those groups of Turner's figures exaggerating this special quality as it manifested itself to him, either in Richmond picnics, barrack domestic life, jockey commerce, or here, finally, in the general relationships of Jack ashore ... His sympathy with the sailor's part of it, however, is deeper than any other, and a most intimate element in his whole life and genius. No more wonderful drawing, take it all in all, exists, by his hand, than this one, and the sky is the most exquisite in my own entire collection of his drawings. It is quite consummately true, as all things are when they are consummately lovely. It is of course the breaking up of the warm rain-clouds of summer, thunder passing away in the west, the golden light and melting blue mingled with yet falling rain, which troubles the water surface, making it misty altogether, in the shade to the left, but gradually leaving the reflection clearer under the warm opening light. For subtle, and yet easily vigorous drawing of the hulls of our old ships of war, study the group in the rain, no less than the rougher one on the right.[18]

To the right is the parish church of 1771; in front of it two hulks, commonly used as floating barracks, storeships or hospital accommodation; behind them, a sheer hulk, its 'sheers' or uprights used for raising masts; and in the centre some covered building slips, a kind of dry-dock shed in which the ships were actually built. One can just see the aperture at the front through which the ships would be launched when completed (the sheds being subsequently flooded), and such building sheds still exist in various naval dockyards in Britain including those at Devonport, which retain their gambrel timber roofs.

Turner unifies the composition by a colour-diagonal, the glow of sunlight on the right continuing the diagonal line running down from the clouds.

28 DUNSTANBOROUGH CASTLE, NORTHUMBERLAND

29 × 42cm (11$\frac{7}{16}$ × 16$\frac{1}{2}$in) c. 1825–8

Turner knew this scene from his youth and also encountered it in Boswell's *Antiquities*. From these early experiences he developed three oil-paintings, another watercolour, and a mezzotint plate for the 'Liber Studiorum'. Two of the oils are in his early dark style, stilted and heavy, and even the 'Liber' plate is quite tame and conventional in comparison. This version of the subject is a further example of ruin with wreck, the shattered castle looking down upon a scene of more recent human disaster. The drawing evokes the exhausted peace after storm, its large empty spaces of sky and beach extending the desolation and loneliness of the dejected figures with their pathetic salvage. The colour, too, is precise in its rendering of early morning light, the merest tinge of warmth entering into the otherwise chilly scene, where the dark coldness of the sea still suggests the previous night's storm.

29 CARISBROOK CASTLE, ISLE OF WIGHT

29 × 41cm (11$\frac{1}{2}$ × 16$\frac{1}{4}$in) c. 1828

Turner demonstrates his understanding of density in the handling of the castle gateway and the equally solid cloud-forms. The drawing takes its rhythm from a series of curves in the castle gateway: the convex and concave lines of the doorway are repeated by the castle wall on the left, the masonry above the doorway, the rainbow, the line of light in the sky above and in the rain. The rotundity of the castle's gate-towers is also repeated in the hind-quarters of the white horse (with its lady rider) and the cumulus clouds.

Turner had made a large watercolour study of this same gateway over thirty years earlier on page 25a of the 1795 'Isle of Wight' sketchbook (TB XXIV) and he used that early work as the basis of this later drawing. He has changed his viewpoint to the opposite side of the gateway and in the process invented a new side of the picture from memory.

The difference between the two versions is nowhere better exemplified than in the rendering of the castle doorway: in the earlier picture it is merely a dark space, while here it is gold and purple, a richness that is far more mysterious. The handling throughout the later drawing betrays nothing of the picturesque conventionality of the former. The force of the sky, the dark black-green shadows in the foreground, the character and disposition of the figures and the physical solidity of the architecture transfigure the subject.

30 WEST COWES, ISLE OF WIGHT

29 × 42cm (11$\frac{1}{4}$ × 16$\frac{1}{2}$in) c. 1827

Turner visited Cowes in July and August 1827, when he stayed with the architect John Nash at his home, East Cowes Castle. Nash had commissioned Turner to paint views of the castle, and the two resultant oil-paintings were exhibited at the Royal Academy in 1828. Turner made many oil-sketches for these paintings and this drawing obviously grew out of that visit, although it is alone in depicting West Cowes itself, seen in the distance across the mouth of the River Medina. The drawing contrasts with the activity of almost all of the oil paintings, matching in mood a dawn scene in oils entitled *Shipping off East Cowes Headland* (Tate Gallery, London) which looks approximately towards the viewpoint of this picture.

Cowes Roads at this time were used by the Royal Yacht Squadron for their regattas and also by vessels from Portsmouth waiting to form convoys.

This shipping is depicted in a peaceful scene with the soft light and red tinges to the sails evoking the gentle melancholy of early evening. Turner deliberately restrains the picture's movement and the underlying compositional unity is formed by an implied diagonal running through the tops of the ships' masts and the line of the sunset's clouds. This is repeated by the officer's gesture in the foreground and by the anchor chain and rigging on the right, and it is countered by an even more subtle diagonal running upwards from the bottom right-hand corner.

The town in the distance seems incidental but the west tower of St Mary's (built by Nash in 1816) is crucial to the composition, introducing contrast to the shipping in the foreground and giving a point of focus to the whole drawing.

The reflection of the moon upon the water at the left was adroitly achieved by scratching the paper.

31 STAMFORD, LINCOLNSHIRE

29 × 42cm (11½ × 16½in) *c. 1825–8*

Once again Turner chooses a subject that indicates his desire to record contemporary events and experience in this series: the use of the stagecoach, as a means of long-distance transport, reached its height immediately prior to the development of the railways. By 1830 Stamford (almost exactly half-way between London and York) was to have thirty stage and forty mail coaches passing through it every day on the Great North Road. The town was the natural place to break the arduous journey and consequently had many coaching inns. Turner therefore depicts one of its main industries as well as its numerous medieval churches which he had studied many years before.

The size of the nearest of these churches, St Martin's, is increased by Turner's diminution of the scale of buildings opposite it, by his increase of the angle of recession of the street in front of it, and by placing on that street another stagecoach racing up the hill towards us. He stresses the church's

stability by contrasting its sunlit, Perpendicular tower with the tumultuous storm beyond. The picture's frenetic movement is added to by the bustle of the travellers in the foreground. The warm humidity creates a palpable feeling of physical discomfort that was, no doubt, very much part of Turner's experience of this primitive means of transport. He had by now travelled many thousands of miles in this way, and although he doubtless had had 'various wonderful stagecoach experiences on the north road, which gave him a love of stagecoaches ever after',[19] he must also have had many a chance to observe the bad temper and aggression that travel often creates. This is as much the picture's subject as are the luminously shining buildings in the damp air, and once again Rawlinson seems quite wrong in writing that the figures in this picture are 'unpleasantly realistic'.[20] The jumble of suitcases on the left, the two dogs barking wildly (symbols of aggression), and the milkmaid representing refreshment embellish the subject.

32 ALNWICK CASTLE, NORTHUMBERLAND

28 × 42cm (11⅛ × 16⅝in) *c. 1825–8*

By Turner's lifetime Gothic buildings were being recycled as Gothick fantasy: to this end this ancient Norman castle was extensively re-modelled by Robert Adam in the late eighteenth century. Turner exaggerates the fantastic style of the architecture by his choice of moonlight and the details are clearly defined with complex interplays of reflection and shadow. The animals add elegance to the scene and Turner echoes the shape of two of the castle's towers by those of the deers' antlers in the foreground. Note the way that the arches of the bridge are distorted in order to place the centre of a span beneath the moon.

33 HOLY ISLAND, NORTHUMBERLAND

29 × 43cm (11¼ × 16¾in) *c. 1825–8*

'This island is so called from its having been the residence of several fathers of the Saxon Church; it is also called Lindisfarne: about eight miles from Berwick and two from the mainland. As in the time of Bede, it is still accessible, both by horses and carriages, at low water, but it is necessary to be acquainted with the quicksands which are dangerous.'
From the 1833 M.B.G. exhibition catalogue.

Relief supplies are being landed from a boat which may have off-loaded them from the steamer on the horizon. The most important of the figures are the two peering down from the small cliff at the left, who are the culmination of the progression of figures extended before them and who also lead our eye to the ruined priory church. The soft tones of the left side of this building suggest the moisture of the sun-warmed air, and its pale colour contrasts with the dark sky to enhance the infinite space beyond. The composition is unified by the inverted V that runs up to the rocks in the exact centre of the composition, though its symmetry is offset by the strong diagonal rays of light and the storm on the right. The drawing corresponds closely to its 'basis' sketch (*see* Concordance) but Turner has moved the distant castle to the right in order to isolate it.

34 WINCHELSEA, SUSSEX

29 × 43cm (11½ × 16¾in) *c. 1825–9*

Turner probably met a regiment on the march here during the Napoleonic Wars because, of the four drawings that he made of the place for subsequent engraving, three of them depict soldiers:

... the *Liber Studiorum*, 'Winchelsea, Sussex', bears the date 1812, and its figures consist of a soldier speaking to a woman, who is resting on the bank beside the road. There is another small

subject, with Winchelsea in the distance, of which the engraving bears date 1817. It has *two* women with bundles, and *two* soldiers toiling along the embankment in the plain, and a baggage wagon in the distance. Neither of these seem to have satisfied him, and at last he did another for the *England* series of which the engraving bears the date 1830. There is now a regiment on the march; the baggage-wagon is there, having got no further on in the thirteen years, but one of the women is tired and has fainted on the bank; another is supporting her against her bundle, and giving her drink; a third sympathetic woman is added, and the two soldiers have stopped, and one is drinking from his canteen . . .[21]

This is a highly-charged study of an early nineteenth-century army, with its retinue of camp-followers, and a sky (described by Ruskin in *Modern Painters* as 'thunder breaking down after intense heat, with furious winds') that may be interpreted as a metaphor for war.

Turner heightens the picture's tension by the extreme black-red range of his colour, glaring in its oppositions; and he also echoes the angry sky by using the zigzag line of march on the ground to suggest lightning.

35 STONEYHURST COLLEGE, LANCASHIRE April/May 1829

28 × 42cm (11 × 16½in)

To understand fully the allegorical significance of this watercolour, it is necessary to see it within its historical context and to know that Stonyhurst College is a Roman Catholic public school founded in 1794.

By the late 1820s moves for Catholic emancipation in Britain had reached their final phase. At the time no Catholic could sit in Parliament nor hold high office in the military or judiciary, although several attempts to alter the legislation had been made over the previous half-century. Despite

the repeal of the Test and Corporation Acts in 1828, these were almost to no avail, George IV in particular being distinctly opposed to any degree of political-religious toleration. In this he was joined by his Home Secretary in the Wellington administration, Sir Robert Peel. Finally, in 1828, the issue was forced to a crisis by the election to Parliament of Daniel O'Connell, a Catholic returned by County Clare in Ireland. He was not allowed to take his seat and, faced with the very real possibility of civil war in Ireland, Peel changed his mind. On Peel's advice, therefore, in his speech to Parliament on 5 February, 1829, to everyone's surprise the King recommended a change in the legislation and after much opposition the Bill to give Roman Catholics almost complete political emancipation was passed on 13 April, 1829. This event was to be of decisive importance in the passing of the Reform Bill three years later.

Within this context the meaning of the picture (with its obscurely motivated figures) becomes clear: it is an allegory of Roman Catholic Emancipation. An adult, a symbol of the King, is seated on a watering horse in the centre and, turning *volte-face*, is raising his arm to quieten some noisy and truculent children on the left, symbols of opposition and quarrelsomeness. The boat, which two boys on the right are about to take from the water, has, like Catholic Emancipation, finally reached the shore. Immediately above them (to identify their affiliation) are Jesuits and academics walking in procession towards the twin gatepiers of the gatehouse of 1592–5 which Turner proudly surmounts with shining crosses. These crosses are not present on the original building or in an earlier sketch or watercolour, and represent the new equality of the two branches of Christianity. The depiction of washer-women on the far side of the Infirmary Pond alludes to the cleansing of Christianity by this political event. Nature enhances the allegory, brilliant sunshine with a rainbow replacing a dark storm whose clouds may be seen passing away to the right. Thus the picture expresses a hope for future religious toleration and fraternity. The past progress of the boat across the water is suggested by a stately line

of ducks who proceed across the water from left to right, also reaching dry land, and the boys running off quickly to the right further enhance this sense of movement. The colouring throughout is in perfect condition and the warmth of the greens on the left complement the cooler tones and deep shadows on the right. Turner had drawn another version of this subject many years earlier, in 1800, in his 'picturesque' manner, a dull drawing now in a private collection in America. That drawing has no figuration other than a couple of swans on the pond. In the later work, however, Turner demonstrates not only his greater mastery of landscape-drawing, but also his powers of imbuing a subject with fresh meaning.

To celebrate the Catholic Emancipation Act, a large church, St Peter's, was added to the site between 1832 and 1835.

36 WALTON BRIDGE, SURREY

29 × 46cm (11⅜ × 18in) c. 1825–8

Turner painted several oils of this bridge, one reminiscent of Cuyp, in the Loyd Collection, and another in the National Gallery of Melbourne, Australia. He used it also in the 'Liber Studiorum' (No 13), and in a late transcription of the 'Liber' image, now titled *Landscape with Walton Bridges* by Butlin and Joll (No 511—private collection, New York). The late painting, however, is pure fantasy on Turner's part, putting the Italianate character of the bridge in its rightful setting; whereas this drawing, with its windswept sky and bracing climate, could be nowhere but England.

The drawing itself is in perfect condition, the colouring very fine in the rich dark tones of the river and light violet reflections on the water beneath the sheep. The straining horses on the left are the keystone of the pictorial architecture. Two linear diagonals emanate from them, one running up into the sky, and the other down the fishing rod and to the line of the riverside. There is a visual pun in the repetition of the shapes of the bridge arches and their reflections in those of the barge.

37 LUDLOW CASTLE, SHROPSHIRE

30 × 46cm (12 × 18in) *c. 1830*

The harvesters share with nature a ripeness that contrasts with the decayed castle. Compared to others in the series this drawing may appear to be rather uninventive in its composition, exemplified by the familiar device of the Claudian tree on the right; but while the tree is too Italianate for Shropshire, it adds to the picture's lyricism, a mood heightened by the strength of colour. The luminous castle and its blue shadows precisely render the ambivalent coolness of early morning sunshine. There is extensive scratching-out of highlights which contributes to the overall brilliancy, and a particularly bold scratch represents the disturbance of the water as a moorhen scutters across the river Teme. The scrapings of the fir tree's foliage and the single shock of emerald green in the foreground are also worth noting.

38 COAST FROM FOLKESTONE HARBOUR TO DOVER

29 × 45cm (11¾ × 17⅞in) *c. 1829–30*

Smuggling was a major industry in Britain during the 1820s: 120,000 highly trained seamen had been discharged from the navy after 1815 into a labour market already depressed by high unemployment. Despite subsequent relaxations in import duties, the profits (and so the temptations) of smuggling were high and led in the prevailing economic climate to violent and desperate acts: whole villages lived off smuggling, gangs fought out their rivalries in public and murder was endemic. The magnitude of the problem was exemplified by an incident in 1820 when a smuggling crew from Folkestone and Sandgate, who had been caught and imprisoned in Dover, was freed by a mob of relatives who literally tore the gaol to pieces!

Judging from the number of times he depicted them, Turner knew the ways of smugglers well, and of his other watercolours of Folkestone most show smugglers at their business. This scene shows the detection of a popular method of smuggling, 'sinking and creeping', which involved the throwing of weighted tubs from a boat into the sea at a pre-arranged spot, for later recovery by 'fishermen'. On the left is a Coastguard officer looking at a map locating the tubs, and these are being dug up from the sand and lined up on the beach for loading onto mules.

39 GOSPORT, ENTRANCE TO PORTSMOUTH HARBOUR

29 × 43cm (11½ × 16¾in) *c. 1825–30*

Called by Ruskin (who later owned it): 'A delightful piece of fast sailing, whether of boats or clouds.'[22] The whole drawing expresses the bustling tempo that Turner associated with Portsmouth Harbour, and which he had already drawn for the 'Southern Coast' series. The sense of movement is launched by the sharp diagonal of the skiff's sail in the foreground, and is repeated throughout, to give us a sense of bobbing and lurching. The picture combines a multitude of rapid motions: the transition of light in the sky, the flurry of waves on the water, and the bustle of the many small boats with their teeming figures fuse together to form a refreshing panegyric upon human and natural physical energy. All of this is increased by the contrast with the men-of-war riding at anchor and the impersonal solidity of the blockhouse on the left (with its beacon to warn vessels). Across the harbour, in the distance on the right, is the dockyard semaphore which regulated the movement of ships in and out of port. Notice also Turner's bawdy joke: the skiff's helmsman, with a phallic rolled flag, has had his head turned by the ladies (although Ruskin with his habitual blindness to sex thought that Turner had mistakenly drawn it the wrong way round). As a result there seems to be some danger of collision with the brig in front of it.

40 WINDSOR CASTLE, BERKSHIRE

29 × 43cm (11¼ × 17in) *c. 1827–9*

As a young man Turner had frequently depicted Windsor Castle and, although after 1809 his interest in the subject seems to have waned, he went on sketching it over the years. This is his last treatment of the subject. The scene is a natural one for any series of comprehensive topographical views in England: the medieval castle combines impressive architecture with a dramatic site. Turner exactly renders the haze of golden morning sunlight and creates an expressive range of textures in the process. The composition is unified by a number of very shallow parallel diagonals in which the interplay of ripples on the Thames participate.

The barge on the right appeared in a very early untraced drawing of Windsor Castle that was engraved for *The Pocket Magazine* in 1795. Here Turner re-uses it and again echoes the flag on the distant Round Tower by the mast's pennant.

41 ETON COLLEGE, BERKSHIRE

30 × 44cm (11¾ × 17½in) *c. 1827–9*

An allegory of learning on a warm summer's evening by the Thames. At the left, before young trees, are two fishermen trapping eels: thus Turner symbolises the acquiring and containing of knowledge. On the right are Eton collegers, the recipients of that knowledge, who relax and fish beneath more mature trees.

The allegorical content of the drawing is fused with its structure: a diagonal runs from the fisherman's net past an immediately adjacent scholar (whose proximity is no accident) through the chimney smoke in front of the chapel to culminate in the line of tree tops on the right, where the opposite diagonal of the rising line of the river bank completes the X.

The diagonals all take their cue from the chapel's gable whose point also represents the apex of a triangle that runs up the sides of the river.

The complex pictorial architecture is further enriched by colour-opposition, most apparent in the sharp contrast between the blue of the chapel against the red-brick building in front of it. There are also human and social differences in this study of antitheses: the precise social distinctions between fishermen and Etonians are as counterposed to each other as are Work and Learning.

42 PEMBROKE CASTLE, WALES

30 × 43cm (11¾ × 16¾in) *c.* 1830

Two other versions of this view were exhibited at the Royal Academy: one in 1801 (now on loan to the National Museum of Wales, Cardiff), and one in 1806 (now at the University of Toronto).

In this later picture the thunderstorm has grown hotter in colour and weaker in mood, replacing the earlier wildness with a constricted composition in which the relationship of the sea to the shore is the chief weakness.

The drawing takes its compositional cue from the curves of the castle's towers. These are repeated both in the shape of the boat on the left, and in the semi-circular forms of the fish in the foreground whose contrary rhythms accentuate the bobbing motion of the sea. The colour is torrid but, as always, Turner conveys the moisture in the air.

43 MALVERN ABBEY AND GATE, WORCESTERSHIRE

29 × 43cm (11¾ × 16⅞in) *c.* 1830–31

Although characterised by Ruskin in Volume I of *Modern Painters* as 'Afternoon, great heat. Thunder gathering', by the time this drawing was engraved in 1832 the storm had broken: Turner rather unconvincingly added a bolt of lightning

into the middle of the engraving. This is another 'England and Wales' subject that had been drawn in several earlier versions, and one of them, which was exhibited at the Royal Academy in 1794, undoubtedly formed the basis of this work. From it he reintroduces the frame-saw seen on the left, together with the broken wagon wheel that also made its appearance there, and he further litters the foreground with a wheel-hub, a wagon harness-block, joinery tools and a second man climbing out of the saw-pit with a basket. The tower of the church rises majestically out of the haze of approaching rain, and its cool greys and purples, by their contrast, throw into relief the golden warmth of the brilliantly sunlit gatehouse. The composition is unified by an arabesque running down from the sky on the left, through the propped timbers and dappled shadows in the centre, and up the side of the gatehouse into the sky beyond. The minute stipplings apparent on the church and in the sky enliven the drawing's fluctuations of light.

44 RICHMOND HILL AND BRIDGE WITH A PIC-NIC PARTY

29 × 43cm (11⅜ × 17⅛in) *c.* 1825–9

A vivacious drawing in which Turner complements the stately harmony of the bridge and the town with verdant trees and elegant figures that seem to step from the pages of Jane Austen. The fresh greens and creams, contrasted by soft blues, remove the drawing far from the gloom of an earlier oil-painting of the same scene dating from 1807–8 and instead relate it far more closely to another Richmond scene of the same period (45).

This Turner drawing was the first ever owned by Ruskin: 'my father buying it for me, thinking I should not ask for another—we both agreeing that it had nearly everything characteristic of Turner in it and more, especially the gay figures! . . . the parasols are put in the foreground so conspicuously, to repeat and reverse the arches of the bridge . . . and the plumy tossing of the foliage, to repeat the feather headdresses of the figures.

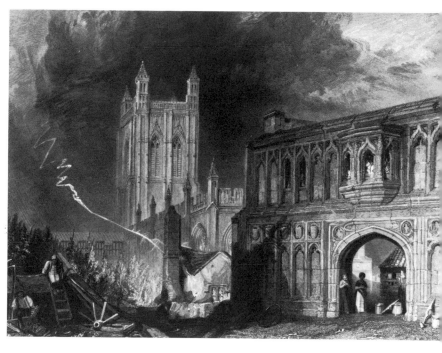

8 *Malvern Abbey and Gate, Worcestershire, engraved by W. R. Smith and published in 1832.*

Nothing can be more exquisite than the aerial foliage beyond the bridge'.[23]

45 RICHMOND HILL

30 × 48cm (11¹¹⁄₁₆ × 19¹⁄₁₆in) *c.* 1825

This drawing was *not* engraved in the 'England and Wales' series but its size and detail suggests that it may have been originally so intended and diverted by the arbitrary way in which drawings were chosen for engraving by Charles Heath. It was subsequently engraved by Edward Goodall and published in 1826 in *The Literary Souvenir,* another of Heath's ventures.

The view from this hill was a favourite of

Turner's and he recorded it in a large number of pictures. Here he identifies himself with the scene by the inclusion of a paint-box and palette. He is also present elsewhere: at the time of this drawing he still owned a house near Richmond ('Sandy-combe Lodge at Twickenham) and he denotes its exact location in the drawing by a small rising trail of smoke seen near the horizon on the right. A figure on the left peers at the smoke through a telescope, further drawing our attention to it.

The drawing is also an object lesson in the creation of compositional unity from a flat pan-orama: Turner repeats the upper curve of the left bank of the river in the line of a cloud to the right of the sun; in the pall of smoke; in the foreground women's parasols; in the forms of the trees throughout; and in the curve that runs up the ground from in front of the paint-box through the kite to the figure standing above it, through the line of treetops to the river and in the repeated curves of the parasols on the left. This constant rhythm counter-points a web of lines radiating from the bottom right-hand corner of the picture.

46 PLYMOUTH COVE, DEVONSHIRE

28 × 41cm (11 × 16¼in) *c.* 1825–9

Against the backdrop of a seaport that typifies Britain's tradition of maritime greatness, Turner sets the bawdy and uninhibited enjoyment of the people who were its real source of power.

The composition is structured upon two diag-onals that meet on the left, and the rendering of the distance is especially fine: the view (from above Sutton Pool and the Cattewater) takes in Mount Batten Point to the left of centre; a fair on the right before the ramshackle town (note one of the houses shored up with timbers); the huge Citadel on the Hoe, its ramparts three-quarters of a mile in circumference; the large bulk of Mount Edge-cumbe across the mouth of the Hamoaze; and down Plymouth Sound in the distance we can see the gigantic breakwater (built by the mid-1820s) sheltering a mass of shipping.

47 MARGATE, KENT

29 × 46cm (11½ × 18in) *c.* 1830–1

A delicate drawing in which the figures and young beech trees reflect the town's youthfulness. Turner extends the row of houses on the right with a line that runs up the hillside to the trees whose graceful forms are echoed by the elegant lines of the woman before them. The town's translucence is heightened by the sharp colours in the foreground and by the dark elms on the right. The differentiations of light and shade in the distance are opposed by the kaleidoscopic overlays of pinks, yellows, blues and greens in the centre of the hillside, and all of them are unified by brilliant highlights which have been scraped and scratched out of the wet colour. Note the juxtaposition of the fast stagecoach with the slow cart at the bottom of the hillside; the distant windmills on the right, beyond Holy Trinity Church (now, like them, demolished); and the minute reflections along the foreshore down by the harbour.

By the late 1820s Turner was a frequent visitor to Margate (taking lodgings with a Mr and Mrs Booth) where he often stayed at weekends. After Mr Booth died in 1833 Turner lived with his widow and eventually moved her up to London where they lived together until her death in 1851.

48 ST CATHERINE'S HILL, NEAR GUILDFORD, SURREY

29 × 43cm (11¼ × 17in) *c.* 1830–1

The chapel on St Catherine's Hill (or Drake Hill) stands three-quarters of a mile south of Guildford above the water meadows of the River Wey. The earliest chapel that stood on the site dated from the thirteenth century, and in 1308 Richard de Wauncey, the rector of St Nicholas's, Guildford, obtained the right to hold an annual five-day fair on the site. This later became a two-day recreational fair and was last held in 1914. Memories of it from about the time of this

drawing were recorded towards the end of the nineteenth century by a local woman who was born in 1801. She noted[24] that the Sunday prior to the fair was known as 'Tap Up Sunday' when all the inhabitants of St Catherine's village had the right to sell home-brewed beer, and that 'Baker the Crock Man from Uxbridge occupied a large portion of the ground for his crockery ware'; we can, indeed, see Staffordshire crockery displayed at the bottom right-hand corner. On the left we see the booth of the London showman, Richardson, who toured many early nineteenth-century fairs, and in front of him a tent with an inscription that refers to the Guildford coaching inns, the Red Lion and the Sun. On the far right we can see an inn, the Half Moon (which has since been demolished) whose sign may, however, represent a woolsack, a symbol that had been used in Guildford since Elizabethan times to represent licensed premises.

The centre of the picture is filled with a crowd surging around a distant 'backsword' fight, and this now vanished sport was described by Thomas Hughes in his novel *Tom Brown's Schooldays*, published in 1857: 'The weapon is a good stout ash-stick with a large basket handle, heavier and somewhat shorter than a common single stick. The players are called "old gamesters" ... and their object is simply to break one another's heads: for the moment that blood runs an inch anywhere above the eyebrow, the old gamester to whom it belongs is beaten, and has to stop.'

These local details are observed within a sweep-ing landscape, the hill to the left soaring in a vast curve whose rhythm is repeated and accentuated by the dark and mysterious cutting to the right through which can be seen the approaching Portsmouth coach.

49 BRINKBURN PRIORY, NORTHUMBERLAND

29 × 46cm (11⅝ × 18⅛in) *c.* 1830–1

A fine study in opposition. The light cascades down the hillside on the left and culminates in the

*9 Detail from **Brinkburn Priory**, engraved by J. C. Varrall.*

*10 **Warwick Castle, Warwickshire**. Turner had a swan added to the picture when it was engraved.*

brilliance of sparkling water; facing this are the cool pinkish tones of the ruined Priory against its gloomy sky. An X line provides the basis of the composition, everything on the left appearing abundant and lush, while on the right all bleak and desolate. Man's ruin is thus opposed to the fertility and regeneration of nature. The light falling from the left is particularly well rendered in the engraving (Ill. 9).

50 WARWICK CASTLE, WARWICKSHIRE

30 × 45cm (11¾ × 17¾in) *c. 1830–1*

This massive fourteenth-century building was another natural choice for the series. Turner articulates the castle's crenellated architecture with a play of light across its surface. The warm sandstone colouring and lyrical setting produce a mood of lethargy which Ruskin placed at exactly: 'Two o'clock. Clouds gathering for rain, with heat.' Like *Blenheim* (which shares this timing) the drawing conveys the oppressive tension of heat. The colour adds to this suggestion of temperature with its hazy contrasts between the blues of the sky and the reds and golds of the foreground.

The view is from the Castle bridge and the composition is structured by two strong diagonals that issue from the bottom left-hand corner. Their emphasis was later added to in the engraving by the inclusion of a swan (Ill. 10) which Turner carried over from the sketch upon which the work was based (*see* Concordance). Its slow drift greatly adds to the picture's hypnotic laziness.

51 KENILWORTH CASTLE, WARWICKSHIRE

29 × 45cm (11½ × 17¾in) *c. 1830–2*

A drawing that speaks of 'man's sorrow' and of the ultimate ruin of grandiose aspirations. The sparsely distributed figures further contribute to the sense of solitude.

In 1831 Sir Walter Scott published his novel *Kenilworth* which Turner knew: there is another (untraced) drawing by him of Kenilworth which was probably intended as an illustration for the book.[25] Here, however, Turner uses the castle to express a poetic vision that is far removed from the bogus historicism of Scott's novel. The framework of the drawing is formed by a series of shallow repeated diagonals which all serve to draw the eye to the rising moon while the milkmaid on the right reiterates the castle's verticality.

Ruskin saw this drawing at Thomas Griffith's house on the very first occasion (in 1840) that he met Turner: 'the drawing of "Kenilworth" was one of those that came out of Mr Griffith's folio after dinner; and I believe I must have talked some folly about it, as being "a leading one of the England series", which would displease Turner greatly. There were few things he hated more than hearing people gush about particular drawings.'[26]

52 BLENHEIM HOUSE AND PARK, OXFORDSHIRE

30 × 48cm (11¾ × 18¾in) *c. 1830–1*

The time of this afternoon scene was specified by Ruskin as the same as that of *Warwick Castle* (50). The colouring is rich and full and the blues and purples of the distance accentuate the greens and hot golds distributed throughout to produce the tension of a gathering summer storm.

1830 was a year of revolutions in Europe, and in France King Charles X had been deposed by a popular uprising. The effects of that revolution were felt in Britain where there was already much agitation for Parliamentary reform and widespread agricultural unrest and the 'Swing' disturbances were partly results of these tensions. Turner reflects this social conflict: we see the landed aristocracy on the left and on the right two quarrelling dogs being separated by a bending figure. By them stands an isolated group of children who, in their proximity to the town on the other

side of the gate, symbolize the growing middle and labouring classes waiting patiently for their rights to Parliamentary representation from the traditional keepers of those privileges, the aristocracy. The sparring dogs (and coming storm) are Turner's intimation of what might happen if they do not get them.

A malevolent figure with a shotgun stares aggressively out at us, reflecting the events which Blenheim was built to reward and symbolizing the entrenched defensiveness of the landed gentry who were opposed to any measure of reform. Seen in this context the bridge, which is the picture's central focus, also takes on a symbolic meaning, representing Turner's wish for communication rather than conflict.

He repeats the curve of the bridge in the cloud-shape around the sun, and the counter-curve of its reflection on the water is reiterated by the long gradual slope away to the great palace standing on the hill to the left, a dominance accentuated by the brilliant light upon the trees beneath it. On the right is the Woodstock Gate, designed by Hawksmoor in 1723 (the palace itself was designed by Vanbrugh) which Turner characteristically has felt free to turn ninety degrees on its axis to accommodate the composition. Note the diminutive horses and sparkle of tiny highlights on the ground in the centre and the girls' clothing reflecting their class, two of them obviously dressed more elegantly than the others.

A colour-study for the work was made by Turner and this is now in the Turner Bequest (CCLXIII-365).

53 NORTHAMPTON, NORTHAMPTONSHIRE

29 × 44cm (11⅝ × 17¼in) Winter 1830–1

This drawing was shown in the 1833 Moon, Boys and Graves Gallery exhibition to which it was lent by Charles Heath who had bought it for engraving. This fact and the drawing's subject, size and wealth of detail support the view that it was intended for this series although it was never engraved. Along with *Stoneyhurst* (35), *Blenheim* (52), *Ely* (54) and *Nottingham* (59) it reveals an unsuspected sympathy on Turner's part with the demands for political change that were to culminate in the passing of the 1832 Reform Bill, a watershed in British political history.

The electoral system at the time of this drawing was archaic, corrupt and blatantly unrepresentative. Only one per cent of Britain's sixteen million population were entitled to vote, and even that electorate was manifestly uneven and unfair in distribution: the majority of the House of Commons was elected by less than fifteen thousand voters. This system had been formed in Tudor times and it failed to represent either the new industrial cities or the emergent middle class. Over the previous half-century the pressure for reform had been checked in Britain by the outbreak of the French Revolution and by the long wars that followed, but, despite repression, by the late 1820s the country was in a state of intense political ferment.

The crisis finally broke in November 1830 with the fall of the Tory Wellington administration who were opposed to Reform. The new monarch, William IV, held Whig sympathies and appointed a Whig, Lord Grey, to form a new ministry. This change in the administration brought about the election depicted here. Lord Grey appointed Lord Althorp (the county member for Northamptonshire) as his new Chancellor of the Exchequer and as a result Althorp had to seek formal re-election, an event that took place on 6 December, 1830. As Eric G. Forrester comments: 'his unopposed return was the occasion of great Reform propaganda. He made a triumphal entry into Northampton with his carriage hauled by supporters and garlanded with laurel wreaths, escorted by a cavalcade gay with crimson and white cockades and favours, bells ringing and bands playing. Owing to the vast throng the nomination meeting at his suggestion was transferred from the County Hall to the market square where a wagon was used as a stand'. In the speeches that followed Althorp pledged his devotion to the cause of Parliamentary Reform. He was then 'returned to the County Hall on an ornate triumphal car emblazoned with the motto "Not for himself, but for his country", and accompanied by a great retinue abounding in banners with such mottoes as "Reform, Peace, Retrenchment", "The Friend of the People", "No Slavery", and "The Freedom of the Press".'[27] A banquet was later held at the George Inn.

Turner draws this scene fairly accurately, the major difference being that the crimson and white cockades and favours are drawn by him in blue and white. This discrepancy, and the differences of the slogans suggest that he elaborated the watercolour from newspaper reports rather than witnessing the scene himself. He had visited Northampton as recently as the late summer when he had passed through the town on his sketching tour of the Midlands, and he had then drawn the façade of All Saints Church on pages 17a–18 of the 'Birmingham and Coventry' sketchbook (TB CCXL).

For the final drawing he has turned the church ninety degrees, filled in the portico and moved the cupola into view from its normal position behind the tower. He has also supplied the banner slogans: 'Speed the Plough' was the title of an old country dance and it obviously refers to the agricultural interests present[28]; 'The Purity of Elections is the Triumph of Law' bears a marked similarity to the title of a famous Radical political meeting held in 1829, which was widely advertised as 'The Triumph of Westminster and Purity of Election', (a catchy slogan that probably stuck in Turner's memory)[29]; and all around are banners for 'Reform' and 'Independence' (notice the top left-hand corner where in his creative haste Turner has transposed the 'A' and the 'M' in Northampton).

On the right we see the George Inn (demolished in 1921) and on the left Lord Althorp being chaired by the crowd with triumphal garlands above his head. He is acknowledging the crowd, but his arm also indirectly points straight at the foreground figure in the bottom left-hand corner. This white-haired gentleman with his gouty foot and old-fashioned tricorne hat clearly symbolizes the spirit of opposition to Reform. Next to him stands a 'Marianne', a French post-revolutionary peasant

archetype (equivalent to 'Britannia'), and her hand on his shoulder enacts both a timely reminder of the recent insurrection in France and a subtle suggestion of the alternative to peaceful concession. Such French peasant figures were frequently drawn by Turner between 1826 and 1830 and they often appear in later engravings of French subjects such as that of Troyes (R. 492). On the other side of the seated symbol of Reaction stand ladies, two of whom are also in French dress, and who are talking to two English ladies (or so the hairstyle of the rear woman on the right would suggest). That this foreground figuration *is* symbolic is supported by the fact that no public building or balcony is known to have stood on Gold Street between Drapery and College Street, the viewpoint of the picture.

To this wealth of social observation and political meaning Turner adds the dynamic movement of a gusty December day, especially to be observed in the wind-blown flags and banners at the upper left. The colouring is superbly controlled to capture the sparse autumn sunshine, and its unity is unbroken by the frequent use of brilliant colours: the deep red of the armchair on the left, the emerald green above it and in the creams, golds, reds and blacks of the crowd. The whole scene oscillates, and this movement is enhanced by sharp tonal shifts exemplified by the sudden softening of the tone at the rear of the stagecoach, the aerial lightness of the church in the background and the Union Jack on the right, which is muted in colour to attune it to the overall tonality of the work. The blues are particularly effective and their distribution reinforces the constantly repeated downward diagonals falling from the left that structure the picture. The stagecoach adds a suggestion of social transition and its winter-coated passengers, craning to observe the passing scene, intensify the mood of urgency. This drawing triumphantly renews the stylistic traditions of earlier generations of English political artists.

54 ELY CATHEDRAL, CAMBRIDGESHIRE

$30 \times 41cm$ ($11\frac{7}{8} \times 16\frac{1}{8}in$) Winter 1831–2

'. . . in the year 1322 the lofty stone tower fell and destroyed the three most western arches: the present magnificent octagonal tower, supported by eight pillars, and terminated by an elegant lantern, which is greatly admired, was erected to supply its place. The view in the drawing represents the south transept and the western Tower'.
(From the 1833 MBG Gallery exhibition catalogue.)

Turner knew Ely Cathedral well and there are several early highly detailed watercolours of the interior, of which perhaps the most magnificent is now in Aberdeen Art Gallery. In addition, in 1802 he made a very careful pencil-outline study of the view as seen here and that study was used as the basis of this watercolour (Ill. 11). Both are now in the same private collection.

This work, therefore, grows out of Turner's intimate knowledge of the building's history as well as his desire to relate the cathedral to the social events of his time. In the foreground we see three boys throwing stones into a pond, and Turner repeats the shape of the crossing tower and three western arches referred to above by depicting one boy standing and the others crouching. The pond's depression in the ground and the falling stones represent the collapse of the tower and arches. The girl nearby strengthens the connection, her pointing arm repeating the diagonal of the transept's gable (which leads our eye to the octagonal lantern) and this diagonal is further reiterated by the chimney smoke below the gable and by the repeated diagonals of the threshers' implements and the flying buttresses on the right.

The Church of England was in a critical position in the immediate period of the great Reform Act of 1832. It had, over the years, become identified with the long-entrenched political system, and its malpractices and corruptions were intimately connected with those of a closely linked aristocracy. It was also compromised by the repeal of the Test and Corporation Acts in 1828 and by the Roman Catholic Emancipation Act of 1829 and was

*11 Sketch upon which **Ely Cathedral, Cambridgeshire** was based.*

increasingly under assault from dissenters and freethinkers. To heighten the unease the tense winter of 1830-31 saw a great deal of agricultural unrest.

In this atmosphere the Church was largely opposed to any measure of Reform, which might also lead to disestablishment. When, as a result, the Spiritual Peers in the House of Lords participated in the successful vote against the second Reform Bill, the Church in particular was assailed by the great wave of popular indignation that followed. Several bishops had their coaches stoned, the Bishop of Exeter had to have his palace defended by coast-guards and yeomenry, and the Bishop of Bristol's palace was burned down. The Anglican clergy were everywhere attacked by the radical press in lampoons and caricatures. Especially singled out for vituperation was the notorious Bishop Sparke, bishop of Ely from 1812 to 1832, who was infamous for his nepotism and abuse of ecclesiastic patronage.

In this context the drawing takes on a new meaning. As in *Blenheim* (52) the social class of the foreground figures can be identified by their dress, the boys being poorly clothed and the girls more prosperously so, symbolizing the labouring

and middle classes angry at the denial of their right to political representation. The stoning boys and threshers may also represent the 'Swing' disturbances of 1830–1, when disaffected agricultural labourers in East Anglia and elsewhere destroyed threshing machines and refused to pay tithes, one of the economic props of the church. Thus Turner uses the collapse of Ely's towers in 1322 to portend the collapse of the Church itself, a symbolism heightened by the depiction of coming storm.

Note the haystack above the threshers that perhaps symbolizes tithe; the 'holy family' group at the corner of the nearest house; and how the large expanse of empty foreground suggests agricultural poverty and also greatly heightens, by contrast, the cathedral's complexity and scale. Ruskin praises this drawing in *Modern Painters* (Vol I, part II) as a great example of Turner's powers of architectural draughtsmanship.

55 TAMWORTH CASTLE, WARWICKSHIRE

29 × 44cm (11½ × 17½in) *c. 1830–1*

As in the earlier *Exeter* (22) this drawing illustrates the urban encroachment of the nineteenth century, and the sun sets here not only on the castle and medieval church of St Editha beyond, but also on an England fast disappearing.

The principal lines of the composition are two diagonals that meet on the extreme left, and these are counterpoised by a triangle at whose apex stands the bulky Norman castle. The shadows of its hill have a rich variety of colours and textures, and the translucence of the river and the dream-like transitions of the bridge are particularly effective. Extensive scratching out on the right (using a wooden brush-end), is especially noticeable in the highlights of the weir and foliage beyond the foreground trees. These trees (and the two on the left) heighten the castle's enclosure by their proximity, and its heavy solidity by their luminous colour.

56 CASTLE UPNOR, KENT

29 × 44cm (11½ × 17½in) *c. 1829–32*

'In the time of Charles II the Dutch admiral, De Ruyter, appeared at the mouth of the Thames, and sent Van Ghent up the Medway to destroy the shipping. This he partially effected; but advancing with six men of war and three fire ships to Upnor Castle, Major Scott, Commandant of the castle, and Sir Edward Spragge, who directed the batteries on the opposite side, opened so hot a fire, that Van Ghent was obliged to retreat with considerable damage, to his ships.'

(From the 1833 MBG Gallery Exhibition catalogue)

Turner's symbolism in this drawing reflects the events for which Castle Upnor was famous. The rather awkward and seemingly out-of-scale figure pulling on his boot in the foreground gives a point of dramatic focus to the picture, and is also a visual pun referring to the fact that Castle Upnor had punished ('booted') the Dutch or that it had rendered help in time of peril ('done boot') and successfully defended Chatham. References to the engagement can be seen in the foreground gun pointing to a massive target-like ring; the piece of wreckage to which it is attached; the sea 'shells' resting on and beneath it; the aggressive dog in the foreground; and the distant wall of shipping which may also allude to the defence of the Medway.

Ruskin thought this was a sunrise, Rawlinson, a sunset. The latter interpretation is preferable, as Chatham can be seen on the left and we are therefore facing south west rather than east.

57 LAUGHARNE CASTLE, CAERMARTHENSHIRE

30 × 46cm (12 × 18¼in) *c. 1831–2*

The salvaging of wreckage was as important an economic factor in the survival of isolated and impoverished coastal communities in the early nineteenth century as was smuggling. Turner

depicts this several times in the series, notably in the drawings of *Whitehaven* (81) and *Tynemouth* (91). The country people around Carmarthen Bay especially (according to one contemporary observer[30]) were always said to arrive at the scene of a wreck fully prepared with hammers and hatchets to strip anything that was salvable (and not minding if the ship was in fact undamaged, as happened in at least one instance in 1840). In 1833 a Carmarthen tradesman even hired out carts to wreckers in order to facilitate the carrying away of cargo!

Turner has taken his usual liberties with topography by widening the estuary of the Taf to oceanic proportions. He emphasizes its loneliness by the inclusion of a dismasted ship off to the right. Observe how he repeats both the squareness of the castle in the shape of the foreground parcel on the left and its narrow turret and broader tower, at its right-hand corner, in the shape of the smashed wreckage on the right (a repetition noticed by Ruskin). Ruskin wrote of this drawing at some length in *Modern Painters* where he says that it 'may be taken as a standard of the expression of fitfulness and power. The grand division of the whole space of the sea by a few dark continuous furrows of tremendous swell (the breaking of one of which alone has strewed the rocks in front with ruin) furnishes us with an estimate of space and strength, which at once reduces the men upon the shore to insects . . . the surges roll and plunge with such prostration and hurling of their mass against the shore, that we feel the rocks are shaking under them.'[31]

Again Turner reveals his pessimism: ruin in both foreground and background, while man pathetically endeavours to save what he can.

58 COVENTRY, WARWICKSHIRE

29 × 44cm (11⅜ × 17¼in) *c. 1830–2*

The sharp demarcation between town and countryside is reflected here by the slow transition from dark storm to brilliant sunshine after rain. Note

Turner's echo of the glistening church spires in the centre with the factory on the extreme left, a detail present in the original sketch; the toll-gate at the bottom of the hill; and the toll-keeper/herdsman running for the toll on the right where one can just make out the flash of a coin, scratched out to make a tiny highlight. Ruskin wrote of the work:

Not only are the lines of the rolling cloud ... irregular in their parallelism, but those of the falling rain are equally varied in their direction, indicating the gusty changefulness of the wind, and yet kept so straight and stern in their individual descent, that we are not suffered to forget its strength. This impression is still further enhanced by the drawing of the smoke, which blows every way at once, yet turning perpetually in each of its swirls back in the direction of the wind, but so suddenly and violently as almost to assume the angular lines of lightning. Further, to complete the impression, be it observed that all the cattle, both upon the near and distant hillside, have left off grazing, and are standing stock still and stiff, with their heads down and their backs to the wind; and finally, that we may be told not only what the storm is, but what it has been, the gutter at the side of the road is gushing in a complete torrent, and particular attention is directed to it by the full burst of light in the sky being brought just above it, so that all its waves are bright with the reflection ... Impetuous clouds, twisted rain, flickering sunshine, fleeting shadow, gushing water, and oppressed cattle, all speak the same story of tumult, fitfulness, power and velocity.[32]

59 NOTTINGHAM, NOTTINGHAMSHIRE

30 × 46cm (12 × 18¼in) Summer-Autumn 1832

This scene was based upon a drawing (now untraced) made over thirty-five years earlier and engraved for *The Copper Plate Magazine* of 28 February, 1795. (Ill. 12). As Ruskin pointed out:

'the one is merely the amplification and adornment of the other. *Every incident* is preserved; even the men employed about the log of wood are there, only now removed far away (beyond the lock on the right, between it and the town) ... The canal bridge and even the stiff mast are both retained; only another boat is added, and the sail dropped upon the higher mast is hoisted on the lower one; and the castle, to get rid of its formality, is moved a little to the left so as to hide one side. But evidently no sketch has been made. The painter has returned affectionately to his boyish impression and worked it out with his manly power.'[33] Yet while Ruskin compares the two he fails to see *why* Turner chose to return to the subject.

The drawing is a symbolic celebration of the passing of the Reform Bill. Nottingham Castle was owned by the Duke of Newcastle who was one of the most active opponents of Reform. In 1829 and 1830 he had caused much popular disgust by evicting tenants who had voted in favour of it and he was widely hated. When the second Reform Bill was defeated by the House of Lords in 1831, Nottingham Castle was fired by the mob in the widespread riots that followed, and Turner clearly alludes to this in his depiction of stubble-burning immediately beneath the castle. Even the letter-press issued with the engraving refers directly to this event (although naturally, considering Turner's patronage, it is rather circumspect on the subject): 'about two years hence it was attacked and devastated by a lawless mob, out of spite to the noble owner, His Grace the Duke of Newcastle whose political principals were obnoxious to the liberal population of the town'. The event was also mentioned in the descriptive notice of the drawing in the 1833 exhibition catalogue.

On 7 June, 1832 the Reform Bill was finally passed and the long process towards modern Parliamentary representation was initiated. Thus, in front of a castle that represents reaction we see the low sail of the 1795 engraving being finally hoisted and a dense throng preparing to disperse and sail through the now open lock-gates. In the bottom right-hand corner are a discarded rope and tackle and a rudder that exactly resembles a

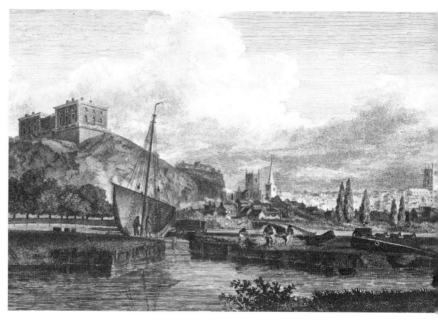

12 *Engraving by J. Walker of Turner's 1794–5 drawing of Nottingham.*

butcher's cleaver (complete with blood-red handle) which have been laid aside as unnecessary. Nature once again extends the allegory, the previous storm retiring to reveal brilliant sunshine and rainbows, with the town and churches glistening in the moist light.

The conglomeration of boats and people in the centre are reminiscent of the richly hued Venetian pictures that Turner was painting during 1832 for exhibition at the Royal Academy the following year. The drawing's iconography, its stylistic resemblance to the Venice pictures and depiction of summer climate indicate that it was made sometime in the summer or autumn of 1832, the engraving following about a year or so later. The drawing is structured by the strong diagonal of Castle Rock which meets the upwards diagonal of the canal bank on the right, and this primary framework is counterpoised by the circular movement of the

double rainbow and filling sail. The pale shadows on the water beneath the lock-gates are especially luminous, and the depiction of reflections in this drawing inspired one of Ruskin's most perceptive passages in *Modern Painters*. He discusses in great detail Turner's accuracy in depicting the reflection of the white signpost on the left, noting that instead of appearing as a white shape against the dark base of the hill, it is reflected as a dark shape against the golden upper reaches of the hillside. This is an example of Turner's ceaseless investigation of every minor visual fact and Ruskin comments that 'I do not know that any more magnificent example could be given of concentrated knowledge'.[34]

In the years between the two versions of this picture, the 'Meadows' (i.e., the scene depicted) were well on their way to becoming one of the two major slum areas in the centre of Nottingham and by 1832 Turner would hardly have recognised it. The castle itself was not restored until long after the 1831 fire. Only in 1875–8 was it renovated to become the first municipal museum of art in England. This picture now hangs there.

60 CAREW CASTLE, PEMBROKE

30 × 46cm (11¾ × 18in) *c.* 1829 – 33

A hot and rather crudely coloured drawing where Turner has had some trouble with his perspective. The cows on the left are out of scale and the line of the river seems equally misjudged. The hot colouring of raw gold-browns and blues does not seem to relate to its subject, and the brilliance of the sky, described by Ruskin as 'descending sun-beams through soft clouds, after rain', is not mirrored by the reflections on the river. The single, small highlight seems totally inadequate to the intensity of light, and the distance (with an obviously retouched pall of rising smoke) lacks the customary conviction. The figures are conventional and the reflections of the castle's windows (which are lit in daylight) are an unsuccessful attempt by Turner to inject some fantasy into the scene.

61 PENMAEN-MAWR, CAERNARVONSHIRE

30 × 43cm (12 × 17in) *c.* 1832

The roadway depicted here was always extremely dangerous even after the sea-wall was built in 1772. Its location between the sea and the mountains was rendered even more perilous by the risk of landslides. As the letterpress tells us, 'the earth being washed away by torrents and rent by severe frosts, fragments sometimes fall, and for a time render the road utterly impassable.'

This quotation explains the wild dash of the stagecoach. Turner diminishes the size of the horses to increase the sense of urgency, and the dramatic placing of the stagecoach is reminiscent both of the drawing of *Coventry* (58) and the later oil-painting *Rain, Steam and Speed, the Great Western Railway*. Ruskin praises the bank of earth on the right of this drawing as 'the standard of the representation of soft soil modelled by descending rain.'[35]

As with *Beaumaris* (72), this drawing was probably based on sketches made on loose sheets during Turner's 1792 tour of North Wales and Anglesea. He refers, in a diary of the trip, to Penmaen-mawr as 'that tremendous mountain running by the sea side with the Puffin or Preston's Island and the Isle of Anglesea on the opposite shore . . . a fine scene' but neither of the two sketches of this subject in the sketchbooks of the Turner Bequest bears much resemblance to this view.

62 CHRIST CHURCH, OXFORD

42 × 29cm (16⅜ × 11¼in) *c.* 1830–3

The building work on the left appears in the sketch upon which this drawing was based (*see* Concordance), and Turner had drawn the college with its impressive Tom Tower many times before, especially in the 1790s. The drawing is a witty symbolic representation of the process of learning (which in this case 'reads' from right to left): we see

a table loaded with prize cups, rosettes etc., symbolizing the competitiveness of entry into Oxford; then two rather crabby Oxford dons; some dogs in dispute; next some carefree kite-flying youths, doubtless the object of the dons' coming attentions; and finally building operations in progress, the levering crowbars demolishing a brick wall on the left suggesting the destruction of youthful gaiety. The placing of an Oxford college beside building work in order to represent education was frequently used by Turner, notably in *Merton College, Oxford* (87) which also uses the argumentative dogs, and also in an earlier (1802–4) drawing of Exeter College, now in the Ashmolean Museum, Oxford.

Turner is at his most dashingly confident and spontaneous here, and as always the architecture is impressively solid, with great attention given to the nuances of colour in shadow. The composition of the drawing is once again built upon an X-configuration, a diagonal running from near the top of the building on the left down to the bottom right-hand corner which is crossed by strong diagonals running up from left to right, at their strongest in the sharp line of shadow on the wall beyond Tom Tower.

63 ENTRANCE TO FOWEY HARBOUR, CORNWALL

28 × 39cm (11⅛ × 15⅜in) *c.* 1825–8

Once more Turner demonstrates his ability to combine a gloomy subject with a brilliant tonality. The bleak sunlight breaks through the intermittent darkness (notice the figures with torches on the right) and allows him to create a ferocious storm scene, using a range of high colours that culminate in the flurry of spray beneath St Catherine's Fort The basis of the composition is a number of parallel diagonals that run up to the right in several directions (thereby enhancing the movement of the sea) and these are crossed by a V-line that runs through the foreground. The work is extremely similar in its topography to another of the same

subject engraved in the 'Southern Coast' series in 1820 (R 109), the original drawing for which is now untraced. Both were worked up from the same sketch (*see* Concordance).

64 LLANBERRIS LAKE AND SNOWDON, CAERNARVONSHIRE

32 × 47cm (12½ × 18½in) *c. 1833*

One can see Dolbardarn Castle in the mid-distance on a spur into the lake, and indeed, when this picture was in the collection of G. Windus at Tottenham in 1840, it was described[36] as being of 'Dolbardarn Castle', a subject painted by Turner long before in his Royal Academy diploma picture of 1800, a dark rendering of the castle from below.

By the time of this watercolour darkness and mystery in Turner have matured into lightness and far greater mastery. Mountain and cloud wheel in a majestic interplay, the trees look habitually windswept and in this elemental landscape man seems insignificant and preoccupied.

The composition, for all its sparsity of figuration, is strong in movement. Its forcefulness is created by the two diagonals of light that strike across from the right, heightened by the cross-diagonals running from the bottom right corner to the mountains at the top left and the downward diagonal of the mountain on the right. All of these complexities are reiterated by the foreground fishermen. The rich colour is perfectly preserved, and the constant shifts from dark to light give the picture a wild and fitful power.

65 CAERNARVON CASTLE, WALES

29 × 44cm (11⅓ × 17⅓in) *c. 1833–4*

A drawing that brings to completion Turner's many early sketches of Caernarvon. The castle rises dreamlike out of mist, and the drawing exudes that sense of pleasant, evening exhaustion brought on by a hot and tiring day. Turner extracts every variation of gold from the light, which he complements with the palest lilacs and blues. Once again he finds the precise psychological component for the mood of the picture: the foreground bathers, only partly a Claudian fantasy, together with the bathing horses, emphasize the need to escape the heat.

The drawing's basic X-structure is counterpointed by a multitude of repeated circles. These can be seen clearly in the shape of the moon; the foreground boat; the waves on the water made both by the closer of the two bathers and by the horses beyond; and it is even repeated in the shape of the tiny coracle on the right. Note the tilting of the boat by the bather launching herself into the water; the children on the right; the repeat of the shape of the castle's pinnacles in the neck and head of the standing girl in the boat; and the normally low Anglesey hills across the Menai Strait raised to alpine heights and stippled across the surface to produce an effect of shimmering distance.

66 DUDLEY, WORCESTERSHIRE

28 × 42cm (11 × 16½in) *c. 1830–1*

'One of Turner's first expressions of his full understanding of what England was to become.'
Ruskin, 'Notes', 1878.

Gloom and ceaseless industry abound in this drawing, and the only romantic feature is that of the sun's last rays illuminating the ruined castle and Cluniac priory in a regretful farewell.

During Turner's lifetime Britain was completely transformed by the Industrial Revolution: in the year Turner was born James Watt perfected the invention of the steam engine, and his death in 1851 coincided with the Great Exhibition. Turner represented this change in many of his pictures, but in none of them does he present such a bleak vision of industrialization as here.

He aligns the central factory chimney with the church spire above it to symbolize the replacement of old values by new, and there is a minimum of linear structure which emphasizes the chaos of the town. The unity of the composition is achieved, instead, by differentiations in colour. The steam-pumping engine depicted on the left was not installed at Dudley until 1841, but doubtless these were seen by Turner many times elsewhere, as they were commonly used on canals to create currents helpful to barges. Notice the barge on the right which gives us the name of the town.

Turner's watercolour technique can be seen clearly in this drawing: the 'wheel of fire' on the right would have been 'washed' into the soaked paper, along with the dark grey of the centre, the warm ochre on the left and the paler mauves around the castle and priory. Only when this was dry would Turner have added the details, scratching out the 'lights' either with a wet brush and blotting paper or with his thumbnail which was kept sharpened for the purpose.

67 BOSTON, LINCOLNSHIRE

29 × 42cm (11¼ × 16½in) *c. 1830–5*

Sunset illuminates the 'Boston Stump', the 282 foot-high tower of St Botolph's church. There is a fine balance of soft, limpid tones throughout, and this is undisturbed by the intrusion of tiny touches of brilliant red and green on the water in the foreground, serving to heighten the suggestion of infinite Lincolnshire space beyond the church. The gentle blue-purples of the sky and beneath the bridge are also seen elsewhere in a range of drawings dating from the early 1830s, the probable date of this work. Note the religious emphasis Turner gives to the cross-masts on the right and the way that he defines the architectural detail of the church tower as it catches the light towards the top.

The drawing contains an anachronism. Turner based it on a sketch made over thirty years earlier (*see* Concordance) and during the intervening period the wooden bridge over the Witham in the centre had been demolished and replaced, in 1807,

by an iron bridge. This reliance on an early sketch also explains the eighteenth-century buildings on either side of the river.

68 ULLSWATER, CUMBERLAND

30 × 43cm (12 × 17in) *c. 1833–4*

This drawing was the first of the Lakeland subjects to be engraved in this series, the other two being *Keswick Lake* (77) and *Winander-mere* (82), and in these three we encounter the strongest similarity to the *Antiquities of England and Wales* coloured by Turner as a boy. In that volume a similar trio occupy a single page, and two of them are of the same places as those of this series: *Derwentwater*—which is another name for Keswick Lake; *Broadwater*—the accompanying text for which mentions Ullswater; and *Winander-mere*—sharing the same archaic spelling for Windermere.

The drawing is remarkable for its limpid mood. The comparative lack of linear structure adds to its effect of emptiness in the distance, and this is heightened by the contrasting foreground figures whose depth of tone complements the delicate colours beyond. In these shadows we can see the soft purples encountered in other drawings from the 1830s.

Ruskin cited the foreground rocks as 'the finest example in the world of the finished drawing of rocks which have been subjected to violent aqueous action. Their surfaces seem to palpitate from the fine touch of the waves, and every part of them is rising or falling, in soft swell or gentle depression, though the eye can scarcely trace the fine shadows on which this chiselling of the surface depends. And with all this, every block of them has individual character, dependent on the expression of the angular lines of which its contours were first formed, and which is retained and felt through all the modulation and melting of the water-worn surface.'[37]

69 POWIS CASTLE, MONTGOMERY

29 × 45cm (11¼ × 17⅜in) *c. 1825–35*

The Elizabethan castle overlooks a scene of impending destruction. At the left is a heron, unaware of the hunter who is positioning himself for the kill. Immediately above the bird are elder trees whose golden luxuriance symbolizes its life. Above the hunter stand two maple trees whose straight forms similarly indicate his single-minded purpose and whose dark green colour is echoed by that of his jacket. Beyond the maples are the distant Breidden Hills and towards them flies another heron which may suggest the spirit of the bird about to die. This further heron is in the exact centre of the composition, the apex of a triangle that runs up from the bottom corners of the picture. A subsidiary triangle is formed by the upper line of the door in the foreground and the line of the hunter's back; and there is yet another important line that extends from the door to the shadow on the right, which is crossed by the line of the stream, forming an X.

Note the distant birds wheeling around the tops of the maples, the open sluice-gate (reminiscent of a guillotine) just above the hunter, and the door in the foreground that also resembles a coffin lid.

70 WORCESTER, WORCESTERSHIRE

29 × 44cm (11½ × 17¼in) *c. 1833–4*

An inimitably English scene, the dark sky passing away to the left and leaving in its wake brilliant green foliage and red sandstone cathedral buildings, dazzling in the warm afternoon sunshine. The bustle of shipping tells of the importance to Worcester of communications passing along the Severn and adjoining canals between the industrial Midlands and access to the sea from Gloucester. In the foreground are two girls fishing for eels, their boat lined with eel-traps.

The compositional structure of the work is a triangle running up to the cathedral at its apex, and this is overlayed by a series of diagonals found both on the right in the line of the lowered main-yard of the barge (and the wall above it) and also in the strong diagonals of light falling from the left. Turner's method of diffusing colour onto wet paper effectively renders the dampness of the air, and in the distant rain the churches and buildings glisten with moisture.

71 LLANTHONY ABBEY, MONMOUTHSHIRE

29 × 43cm (11¾ × 16¾in) *c. 1834–5*

This drawing was acquired by Ruskin in 1843 and praised by him for its atmospheric effects, its observation of rock formations, and for its depiction of water: '[it is] the standard of torrent drawing . . . The whole surface is one united race of mad motion . . . The rapidity and gigantic force of this torrent, the exquisite refinement of its colour, and the vividness of [its] foam . . . render it about the most perfect piece of painting of running water in existence.'[38]

The depiction of the rays of sunlight passing through rain is particularly adroit: 'The shower is here half exhausted, half passed by, the last drops are rattling faintly through the glimmering hazel boughs, the white torrent, swelled by the sudden storm, flings up its hasty jets of springing spray to meet the returning light; and these . . . pass as they leap, into vapour, and fall not again, but vanish in the shafts of the sunlight.'[39]

These effects are achieved by washing dark-toned colours into the wet paper, allowing them to 'bleed' into lighter areas, over which the details are drawn later. The sense of loneliness is complete, the suggested sound of rushing water echoing through the Black Mountains.

72 BEAUMARIS, ISLE OF ANGLESEA

29 × 43cm (11⅝ × 16¾in) *c.* 1834–5

The view is from the Isle of Anglesey across the Menai Strait towards Bangor and the Snowdon range, but no such scene was recorded in any of the sketchbooks in the Turner Bequest. The only record of Turner ever having visited Anglesey is a diary kept by him on his first-ever sketching tour in July and August 1792. This diary, now in the Pierpont Morgan Library, New York, mentions a visit to Beaumaris and reveals his acute observation of both man and nature. In it he compares the poverty-stricken inhabitants of Anglesey with the wealth of their aristocratic employers, and he also records seeing a view of the Caernarvon hills which he describes as 'seen to be from the rays of the setting sun impregnated with gold and silver'. Perhaps it was that long-remembered sunset that Turner depicts here. He suggests the poverty of Beaumaris both by the crude buildings and the foreshore whose emptiness elevates the heights beyond.

The composition is structured by a lattice-like crossing of diagonals that are seen most clearly in the lines of the mountain ranges and in the crossing lines of stones, implements and figures in the foreground.

73 LONGSHIPS LIGHTHOUSE, LANDS END

29 × 44cm (11¼ × 17¼in) *c.* 1834–5

Ruskin wrote eloquently of this work in *Modern Painters* in passages that demonstrate Turner's understanding of natural forces:

> In the Longships Lighthouse, Lands End, we have clouds without rain at twilight, enveloping the cliffs of the coast, but concealing nothing, every outline being visible through their gloom; and not only the outline, for it is easy to do this, but the *surface*. The bank of rocky coast approaches the spectator inch by inch, felt clearer as it withdraws from the garment of cloud, not by edges more and more defined, but by a surface more and more unveiled. We have thus the painting, not of a mere transparent veil, but of a solid body of cloud, every inch of whose increasing distance is marked and felt. But the great wonder of the picture is the intensity of gloom which is attained in pure warm grey, without either blackness or blueness. It is a gloom dependent rather on the enormous space and depth indicated, than on actual pitch of colour; distant by real drawing, without a stroke of blackness: and with all this, it is not formless, but full of indications of character, wild, irregular, shattered and indefinite; full of the energy of storm, fiery in haste, and yet flinging back out of its motion the fitful swirls of bounding drift, of tortured vapour tossed up like men's hands . . . It is this untraceable, unconnected, yet perpetual form, this fullness of character absorbed in universal energy, which distinguish nature and Turner from all their imitators. To roll a volume of smoke before the wind, to indicate motion or violence by monotonous similarity of line and direction, is for the multitude; but to mark the independent passion, the tumultuous separate existence, of every wreath of writhing vapour, yet swept away and overpowered by the omnipotence of storm . . . this belongs only to nature and to him . . . the whole surface of the sea becomes one dizzy whirl of rushing, writhing, tortured, undirected rage, bounding and crashing, and coiling in an anarchy of enormous power . . . and throughout the rendering of all this there is not one false curve given, not one which is not the perfect expression of visible motion; and the forms of the infinite sea are drawn throughout with that utmost mastery of art which, through the deepest study of every line, makes every line appear the wildest child of chance, while yet each is in itself a subject and a picture different from all else around. Of the colour of this magnificent sea . . . it is a solemn green grey (with its foam seen dimly through the darkness of twilight), modulated with the fullness, changefullness, and sadness of a deep, wild melody.[40]

The awesome desolation is intensified by the absence of any figuration. The composition is structured by a series of superimposed shallow V-lines that support two emphatic diagonals, and these converge at the distant lighthouse. Its dramatic juxtaposition with the foreground wreckage is ironic (considering its purpose) and the picture is another of Turner's indications of the futility of human endeavour.

74 LYME REGIS

(28 × 44cm) (11 × 16¼in) *c.* 1834–5

In addition to their cargoes the wrecked ships themselves were abundant providers of expensive or unobtainable materials such as copper, nails, rope and cloth to the eighteenth- and nineteenth-century coastal poor. Even timber was in great demand as a result of the large-scale enclosures of commons and woodlands. Daniel Defoe in 1724 told of seeing whole communities in Norfolk built with 'old planks, beams, wales and timbers, etc., the wrecks of ships and ruins of merchants and mariners fortunes'.[41]

On the left side of this drawing a sailing boat attempts to retrieve a wrecked ship's mast. Beyond is the 'Cobb', an eighteenth-century breakwater, and amid the breakers some stanchions are being washed on to the beach where various salvage operations are taking place. On the other side of a smaller breakwater we can see Lyme Regis itself with the church of St Michael dominating its skyline. The extremely low shoreline of the town was a regular cause of flooding at Spring tides (an event referred to in the letterpress) and Turner suggests this by distorting its perspective.

Turner had drawn this town for engraving in the 'Southern Coast' series, and the print (the drawing is untraced) conveys the windy and invigorating location with great freshness. Here, however, he suggests a far more dangerous relationship of town

to sea, and the rain-wet air, stormy sky and the work's raw colour add to the mood of urgent and joyless activity.

75 FLINT CASTLE, NORTH WALES

27 × 39cm (10⅝ × 15½in) *c.* 1834–5

'This is the loveliest piece of pure watercolour painting in my whole collection; nor do I know anything elsewhere that can compare, and little that can rival, the play of light on the sea surface and the infinite purity of colour in the ripples of it as they near the sand.

The violent green and orange in the near figures are in themselves painful; but they are of invaluable use in throwing all the green in the water, and warm colours of the castle and sky, into aerial distance; and the effect of the light would have been impossible without them.'

Ruskin, 'Notes', 1878

The richness of colour and wealth of detail make this drawing one of the finest in the series. The setting sun demonstrates Turner's technical mastery at full stretch: probably using a damp sponge, he has simply wiped out the sun and its reflection from the initial wash of colour.

The compositional crux of the drawing is the counter-diagonal of the shrimp fisherman's netpole in the foreground, while the moist air and sands render dream-like the distant castle, ships and people. Turner made another drawing of this subject (89) during the 1820s. The shrimpers boats and sunset are depicted in both works, but the naturalism of the earlier picture has been transformed into a far more formally integrated and imaginative vision.

76 LOWESTOFFE, SUFFOLK

27 × 43cm (10⅘ × 16¾in) *c.* 1835

A bleak vision which Ruskin puts at 'an hour before sunrise in winter. Violent storm with rain' and it is praised by him as a model of colouring composed almost entirely of variations of grey.

Once again the lighthouses have failed in their purpose (as in *Longships Lighthouse*—73), and the scene is one of forlorn desolation.

Turner here depicts a local occupation. Lowestoft is situated on a particularly hazardous stretch of the east coast, and it was the home of the world's first effective lifeboat, the *Francis Ann,* launched in 1807. It also harboured, in its beachmen, an infamous body of 'wreckers': in 1821, for instance, they forced the lifeboat to turn away from a wreck that they had claimed as salvage (even though it was still manned by some of its crew) and four lives were consequently lost.

Turner's technique of washing colour onto the soaked paper can be seen very clearly, especially in the sky, and his depiction of the sea is particularly effective, the tiny boats impotently bobbing and vanishing in the swell.

77 KESWICK LAKE, CUMBERLAND

25 × 44cm (10 × 17¼in) *c.* 1835–6

Turner here effectively balances warm sunlight with cool shadow, and storminess with stillness. The feeling of space is heightened by the figures in the foreground, who are hurrying from the boat after being caught on the lake by a shower. Turner conveys their drenched coldness as they huddle together and the two dogs express the sense of liberation from the confined spaces of the boat. Above it are the falls of Lodore (the lake is today called Derwentwater) and worth noting is the boat's wake whose suggested motion fixes the mood of silent and ineffable calm.

The composition is pinioned by a main diagonal running from the hills near the top left and lining up with the piece of flotsam on the water's edge at the right below the rainbow. This, in turn, is crossed by another diagonal running through the oars; and both rhythms serve to complement the picture's two distant focal points, the waterfall and the rainbow, which are located within the areas of maximum dark and light.

78 KIDWELLY CASTLE, SOUTH WALES

29 × 44cm (11½ × 17½in) *c.* 1832–3

A drawing of ethereal beauty that ranks as one of the finest examples of Turner's genius as a colourist. Raw sunshine emerges slowly across the estuary of the Gwendraeth Fach, and it brings with it a hint of warmth to the moist air. The colours and tones in the pearly light are everywhere exquisite: the golds, pinks and soft purple-blues of the castle contrast with the dark tones of the sky and these are further enriched by wide tonal ranges of green in the foreground. The textures of the rubbed paper contribute importantly to the vibrant movement of the storm.

In the distance a young couple are walking toward us in a close embrace; in the foreground a father is pointing to a young child held by its mother. Linking the two groups is a procession of approaching horses and carts. Midway between them is a figure pointing toward the castle in a *parallel* gesture to that of the father. This transition from background to foreground may represent the process whereby the young couple in the distance have become the parents in the foreground and the unearthly radiance of the castle in the bleak light would thereby suggest the sexual experience that has generated their child.

79 LLANGOLLEN, NORTH WALES

27 × 42cm (10½ × 16½in) *c.* 1828–36

A blinding dawn scene in which the iridescence of the wet air creates a multiplicity of colours. The vagueness of definition in the distance is greatly intensified by the sharper delineation of the foreground, and the torrential movement of the river is contrasted and amplified by the elegant trees on the right, the pointed angularity of the rocks and the solidity of the trout fisherman. The rushing of the river, the constant fluctuation of brilliance and shadow, and the linear repetitions of the arches of the distant viaduct give the drawing

an intense movement. Note the gentle eddies of water on the right, scratched out with the wooden brush-end; the area of pure ultramarine in the opposite hillside, where its 'bleeding' in the initial colour-wash can still be clearly discerned; the streaming light across that hillside, whose forms are barely perceptible in the glare; and high up on the left, Castell Dinas Brân which also appears in the drawing of Valle Crucis Abbey (14).

80 DURHAM CATHEDRAL

29 × 44cm (11⅝ × 17⅜in) *c. 1834–5*

The cathedral towers majestically in the still evening light and its imposing scale is increased by the birds on the left and the figures on the right. Its solid architecture and the elegant trees on the left display an equal comprehension of structure, and Ruskin cites these trees as amongst the finest in all painting, especially praising the grace of their upper boughs.

The drawing's composition is equally inventive. Two diagonals meet at the figures on the right, one line running upwards through the line of the weir and the other down the roof of the cathedral from the top left-hand corner of the picture; and this principal line is crossed by a subsidiary that again uses the weir and the further bank of the river.

Turner sketched Durham Cathedral and Castle many times, and two 'colour-beginnings' in the Turner Bequest are identical in viewpoint to this drawing: TB CCLXIII No 125, and TB CCCLXIV No 406 which is a probable colour sketch for this picture: the entire composition is identical, even including indications of birds (but at the lower right). Only the early afternoon lighting is substantially different.

81 WHITEHAVEN, CUMBERLAND

32 × 48cm (12½ × 18¾in) *c. 1834–6*

Turner depicts wrecks and wreckers yet again, this time even including what look like two coffins in the centre. A continuous line unifies the composition in a vortex of stunning force, running from the sunlit hillside on the left, through the surging of the sea, around the dark ship in the distance and up into the clouds.

The viewpoint is characteristically from just offshore: 'It is not, however, from the shore that Turner usually studies his sea. Seen from the land, the curl of breakers, even in nature, is somewhat uniform and monotonous; the size of the waves out at sea is uncomprehended; and those nearer the eye seem to succeed and resemble each other, to move slowly to the beach, and to break in the same lines and forms.

'Afloat even twenty yards from the shore, we receive a totally different impression. Every wave around us appears vast, every one different from all the rest; and the breakers present, now that we see them with their backs towards us, the grand, extended, and varied lines of long curvature which are peculiarly expressive both of velocity and power . . . Aiming at these grand characters of the sea, Turner almost always places the spectator, not on the shore, but twenty or thirty yards from it, beyond the first range of breakers'.[42]

There is no record in the sketchbooks of Turner's ever having visited Whitehaven, Cumberland apart from noting its location on a small sketch-map included in the 1809 'Cockermouth' sketch-book (TB CX) which he used in connection with a commission from Lord Egremont to paint Cockermouth Castle. Turner toured the district (Cockermouth being about 12 miles from White-haven) and probably sketched it on this tour, although no sketch is included in the Turner Bequest.

82 WINANDER-MERE, CUMBERLAND

29 × 46cm (11¾ × 18⅛in) *c. 1834–6*

Turner had first visited Lake Windermere on his earliest tour of the Lake District in 1797. He used the sketchbook from that tour for this drawing but it should not be imagined that he has merely translated the lines from the early sketch and coloured them, adding the figures in the process. The topography of the real landscape is virtually ignored. The distant fells and mountains rise and fall according to his artistic needs and echo the motion of the boats. However, the crowded fore-ground does not destroy the picture's overall effect of tranquillity. The composition is structured by a triangle that runs up the lake to the distant point beneath the sun, and its lines are repeated by the boats' oars and the reflections on the water in a succession of shimmering movements.

83 CRICKIETH CASTLE, NORTH WALES

29 × 43cm (11⅖ × 16¾in) *c. 1835–6*

A passing storm leaves shipwrecked men on the beach, their pathetic salvage being supervised by coastguard officers. The composition is again based upon two intersecting diagonals that meet on the right, the lower one of which creates the sense of strain in those figures still straggling ashore with their loads; and these compositional lines are paralleled throughout, particularly by the diagonal rays of light in the sky, the levering crowbar on the beach and the pointing figure on the right. The desolate air of the castle is also echoed in the mood of the seamen, bewildered and lost as they wait on the beach. Turner not only renders the colour and moisture of damp sand, but also conveys its precise grainy texture by stippling and rubbing the paper's surface. The microscopic figures on the beach in the distance make the castle and the hovels of Cricieth seem particularly overwhelming.

When this work was engraved in 1837 Turner had the letters 'C.H.' added to one of the items of debris in the foreground. They probably stand for Charles Heath, who was financially 'washed-up' by now.

84 CHAIN BRIDGE OVER THE RIVER TEES

27 × 43cm (10¾ × 16¾in) *c.* 1825–36

Death approaches relentlessly from the distance in the guise of a hunter, his gun poised, the grouse in the right foreground unaware of him. Observe the strong diagonal that links them, and the infinite chasm that opens to the left. Ruskin praises the truthfulness of the rendering of both water and foliage in this drawing:

Turner was the only painter who had ever represented . . . the *force* of agitated water. He obtains this expression of force in falling or running water by fearless and full rendering of its forms. He never loses himself and his subject in the splash of the fall, his presence of mind never fails as he goes down; he does not blind us with the spray, or veil the countenance of his fall with its own drapery. A little crumbling white, or lightly rubbed paper, will soon give the effect of indiscriminate foam; but nature gives more than foam, she shows beneath it, and through it, a peculiar character of exquisitely studied form bestowed on every wave and line of fall; and it is this variety of definite character which Turner always aims at, rejecting, as much as possible, everything that conceals or overwhelms it . . . in the 'Chain Bridge over the Tees' this passiveness and swinging of the water to and fro are yet more remarkable; while we have another characteristic of a great waterfall given to us, that the wind, in this instance coming up the valley against the current, takes the spray up off the edges, and carries it back in little torn, reverted rags and threads, seen in delicate form against the darkness on the left . . . The piece of thicket on the right . . . is peculiarly expressive of the aerial relations and play of light among complex boughs . . .'[43]

When the drawing was engraved the tonality was darkened and Turner had two white birds added on the left. As with the heron of *Powis Castle* (69) they can also be seen as spirits of the dead.

85 RICHMOND TERRACE, SURREY

29 × 44cm (11½ × 17½in) *c.* 1836

This is the last of Turner's many versions of this view and with it the subject finally reaches its fulfilment. A panorama on two levels, Turner matches the landscape with a survey of British society.

From left to right we see the monarchy (represented by a State coach) and the aristocracy in a group (diminutive Scot included); a large (social) gap and then the inquisitive middle classes in their elegant attire in the centre, a small dog running to the left perhaps representing their aspirations for social advancement; and finally the labouring classes on the right, including strolling workers in their 'Sunday best', an obviously exhausted figure slumped under the nearest of the trees and a barrow of flowers and fruit which represents the produce of their labours. The human motives of love and hate are signified by the immediate juxtaposition of two children playing with a hoop and two dogs arguing; and over all of this looms a tree that not only gives essential vertical emphasis to an otherwise horizontal view, but which also enfolds us in its verdant splendour.

86 MOUNT ST. MICHAEL, CORNWALL

32 × 44cm (12⅝ × 17¼in) *c.* 1834–7

The open sale of wrecked timber was common in Cornwall during the nineteenth century and here it is being broken up, the twelfth-century monastery producing Turner's familiar conjunction of wreck with ruin. The framework of the drawing is provided by a vortex whose circular line runs through the sky and, repeated by the shrimper on the left, is carried through the rudder and timbers in the foreground to complete the circle. The depiction of the clouds is wonderfully assured. Turner imitates the line of their shower in the upright wreck-staves beyond the packhorses. In the area on the right a bright beam of light falls

through a cascading sheen of rain and here Turner achieves depth by juxtaposing the dazzle of light upon Marazion alongside the darkest area of the whole picture. The blue of this shadow is repeated by a shallow diagonal line that carries our eye up to the mount.

Turner produced two other watercolours of this subject, the first of which was engraved for the 'Southern Coast' series (1814) and the second for *Milton's Poetical Works* (1835). There is also an oil-painting (Victoria and Albert Museum), exhibited at the Royal Academy in 1834.

87 MERTON COLLEGE, OXFORD

30 × 44cm (11¾ × 17¼in) *c.* 1838
 TB CCLX-III–349

The subject, symbolism, size and handling suggest that this picture was made for the series although it was never engraved, an assertion supported by Finberg. Building work took place on the Merton Street façade of the college between 1836–8 but whether Turner witnessed this or not he has introduced it here, as he did in *Christ Church* (62), to symbolize the constructive process of education. He again relates the dons to disputing dogs, linking them by a diagonal timber beam, and indicates the refreshment of the mind by the milkmaid on the right. Note the builder who is glancing at her, the phallic emphasis of the gateway above him and the formal repetition of the gateway's turrets in the narrow shape of the dons.

Commentaries continued on p. 152.

1 SALTASH, CORNWALL British Museum, London

2 RIVAULX ABBEY, YORKSHIRE Private Collection, UK

3 LANCASTER ,FROM THE AQUEDUCT BRIDGE Lady Lever Art Gallery, Port Sunlight, UK

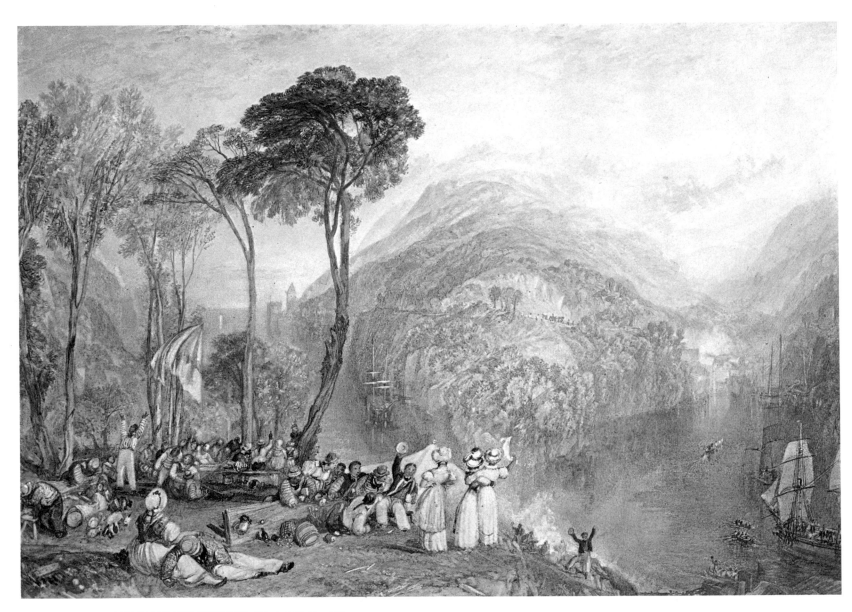

4 DARTMOUTH COVE, WITH SAILOR'S WEDDING Private Collection, UK

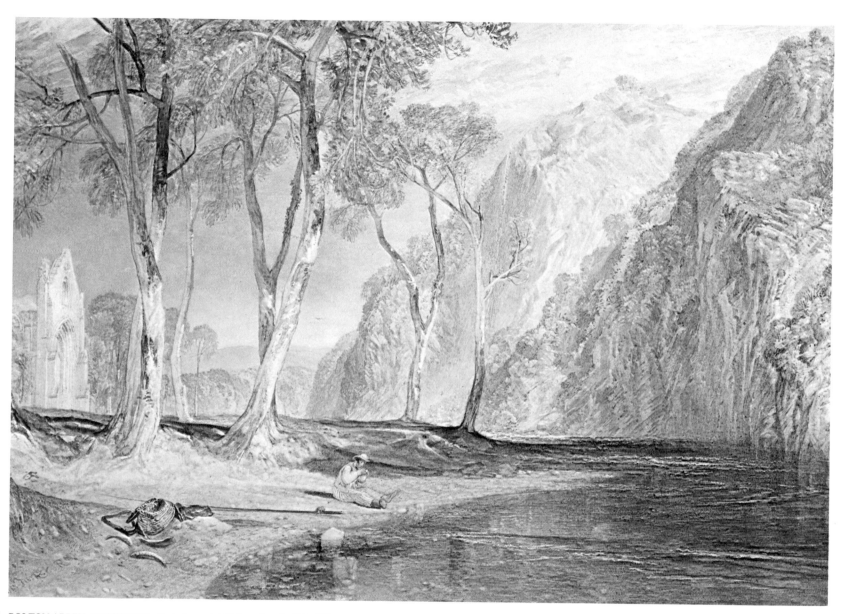

5 BOLTON ABBEY, YORKSHIRE Lady Lever Art Gallery, Port Sunlight, UK

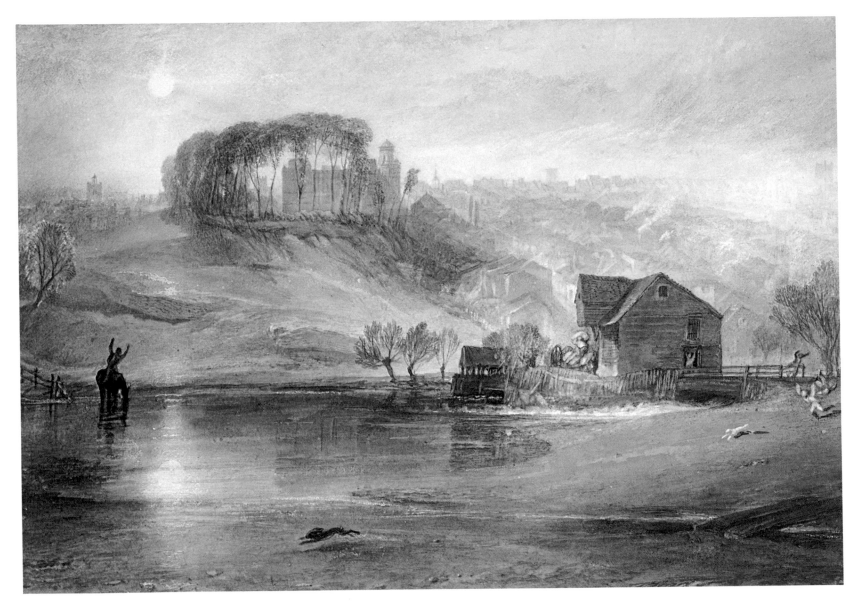

6 COLCHESTER, ESSEX Courtauld Institute, London

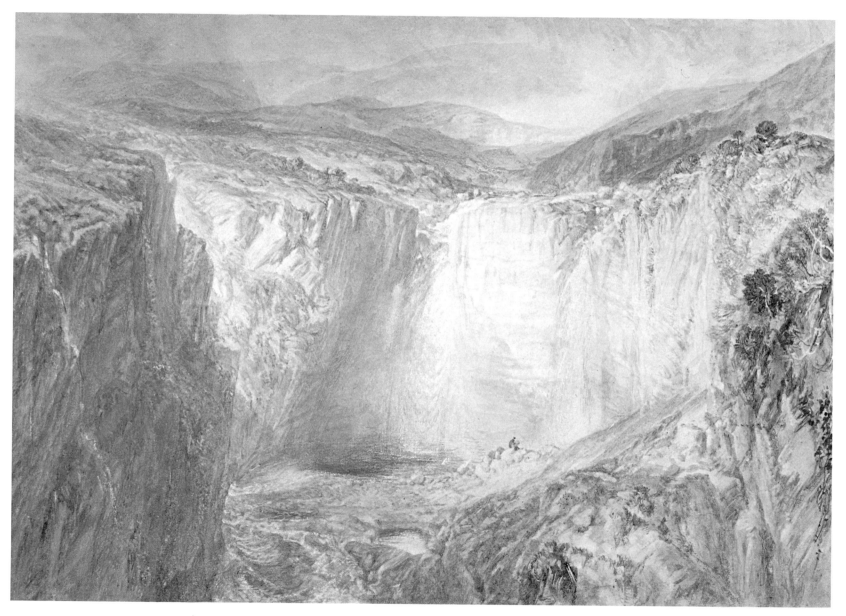

7 FALL OF THE TEES, YORKSHIRE Private Collection, UK

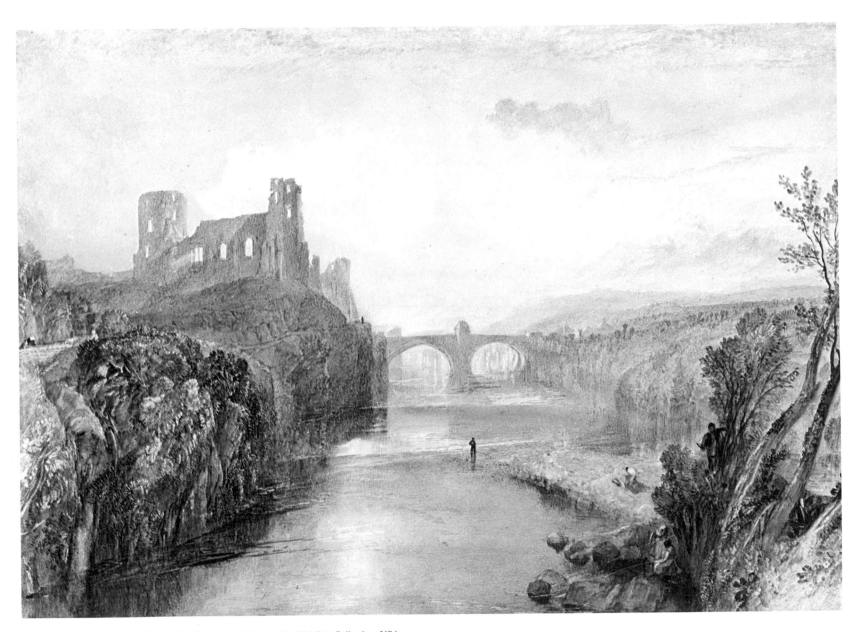

8 BARNARD CASTLE, DURHAM Yale Center for British Art, Paul Mellon Collection, USA

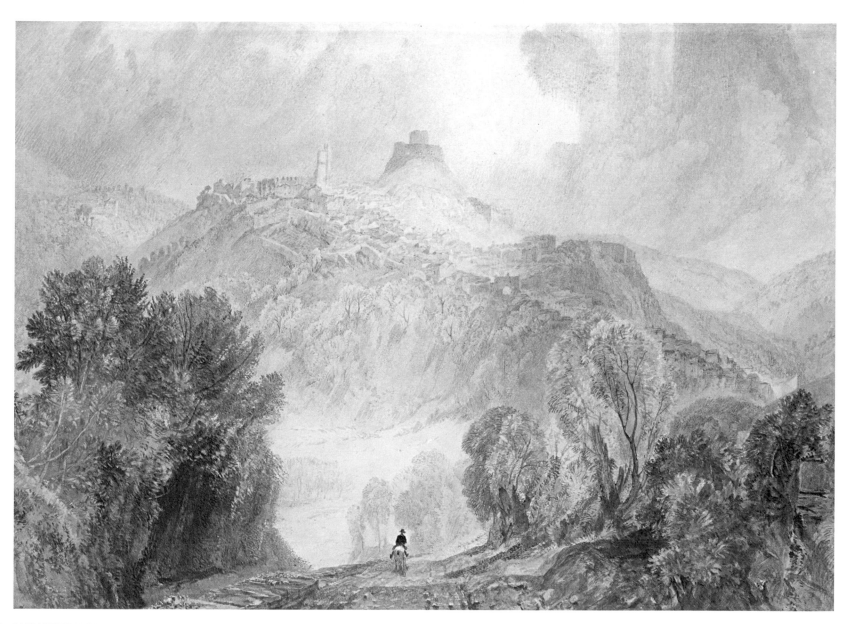

9 LAUNCESTON, CORNWALL Private Collection, Iran

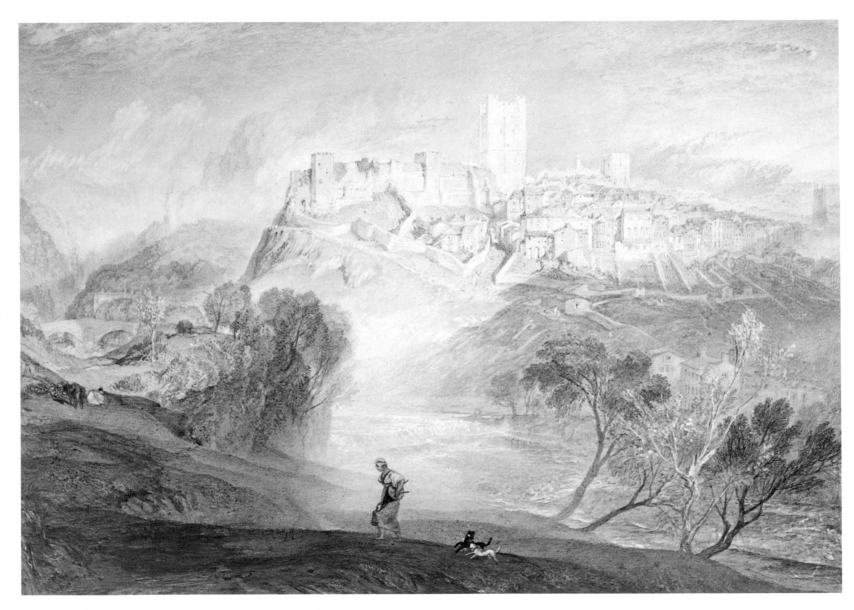

10 RICHMOND CASTLE AND TOWN, YORKSHIRE British Museum, London

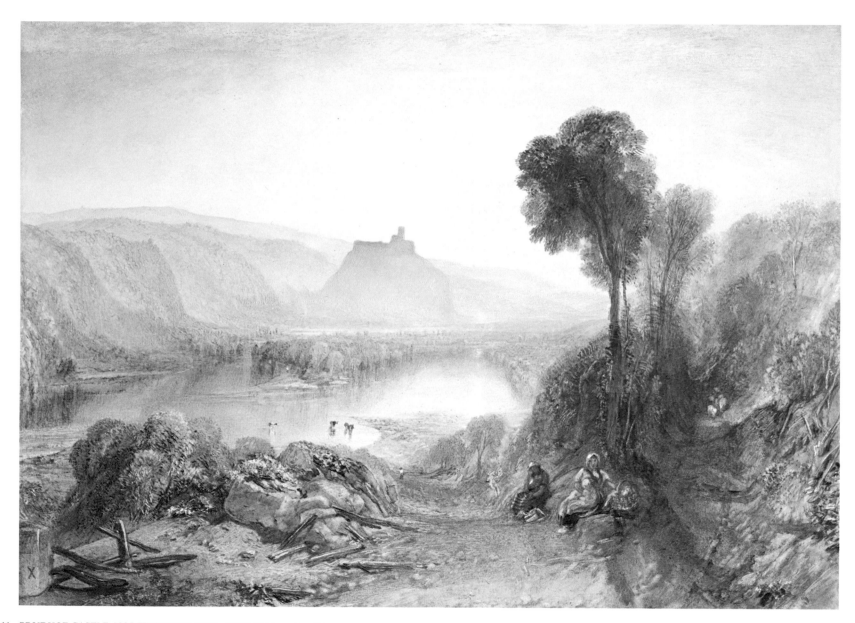

11 PRUDHOE CASTLE, NORTHUMBERLAND British Museum, London

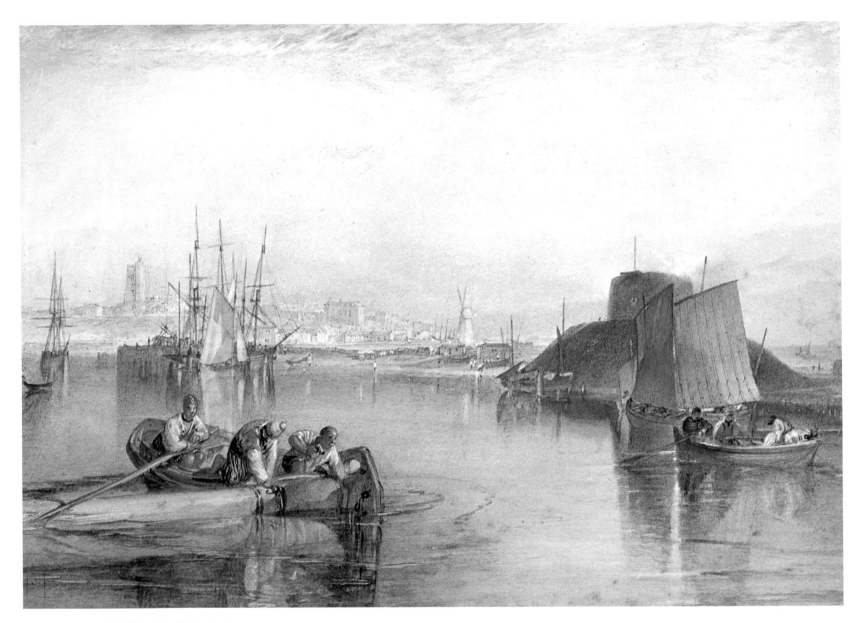

12 ALDBOROUGH, SUFFOLK Tate Gallery, London

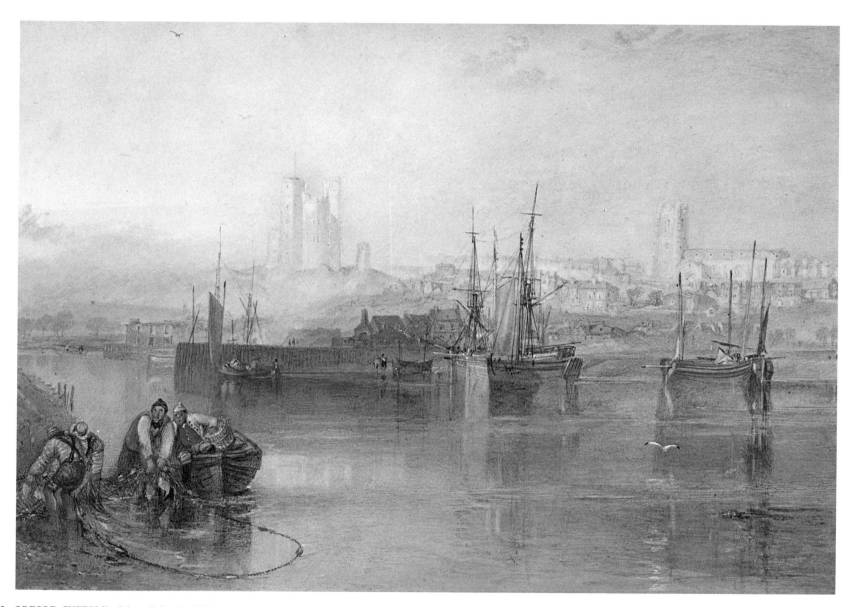

13 ORFORD, SUFFOLK Private Collection, UK

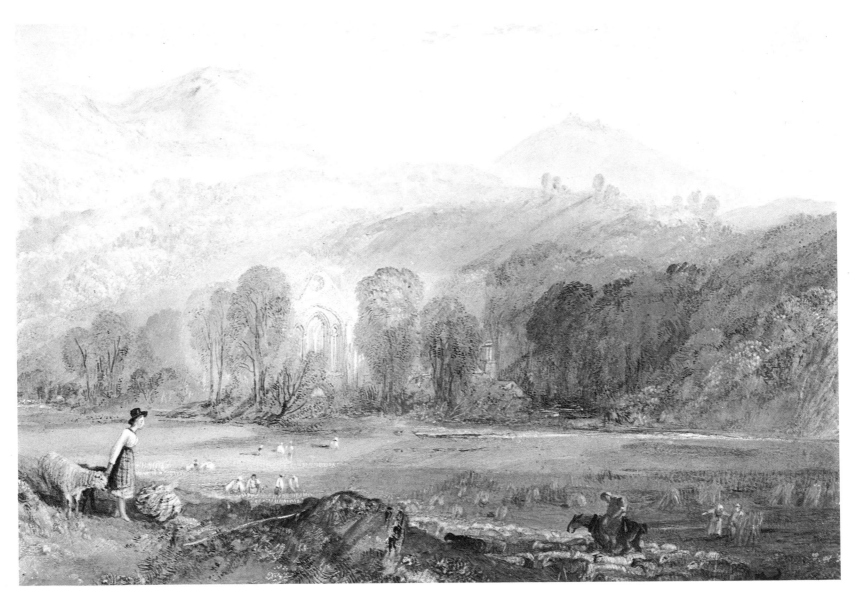

14 VALLE CRUCIS ABBEY, DENBIGHSHIRE City Art Gallery, Manchester, UK

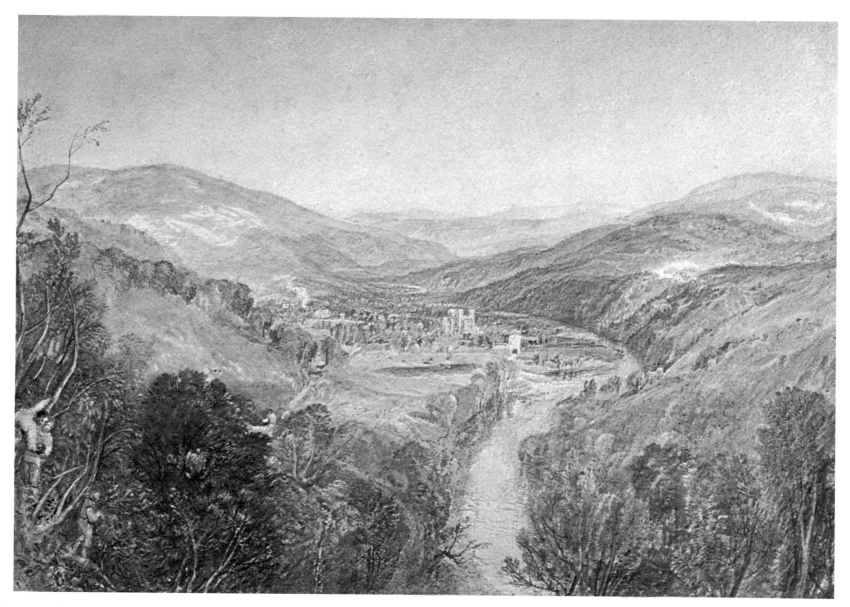

15 BUCKFASTLEIGH ABBEY, DEVONSHIRE Private Collection, UK

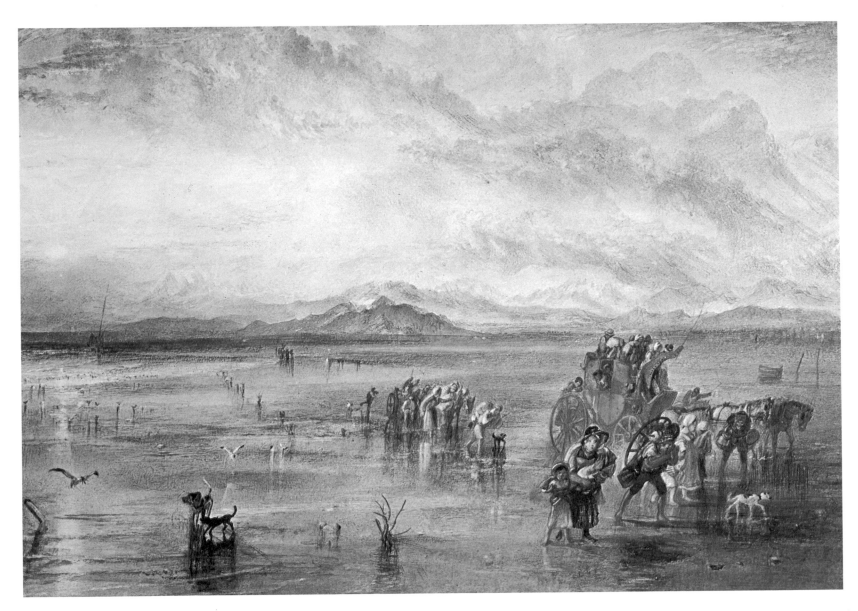

16 LANCASTER SANDS British Museum, London

17 OKEHAMPTON, DEVONSHIRE National Gallery of Victoria, Melbourne, Australia

18 LOUTH, LINCOLNSHIRE British Museum, London

19 KNARESBOROUGH, YORKSHIRE Private Collection, UK

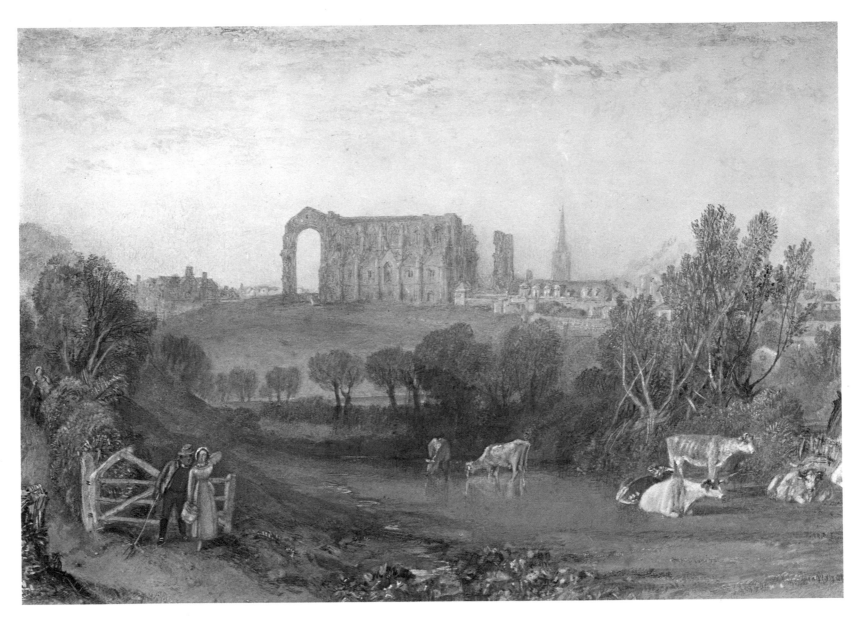

20 MALMESBURY ABBEY, WILTSHIRE Private Collection, UK

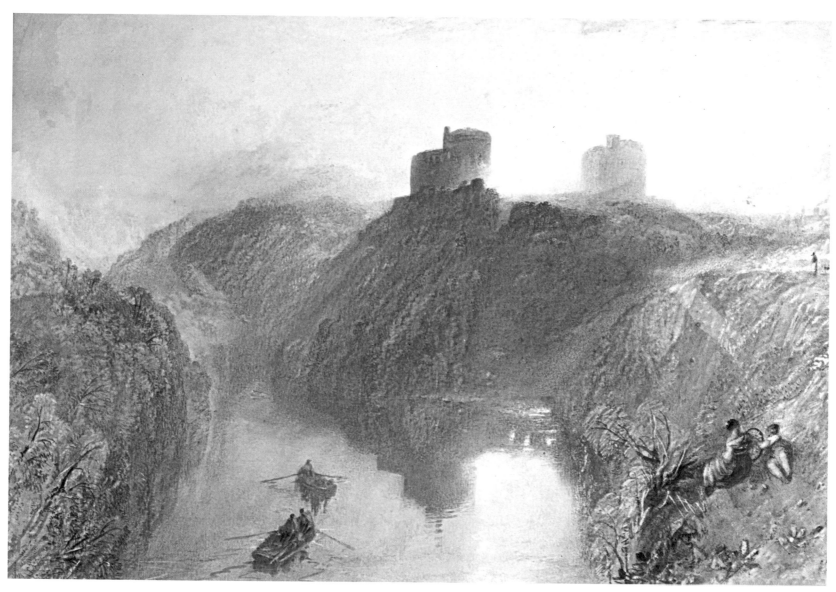

21 KILGARREN·CASTLE, PEMBROKESHIRE Private Collection, UK

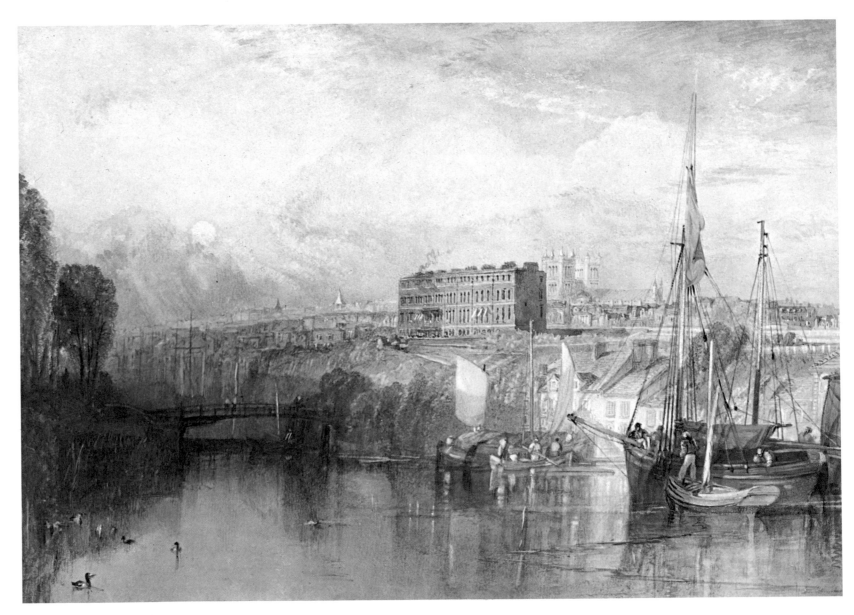

22 EXETER City Art Gallery, Manchester

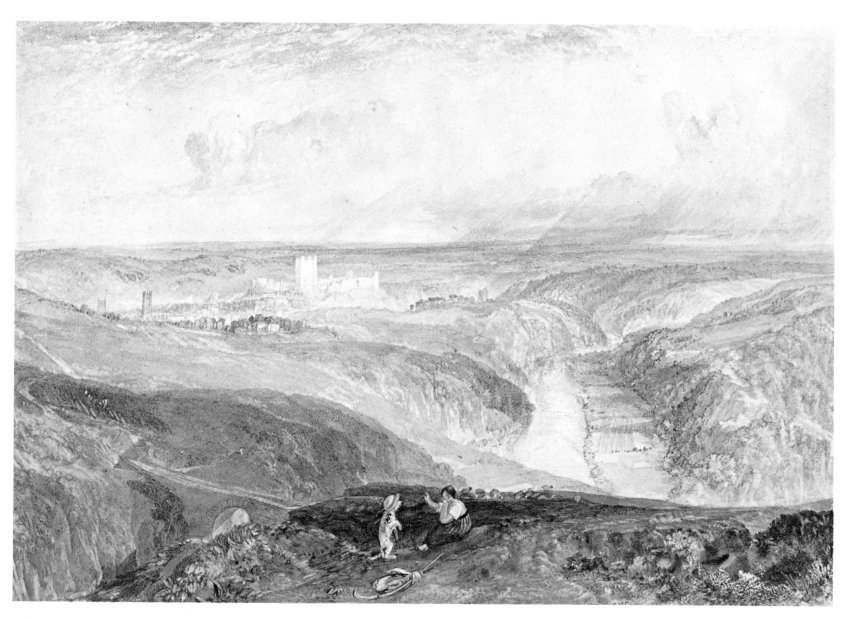

23 RICHMOND, YORKSHIRE Fitzwilliam Museum, Cambridge, UK

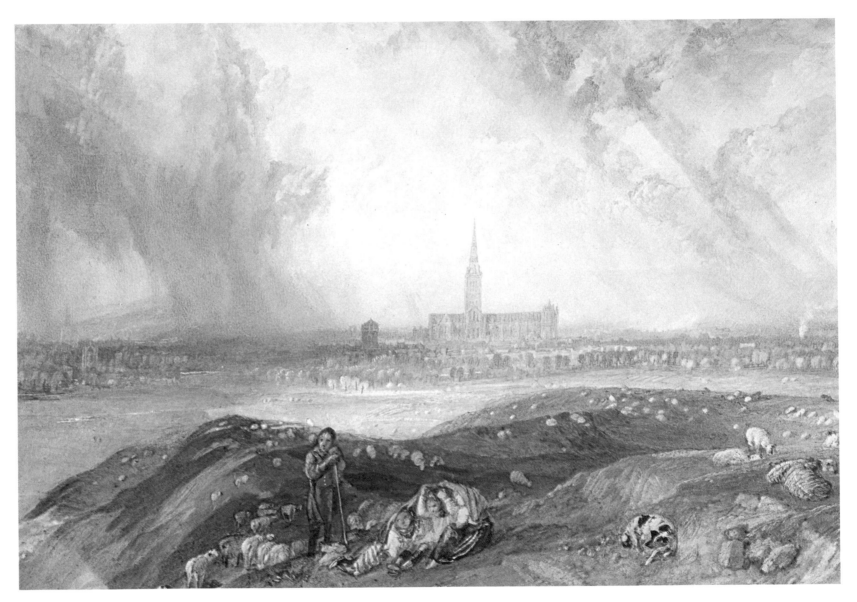

24 SALISBURY FROM OLD SARUM INTRENCHMENT Private Collection, UK

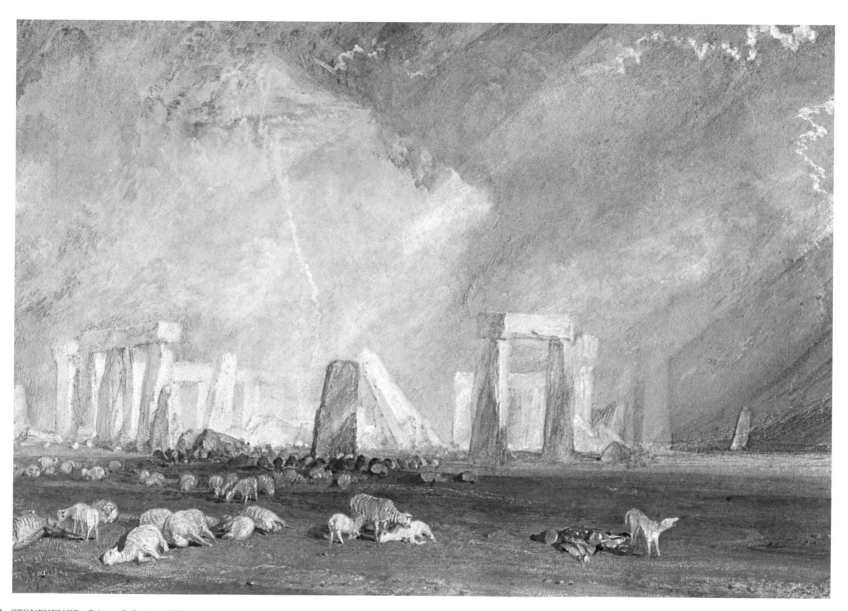

25 STONEHENGE Private Collection, UK

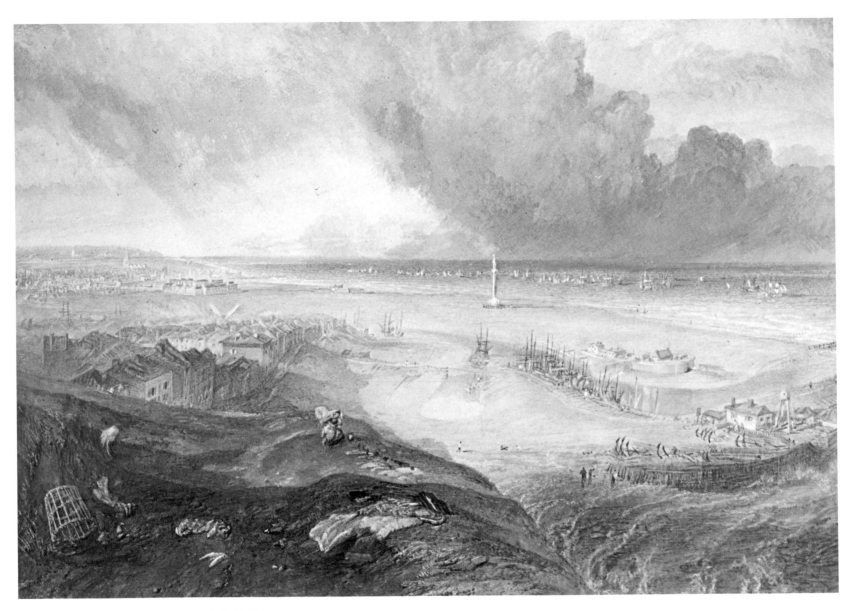

26 GREAT YARMOUTH, NORFOLK Private Collection, UK

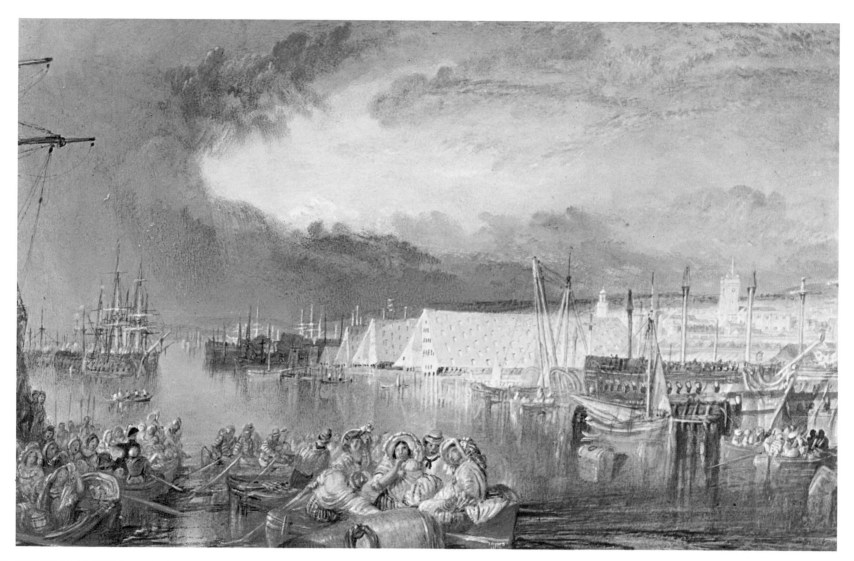

27 DOCKYARD, DEVONPORT , SHIPS BEING PAID OFF Fogg Art Museum, Harvard University, Cambridge, Massachusetts

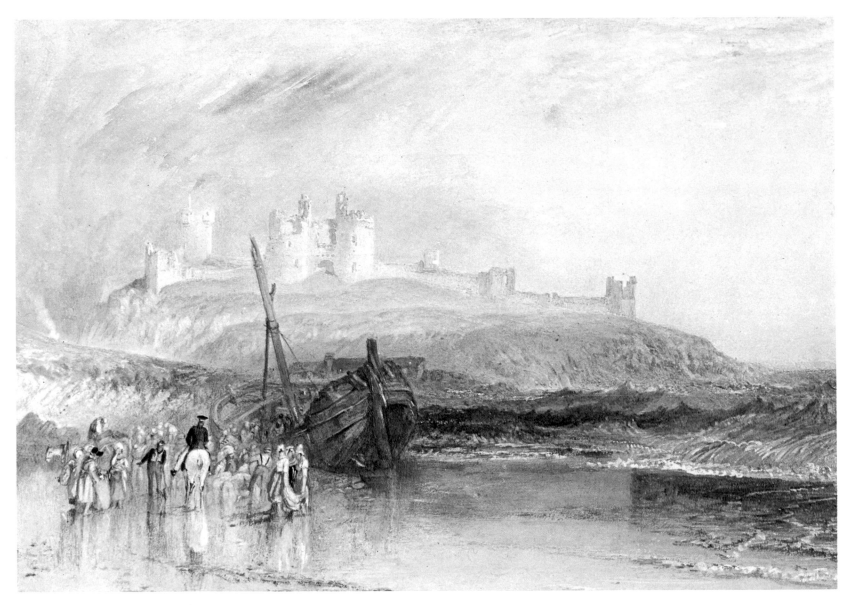

28 DUNSTANBOROUGH CASTLE, NORTHUMBERLAND City Art Gallery, Manchester, UK

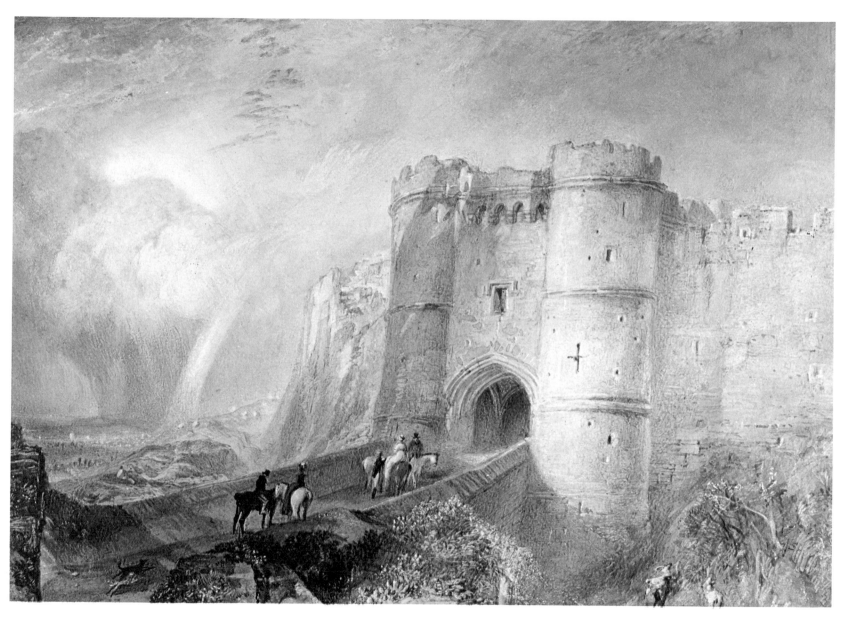

29 CARISBROOK CASTLE, ISLE OF WIGHT Private Collection, UK

30 COWES, ISLE OF WIGHT Private Collection, UK

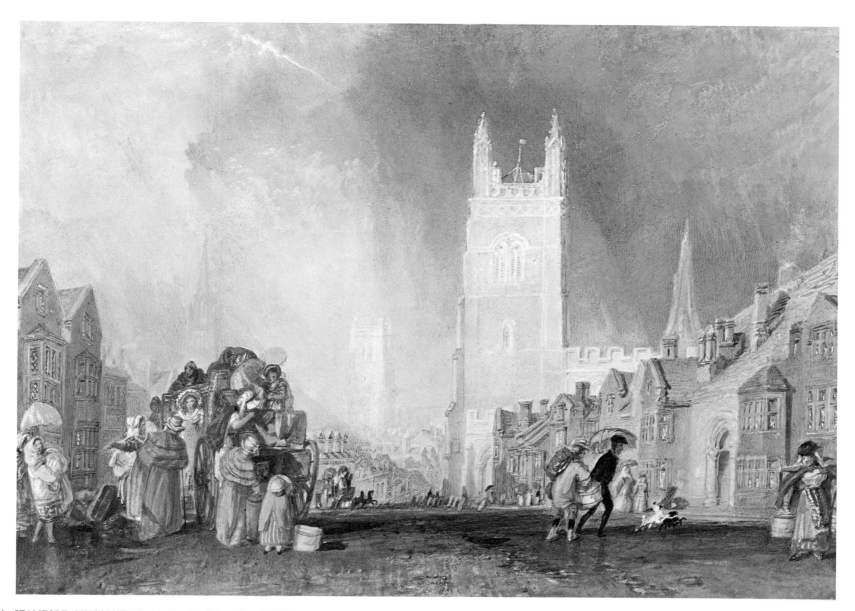

31 STAMFORD, LINCOLNSHIRE Usher Art Gallery, Lincoln, UK

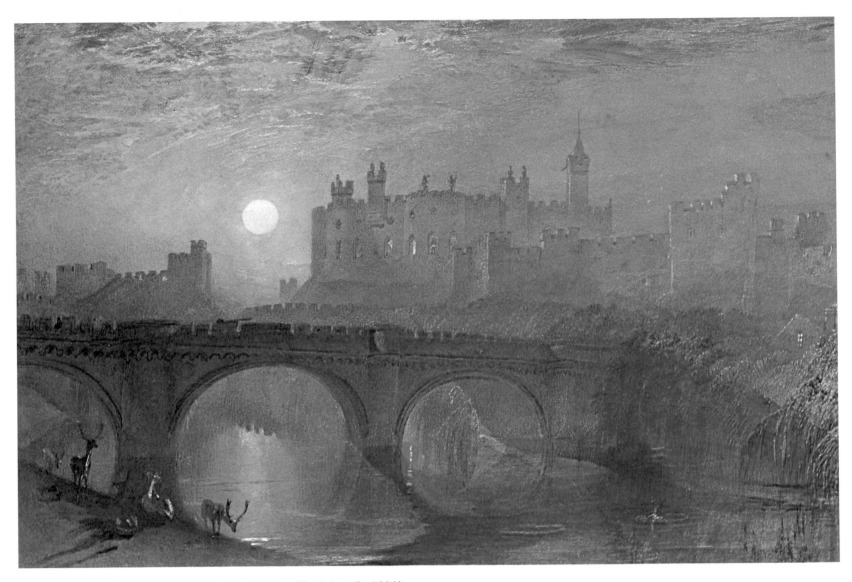

32 ALNWICK CASTLE, NORTHUMBERLAND National Gallery of South Australia, Adelaide

33 HOLY ISLAND, NORTHUMBERLAND Victoria and Albert Museum, London

34 WINCHELSEA, SUSSEX British Museum, London

35 STONEYHURST COLLEGE, LANCASHIRE Private Collection, UK

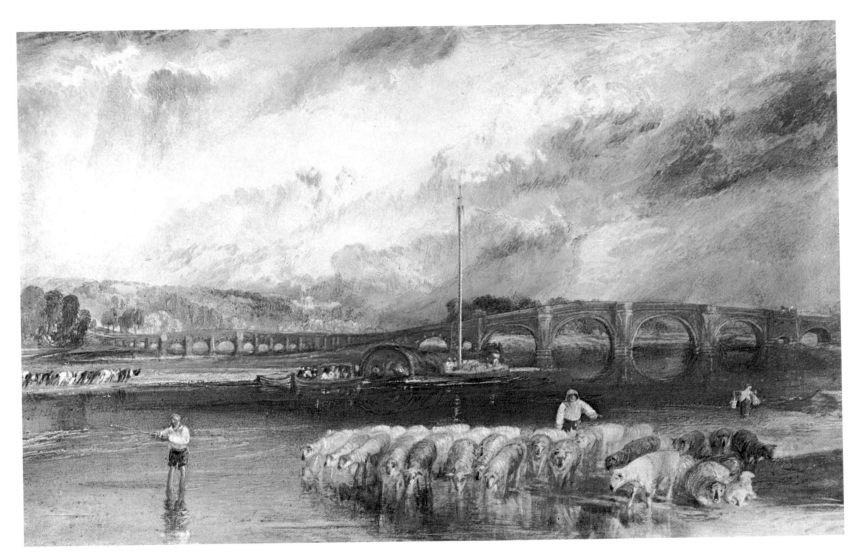

36 WALTON BRIDGE ON THAMES, SURREY Private Collection, UK

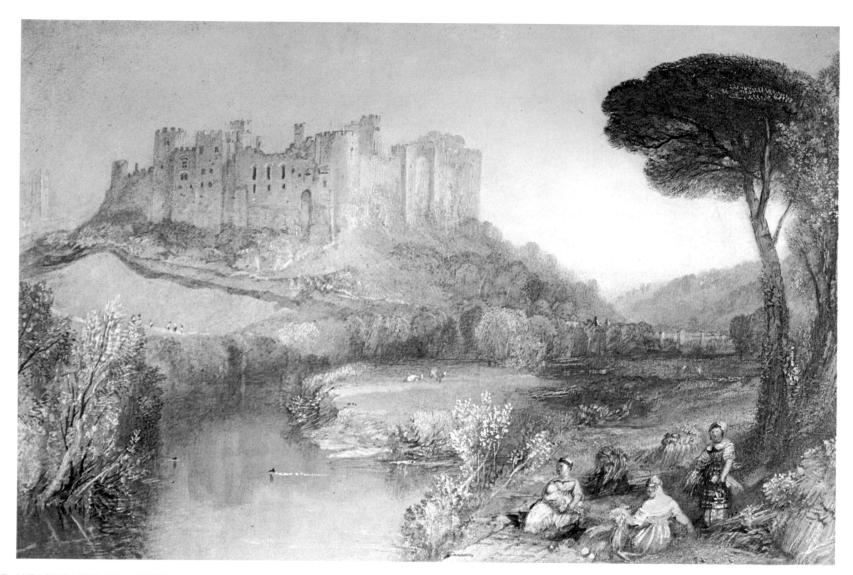

37 LUDLOW CASTLE, SHROPSHIRE Private Collection, UK

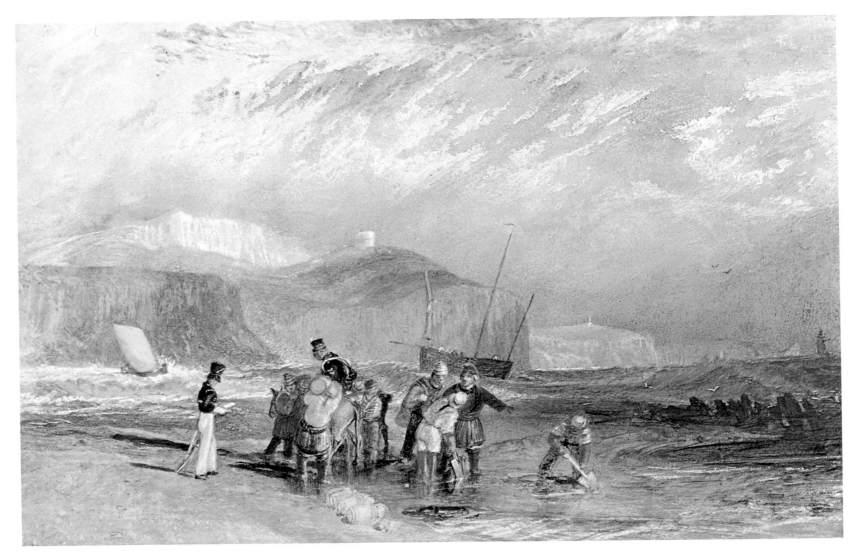

38 COAST FROM FOLKESTONE HARBOUR TO DOVER Yale Center for British Art, Paul Mellon Collection, USA

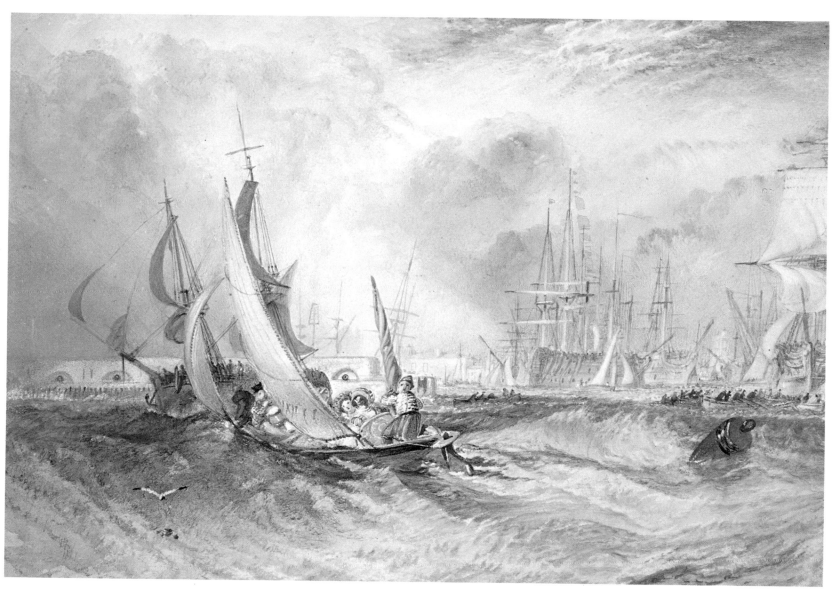

39 GOSPORT, ENTRANCE TO PORTSMOUTH HARBOUR Private Collection, UK

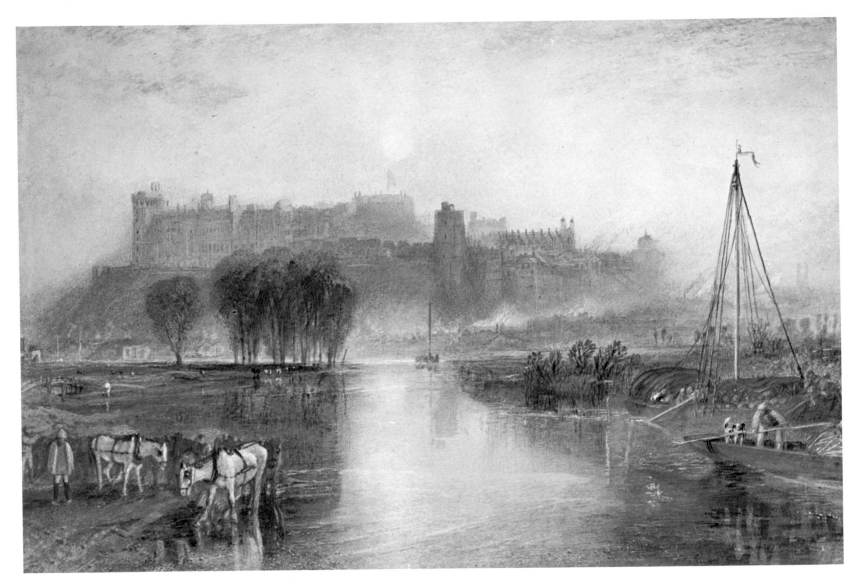

40 WINDSOR CASTLE, BERKSHIRE British Museum, London

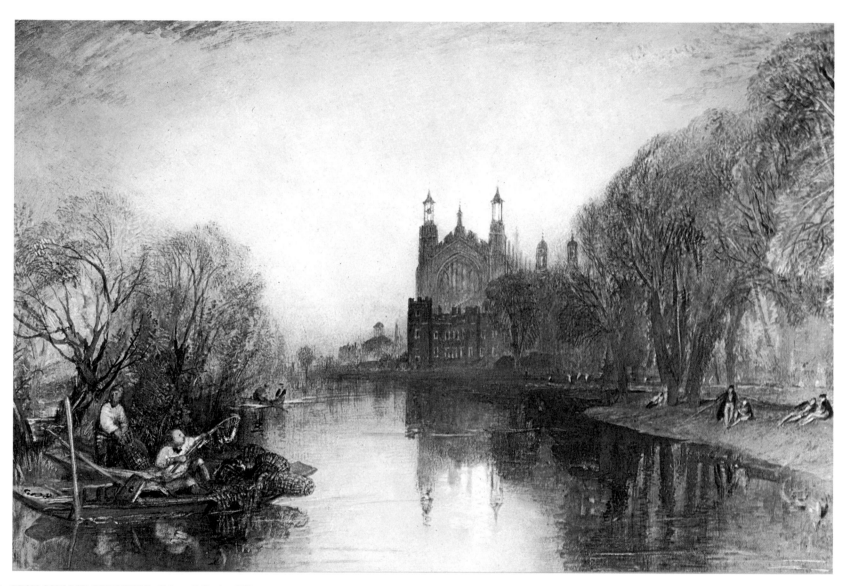

41 ETON COLLEGE, BERKSHIRE Private Collection, UK

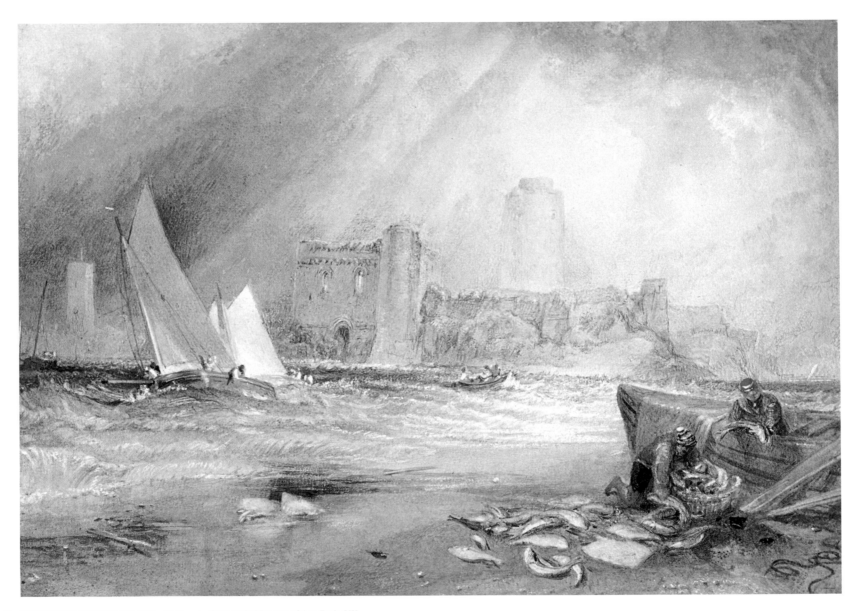

42 PEMBROKE CASTLE, WALES Holburne of Menstrie Museum of Art, Bath, UK

43 MALVERN ABBEY AND GATE, WORCESTERSHIRE City Art Gallery, Manchester, UK

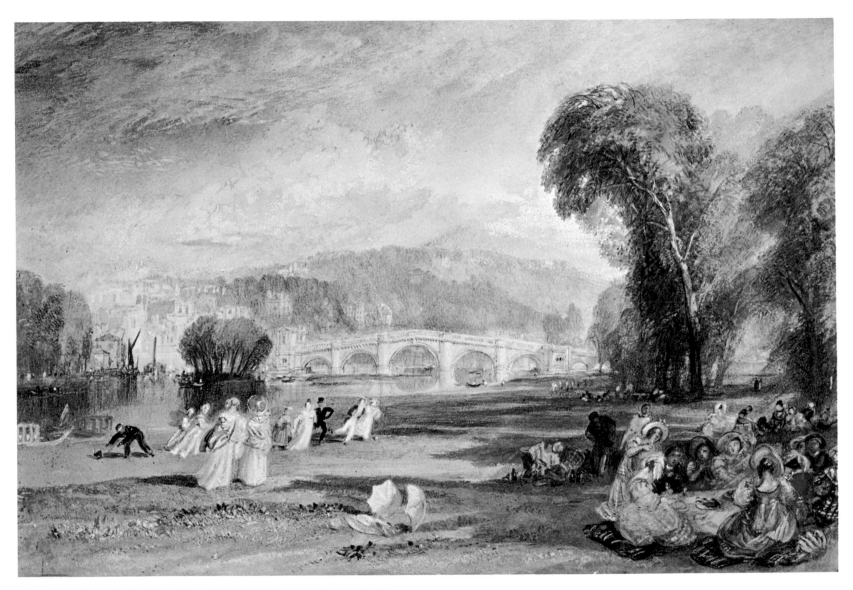

44 RICHMOND HILL AND BRIDGE, WITH A PIC-NIC PARTY British Museum, London

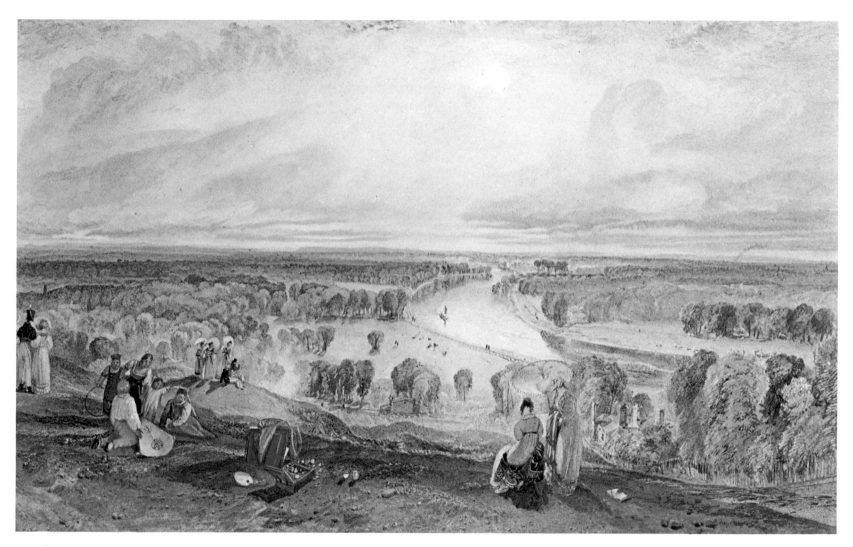

45 RICHMOND HILL Lady Lever Art Gallery, Port Sunlight, UK

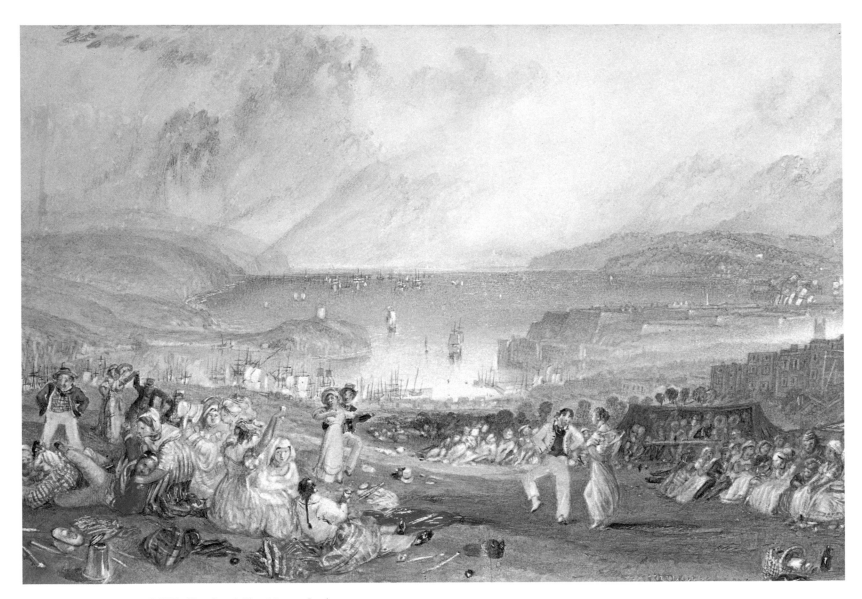

46 PLYMOUTH COVE, DEVONSHIRE Victoria and Albert Museum, London

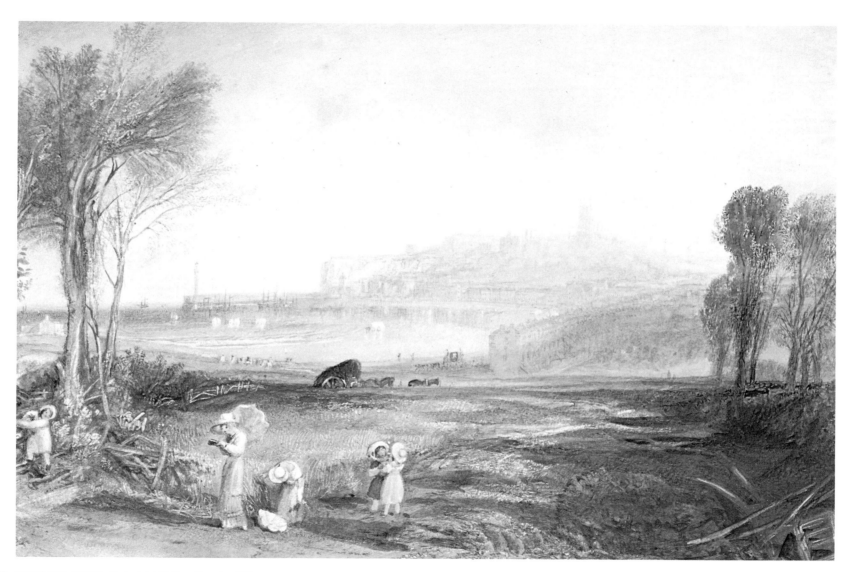

47 MARGATE, KENT Herbert Art Gallery, Coventry, UK

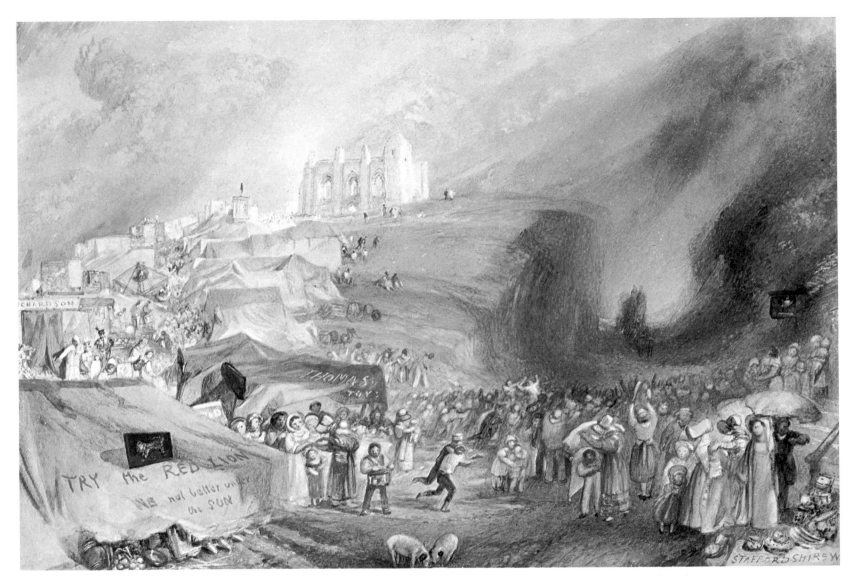

48 ST CATHERINE'S HILL, NEAR GUILDFORD, SURREY Yale Center for British Art, Paul Mellon Collection, USA

49 BRINKBURN PRIORY, NORTHUMBERLAND Graves Art Gallery, Sheffield, UK

50 WARWICK CASTLE, WARWICKSHIRE Whitworth Art Gallery, Manchester, UK

51 KENILWORTH CASTLE, WARWICKSHIRE Fine Arts Museum, San Francisco

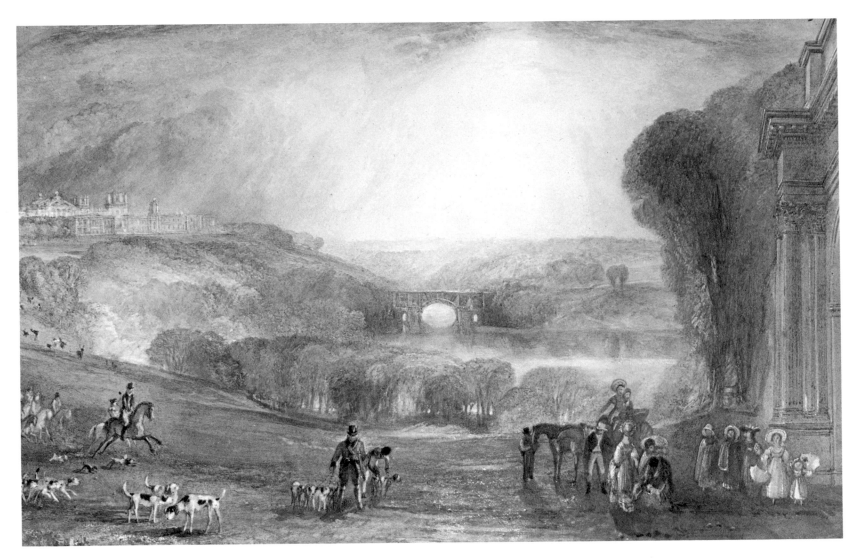

52 BLENHEIM, OXFORDSHIRE City Museums and Art Gallery, Birmingham, UK

53 NORTHAMPTON, NORTHAMPTONSHIRE Private Collection, UK

54 ELY CATHEDRAL, CAMBRIDGESHIRE Private Collection, UK

55 TAMWORTH CASTLE, WARWICKSHIRE Private Collection, UK

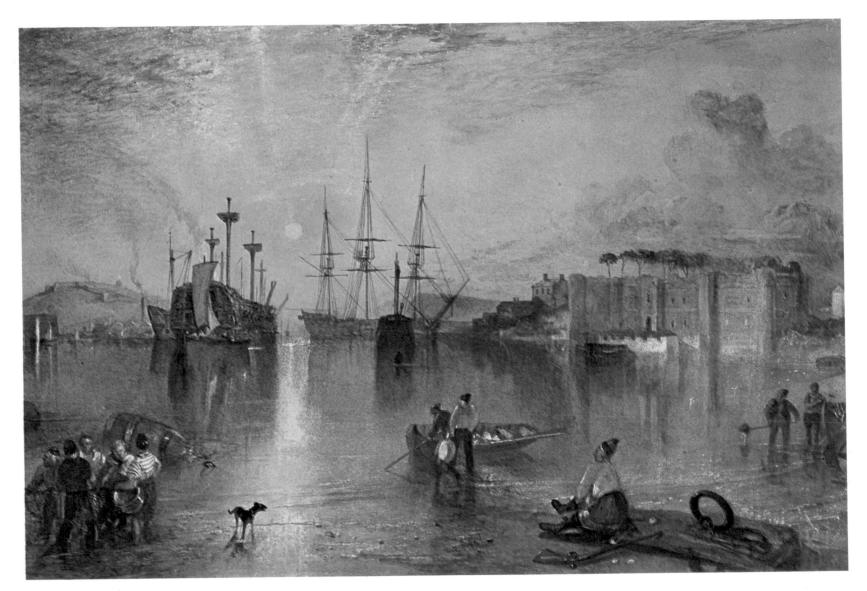

56 CASTLE UPNOR, KENT Whitworth Art Gallery, Manchester

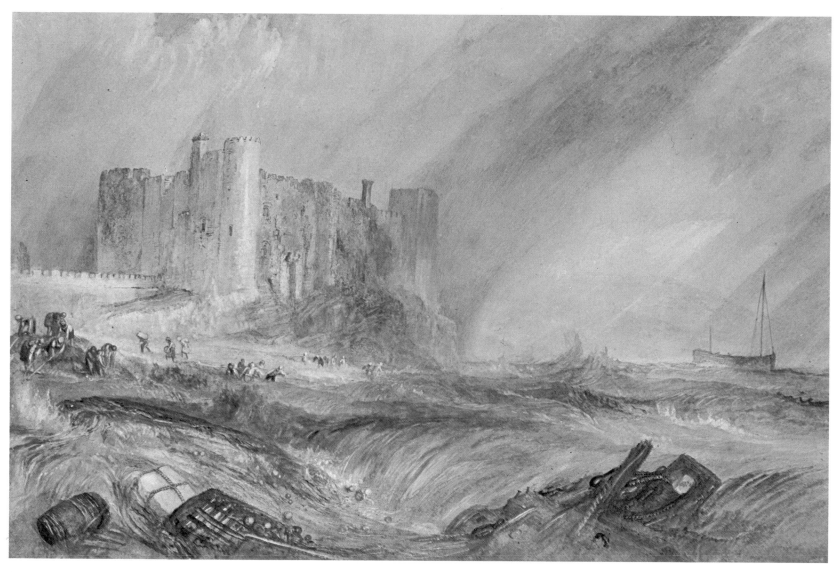

57 LAUGHARNE CASTLE, CAERMARTHENSHIRE Columbus Museum of Art, Ohio, USA: Bequest of Frederick W. Schumacher

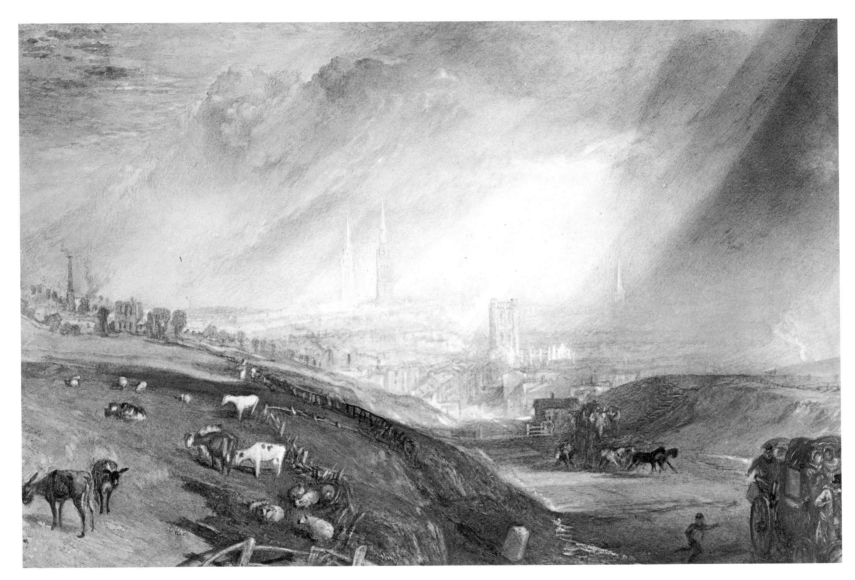

58 COVENTRY, WARWICKSHIRE British Museum, London

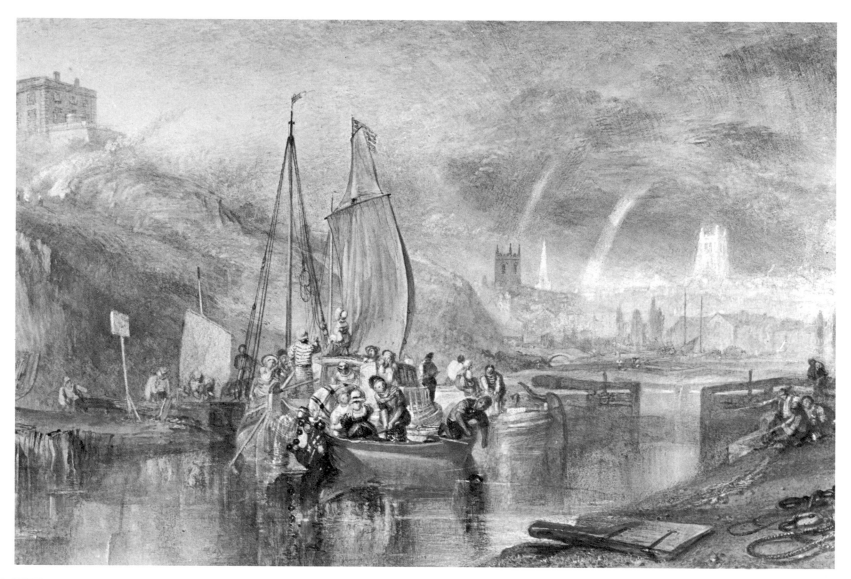

59 NOTTINGHAM, NOTTINGHAMSHIRE Museum and Art Gallery, Nottingham, UK

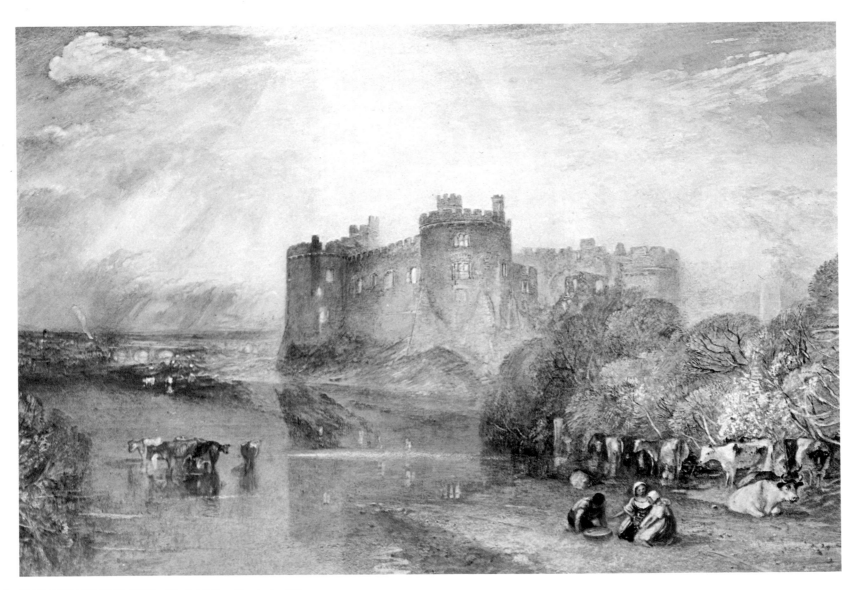

60 CAREW CASTLE, PEMBROKE City Art Gallery, Manchester, UK

61 PENMAEN-MAWR, CAERNARVONSHIRE British Museum, London

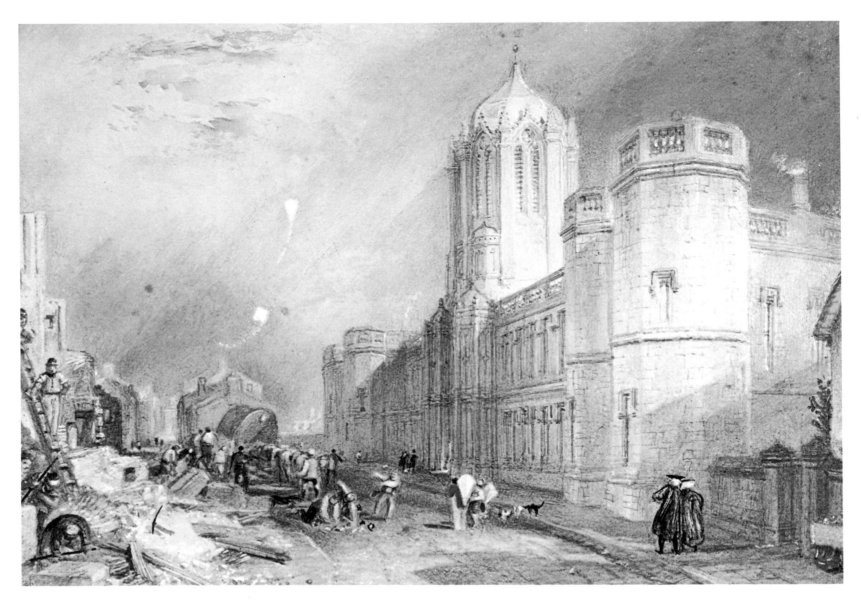

62 CHRIST CHURCH, OXFORD Private Collection, UK

63 ENTRANCE TO FOWEY HARBOUR, CORNWALL Private Collection, USA

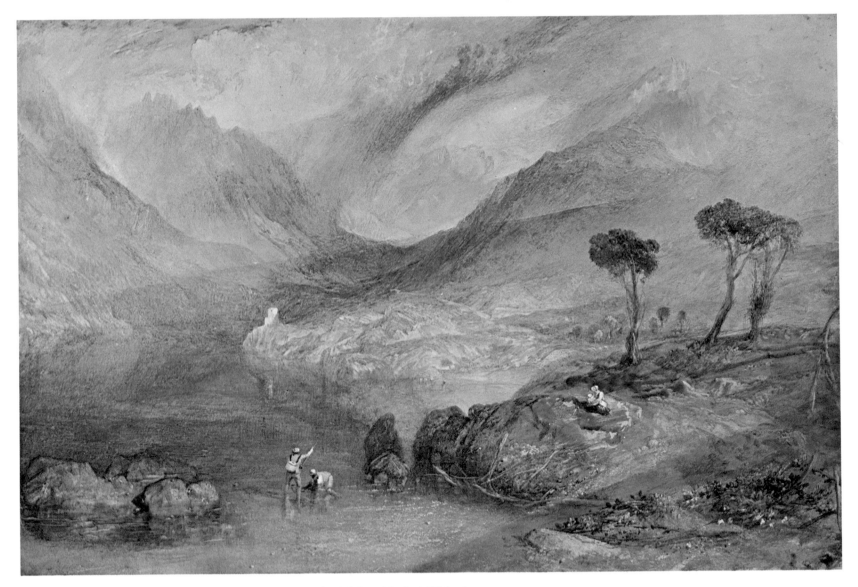

64 LLANBERRIS LAKE AND SNOWDON, CAERNARVONSHIRE National Gallery of Scotland, Edinburgh

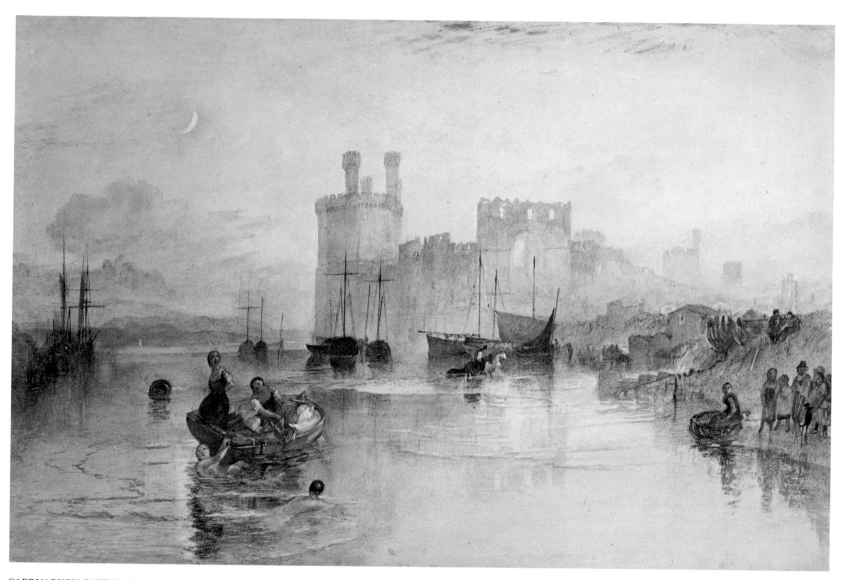

65 CAERNARVON CASTLE, WALES British Museum, London

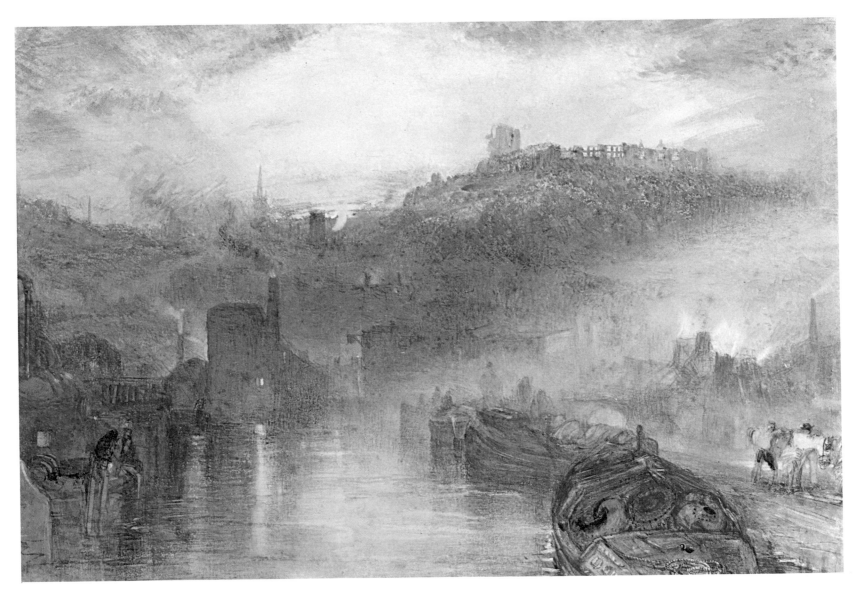

66 DUDLEY, WORCESTERSHIRE Lady Lever Art Gallery, Port Sunlight, UK

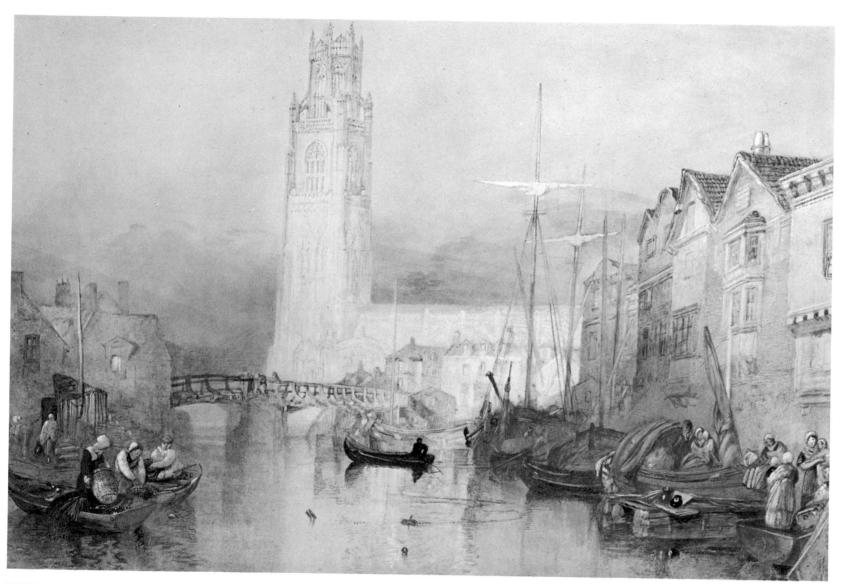

67 BOSTON, LINCOLNSHIRE Private Collection, UK

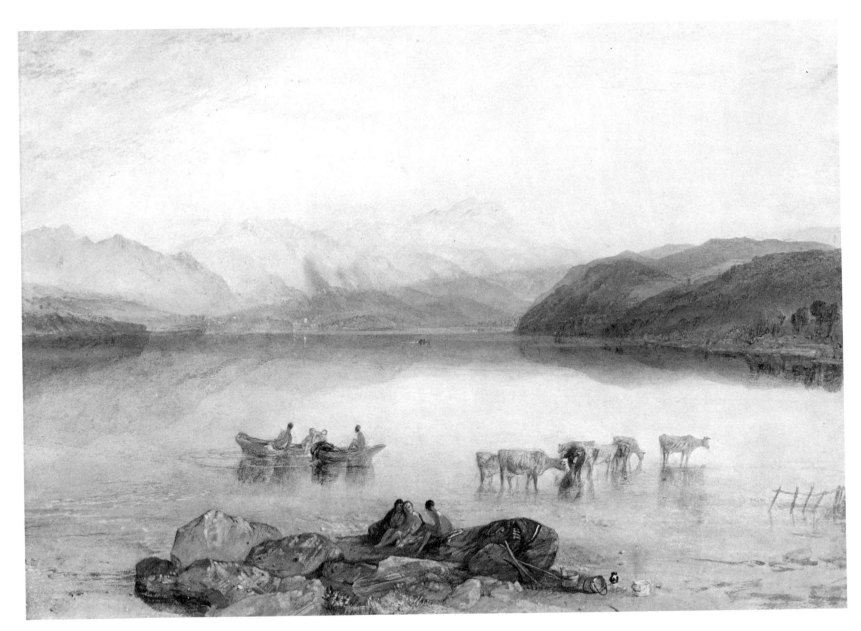

68 ULLSWATER, CUMBERLAND Brian Pilkington, Esq

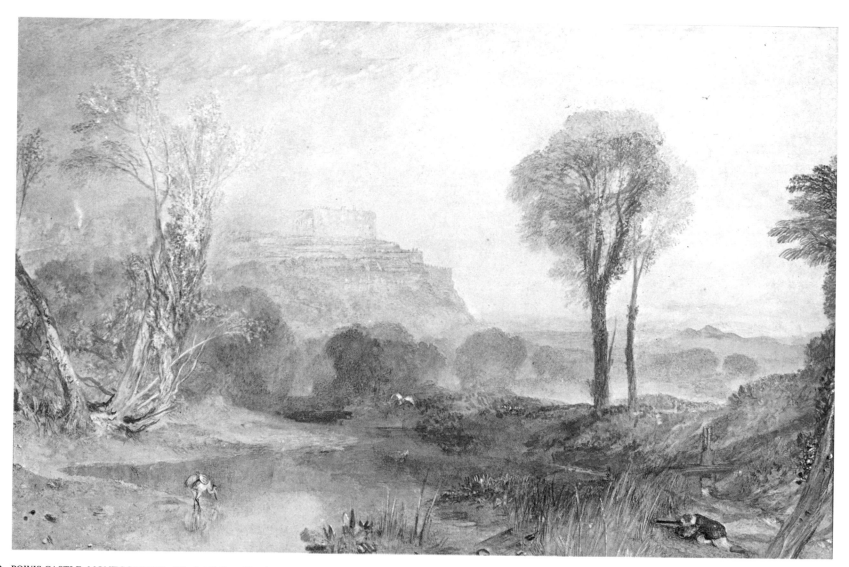

69 POWIS CASTLE, MONTGOMERY City Art Gallery, Manchester, UK

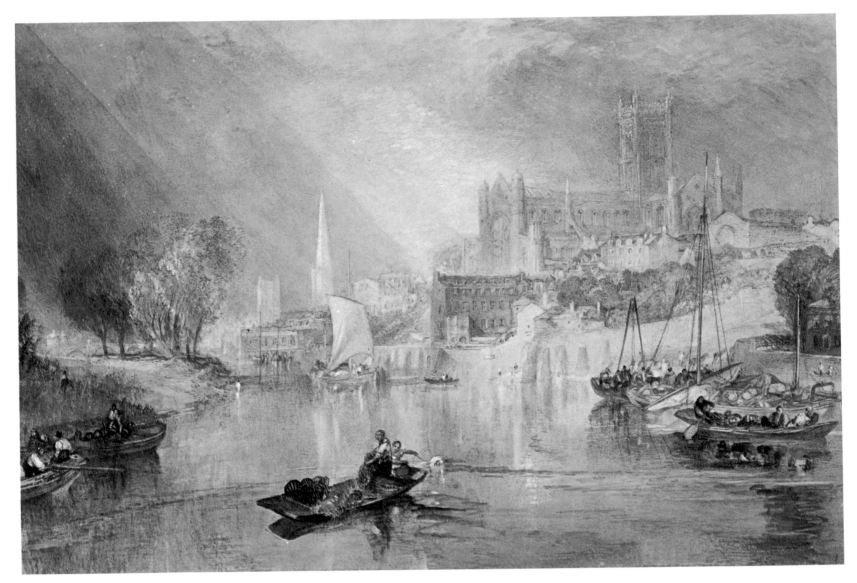

70 WORCESTER, WORCESTERSHIRE British Museum, London

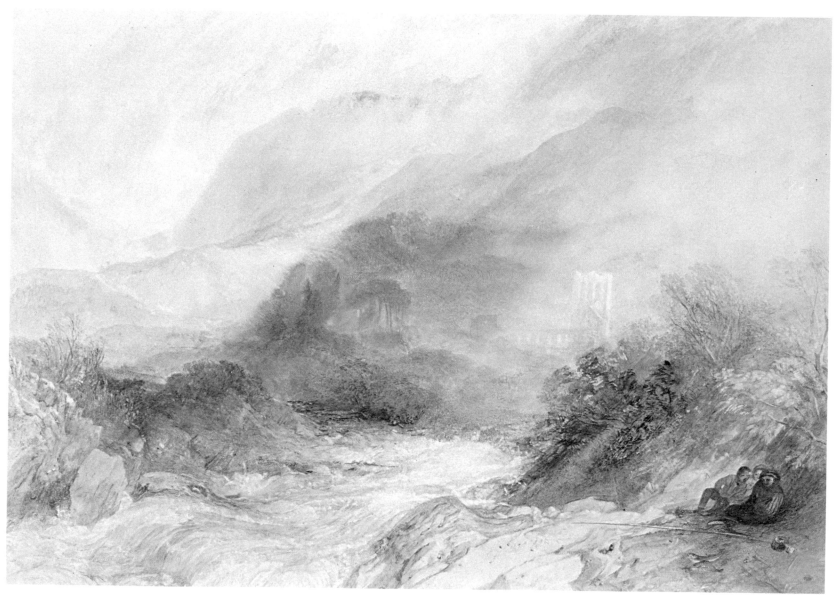

71 LLANTHONY ABBEY, MONMOUTHSHIRE On loan to the Indianapolis Museum of Art from the Pantzer Collection, USA

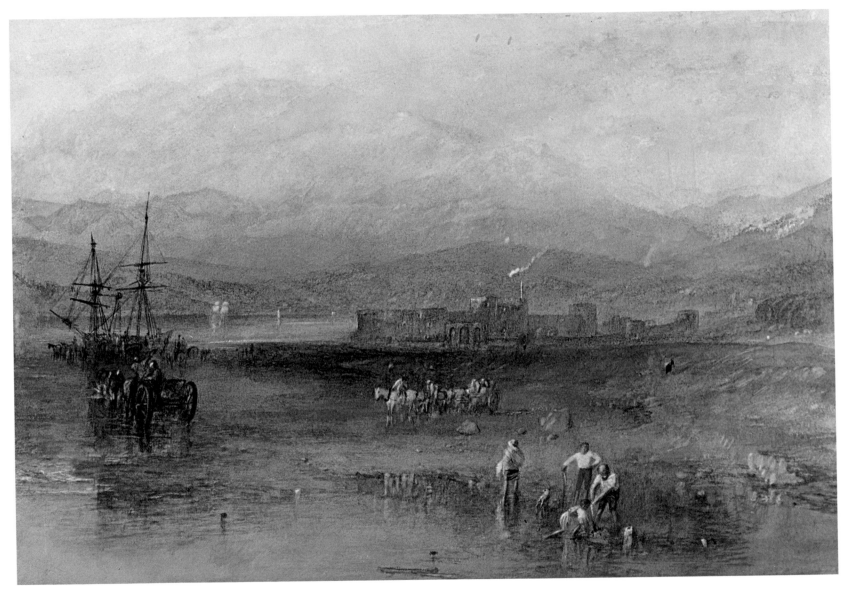

72 BEAUMARIS, ISLE OF ANGLESEA Henry Huntington Museum, San Marino, California, USA

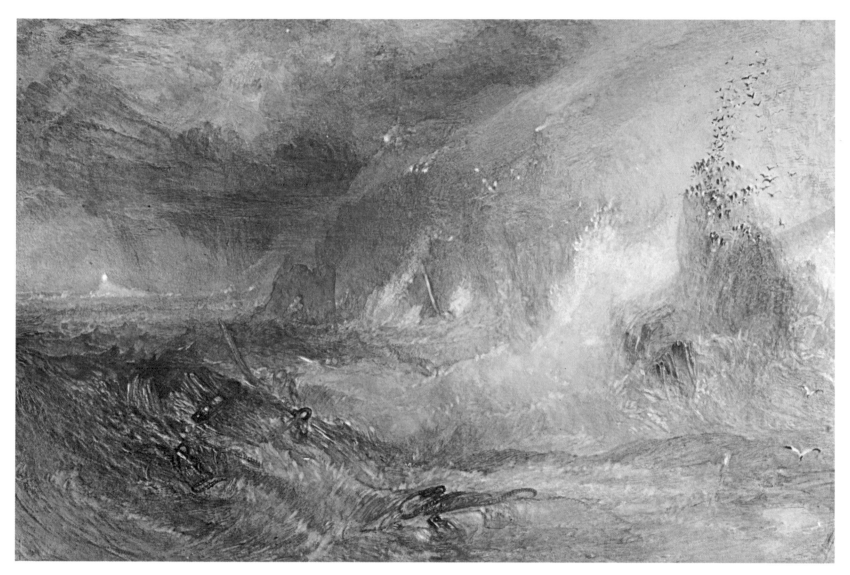

73 LONGSHIPS LIGHTHOUSE, LANDS END Private Collection, UK

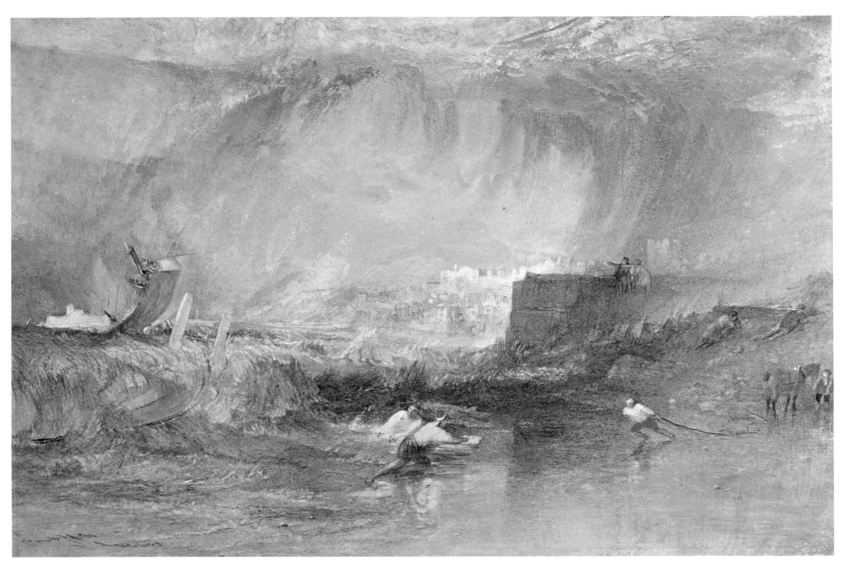

74 LYME REGIS Cincinatti Art Museum, USA

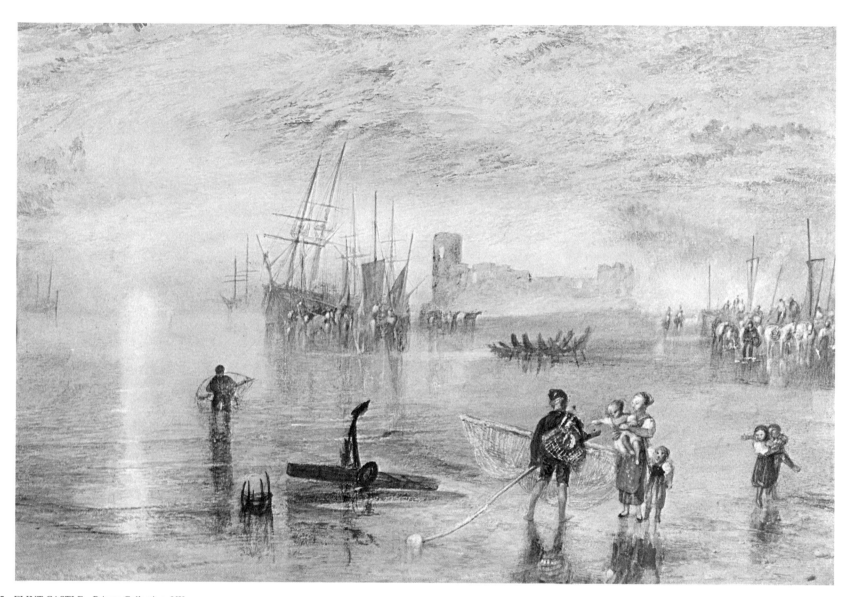

75 FLINT CASTLE Private Collection, UK

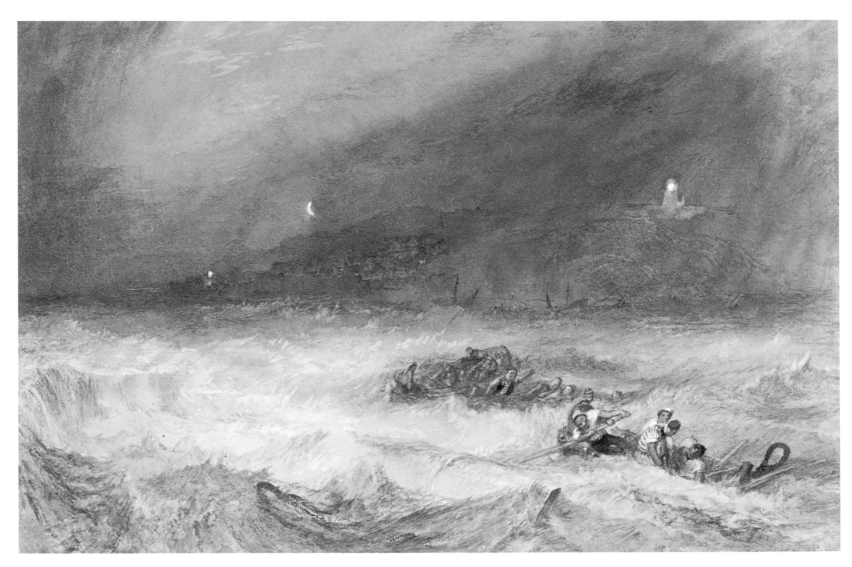

76 LOWESTOFFE, SUFFOLK British Museum, London

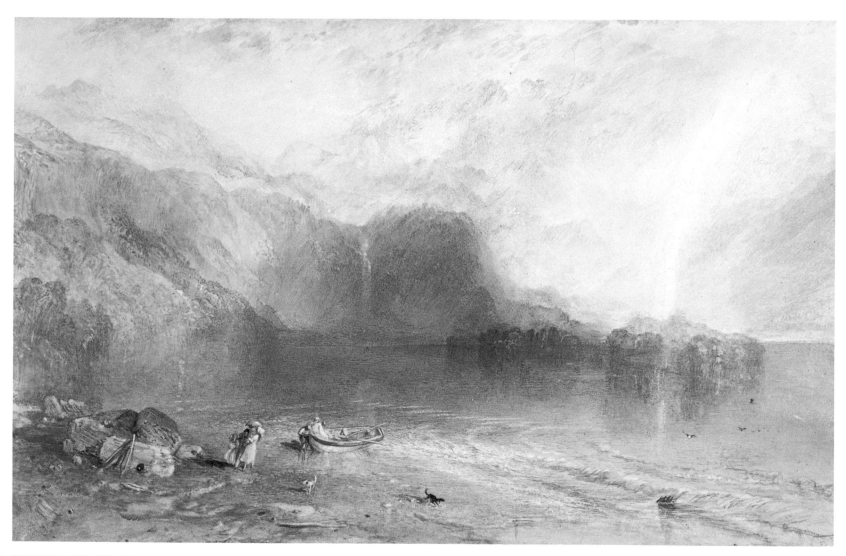

77 KESWICK LAKE, CUMBERLAND British Museum, London

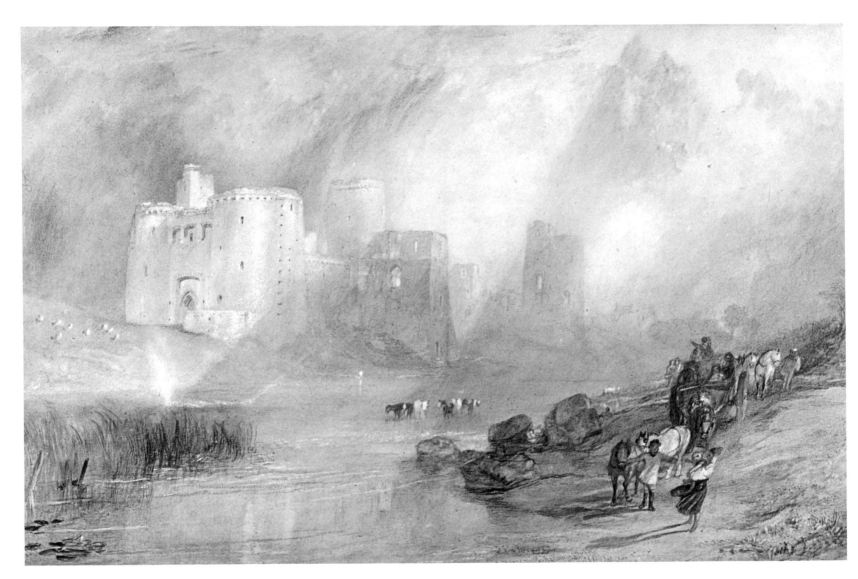

78 KIDWELLY CASTLE, SOUTH WALES Harris Art Gallery, Preston, UK

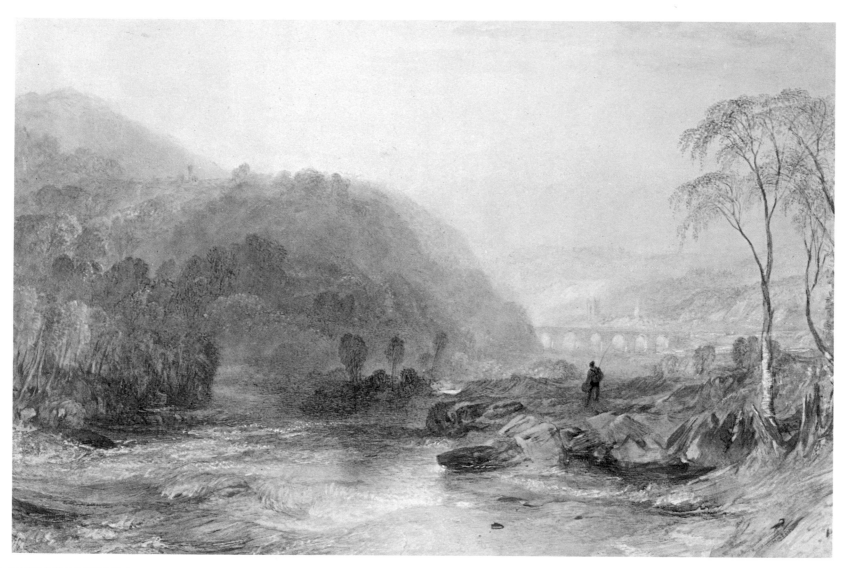

79 LLANGOLLEN, NORTH WALES Private Collection, UK

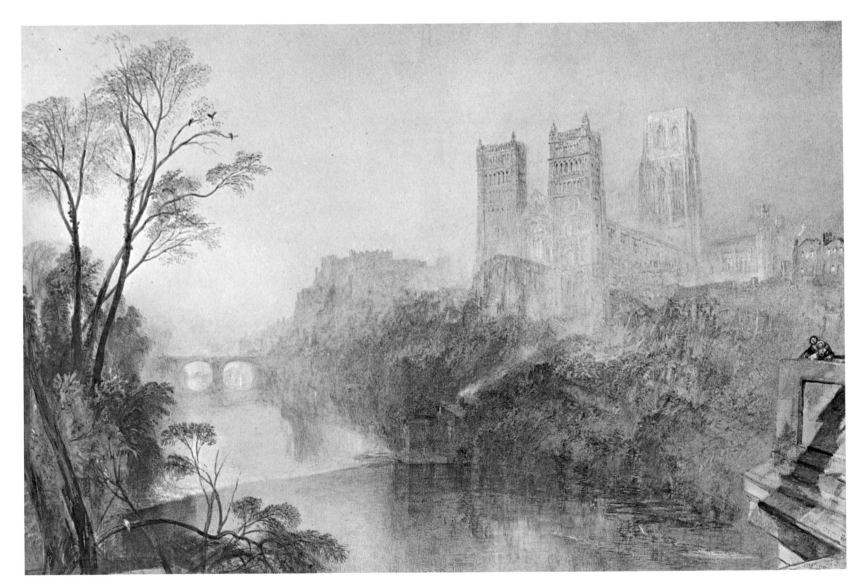

80 DURHAM CATHEDRAL National Gallery of Scotland, Edinburgh

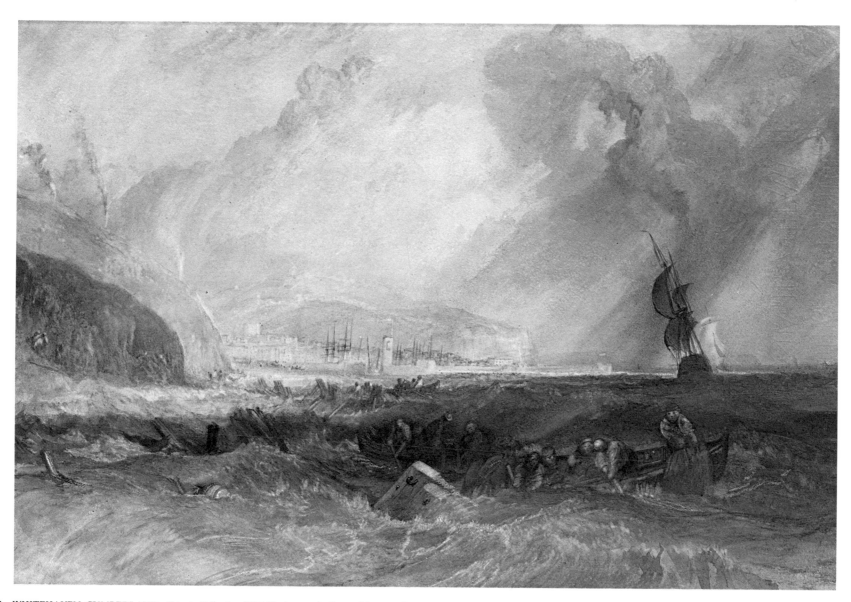

81 WHITEHAVEN, CUMBERLAND Private Collection, USA (On loan to the Boston Museum of Fine Arts)

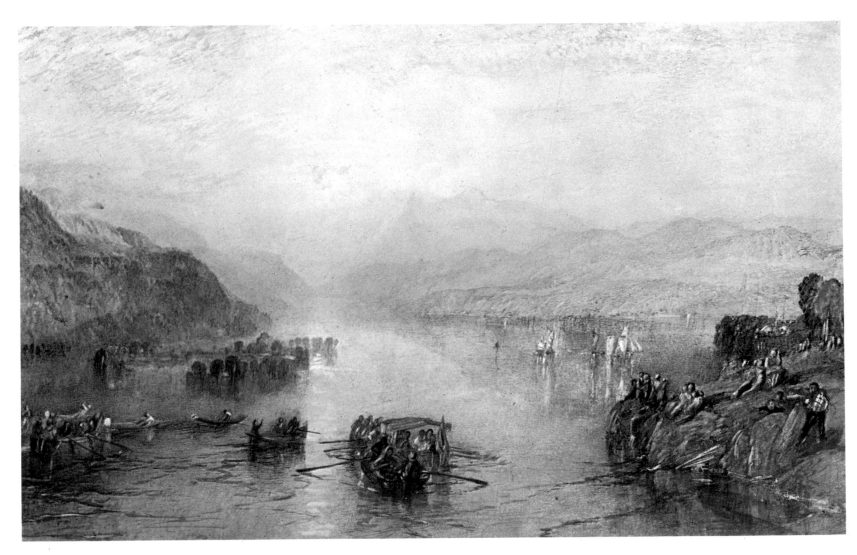

82 WINANDER-MERE, CUMBERLAND City Art Gallery, Manchester, UK

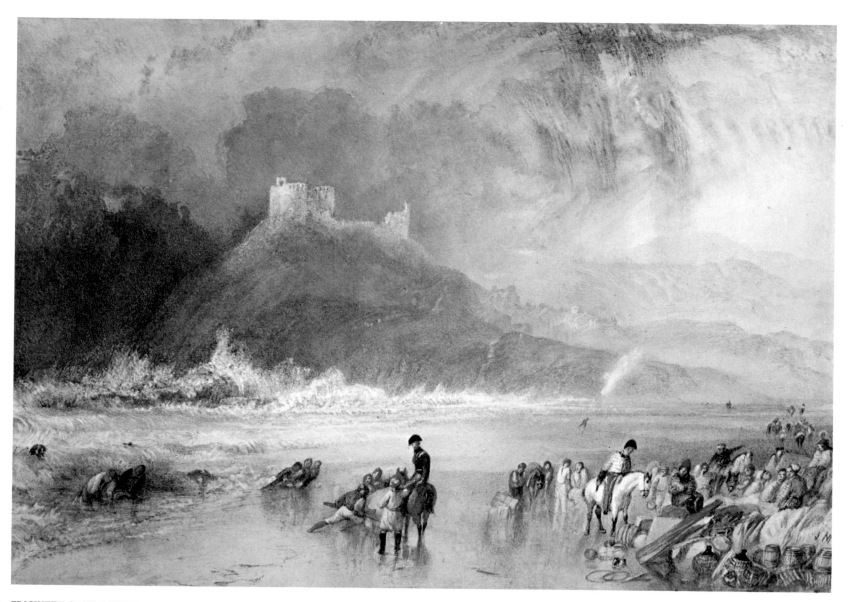

83 CRICKIETH CASTLE, NORTH WALES British Museum, London

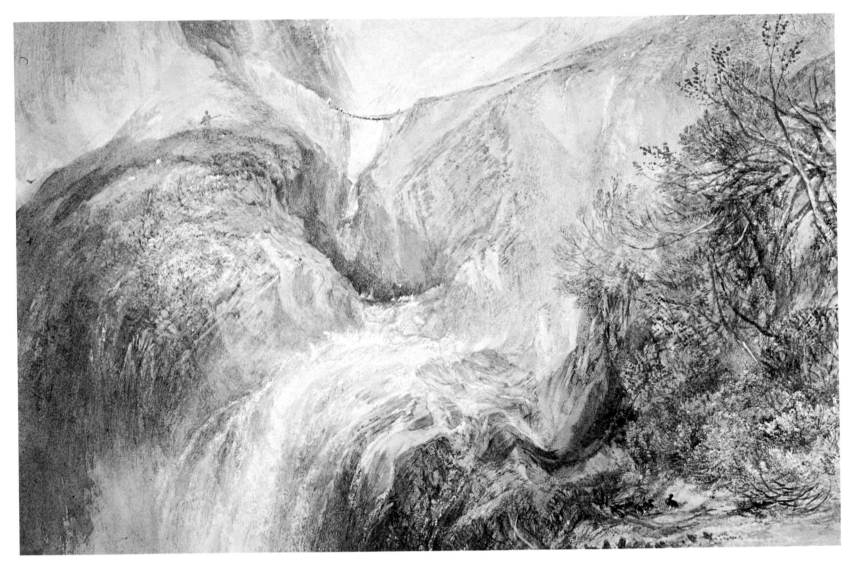

84 CHAIN BRIDGE OVER THE RIVER TEES Private Collection, UK

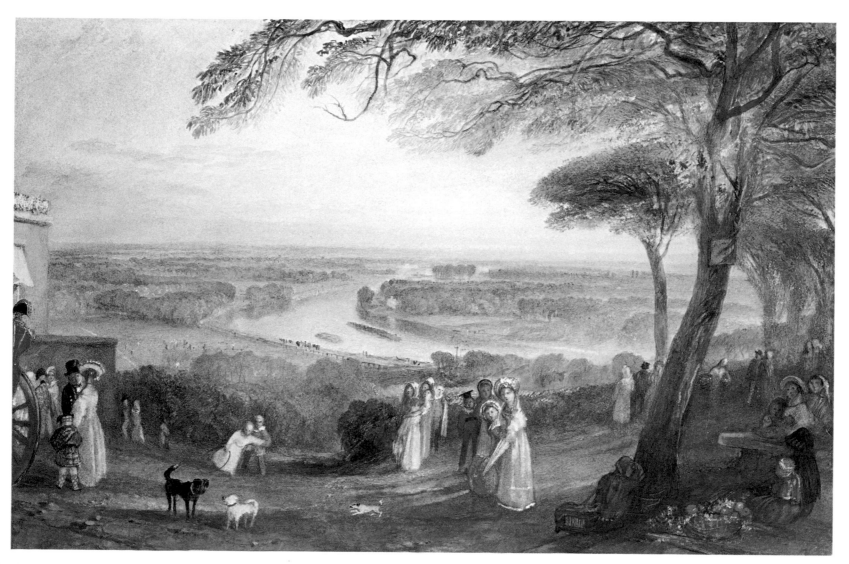

85 RICHMOND TERRACE, SURREY Walker Art Gallery, Liverpool, UK

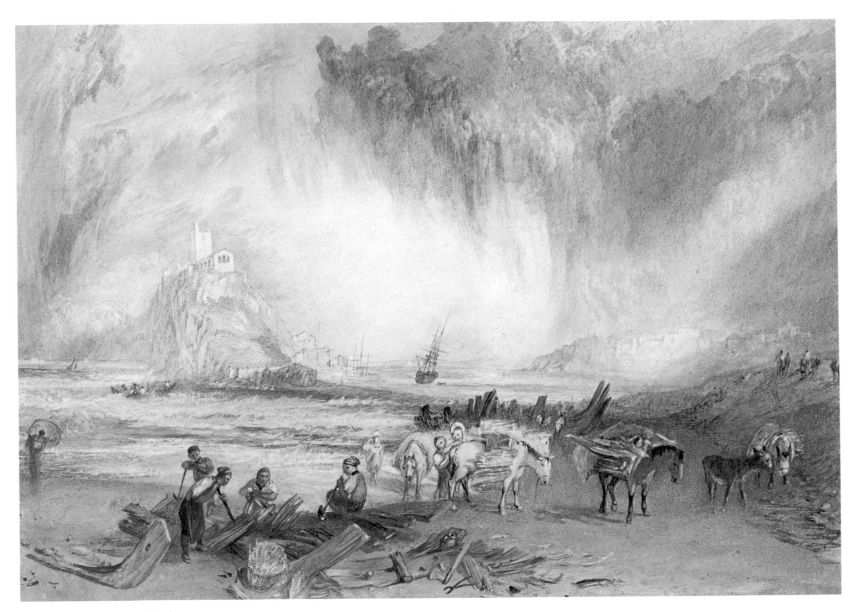

86 MOUNT ST MICHAEL, CORNWALL University of Liverpool, UK

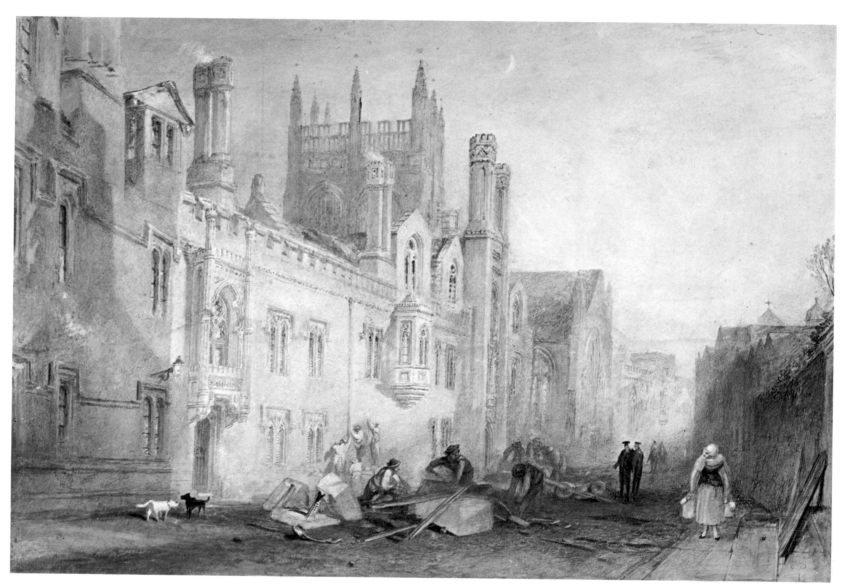

87 MERTON COLLEGE, OXFORD British Museum, London (Turner Bequest)

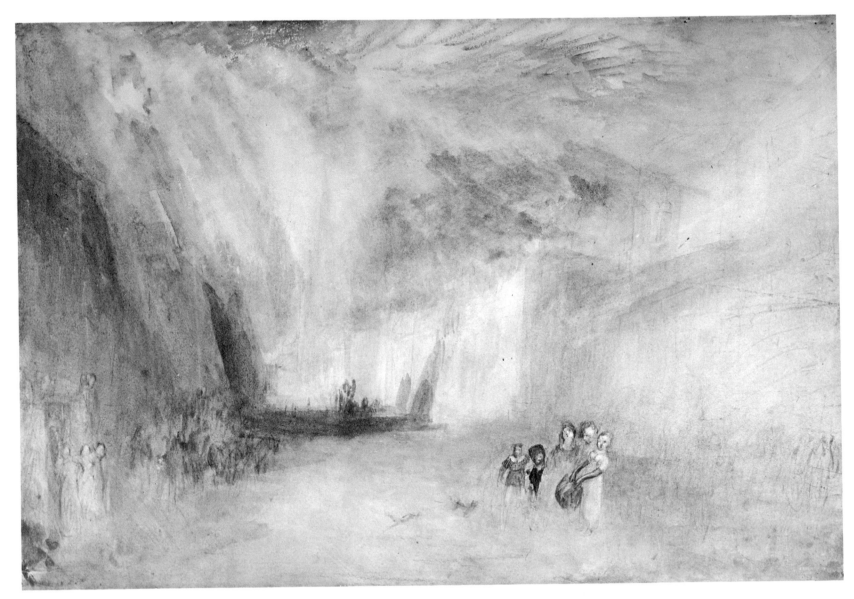

88 THE HIGH STREET, OXFORD British Museum, London (Turner Bequest)

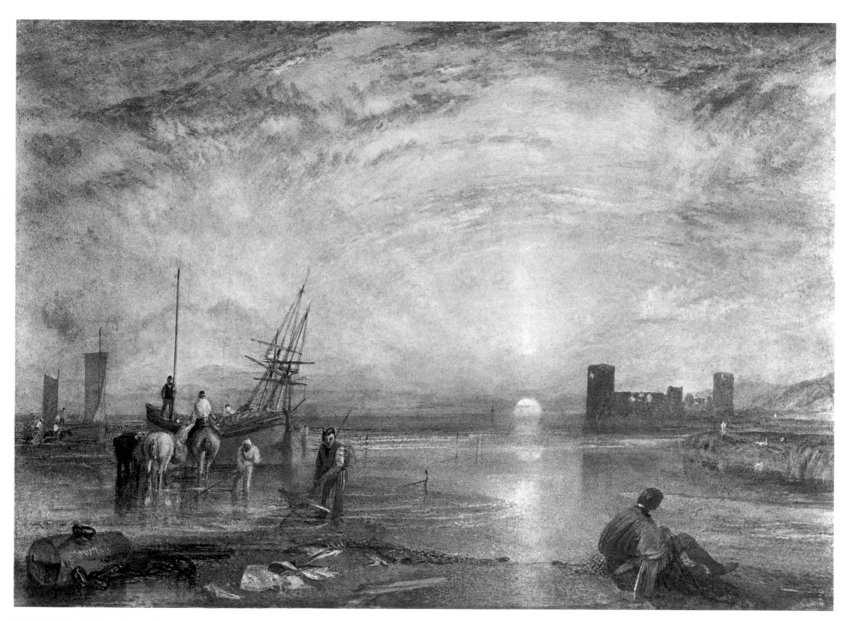

89 FLINT CASTLE Private Collection, Japan

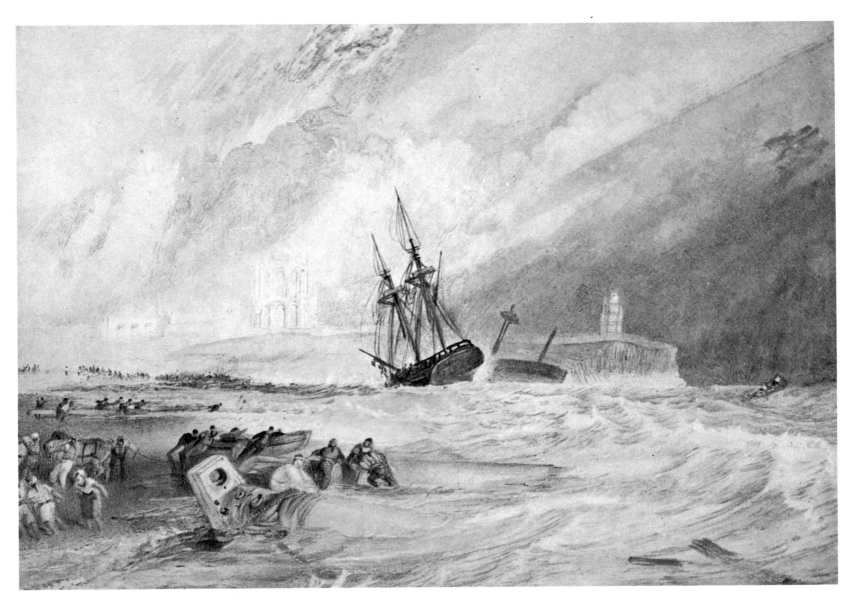

90 TYNEMOUTH, NORTHUMBERLAND Destroyed by fire, 1962

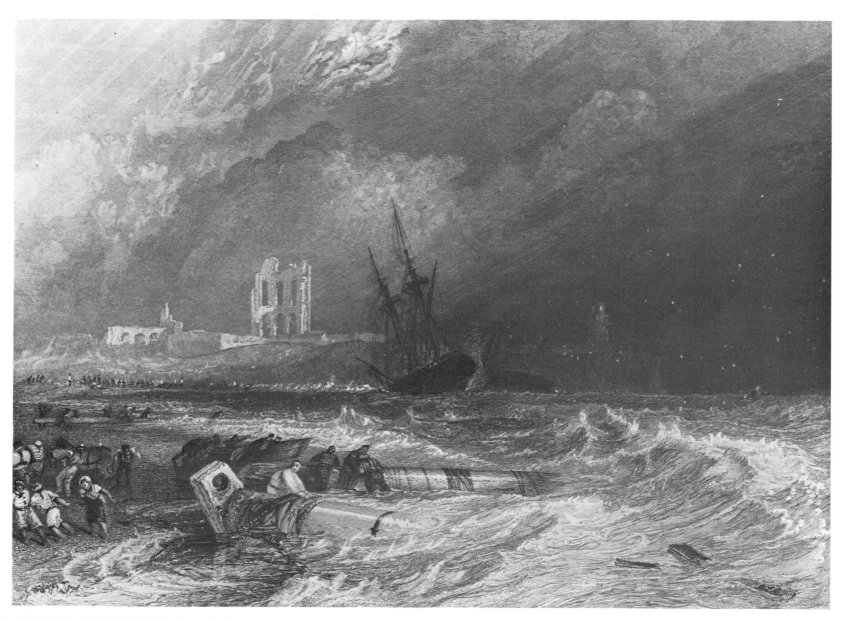

91 TYNEMOUTH, NORTHUMBERLAND British Museum, London

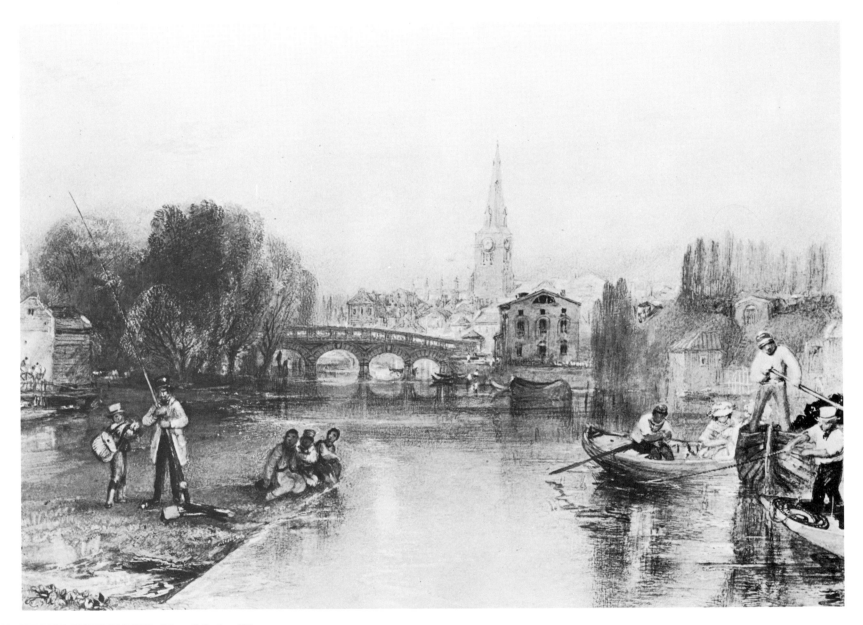

92 BEDFORD, BEDFORDSHIRE Private Collection, UK

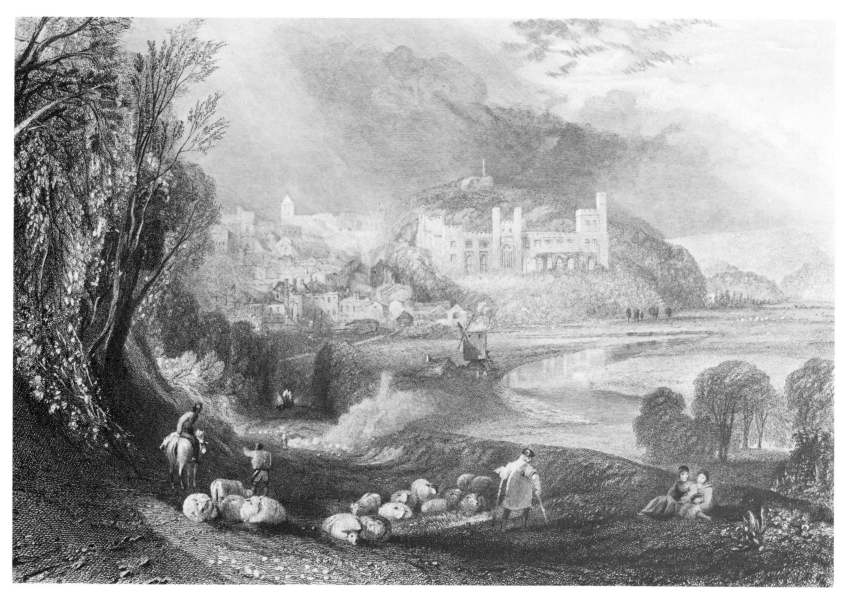

93 ARUNDEL CASTLE AND TOWN, SUSSEX British Museum, London

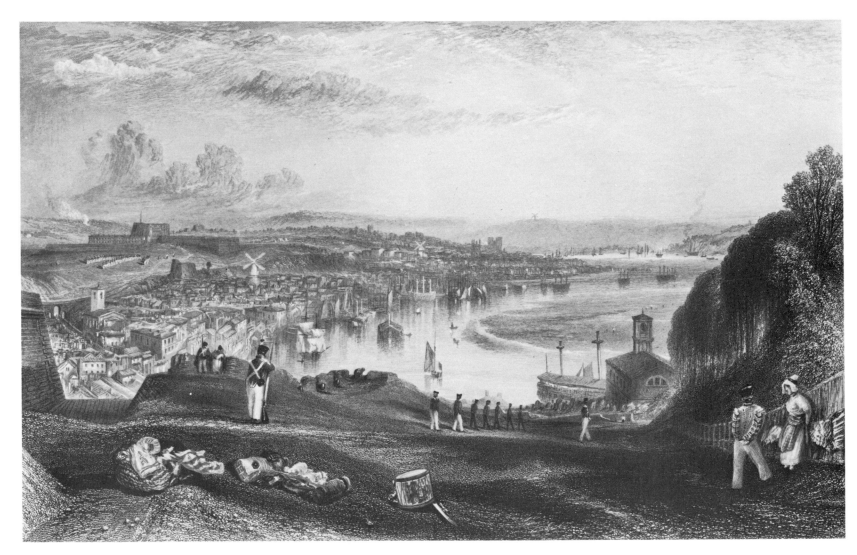

94 CHATHAM, KENT British Museum, London

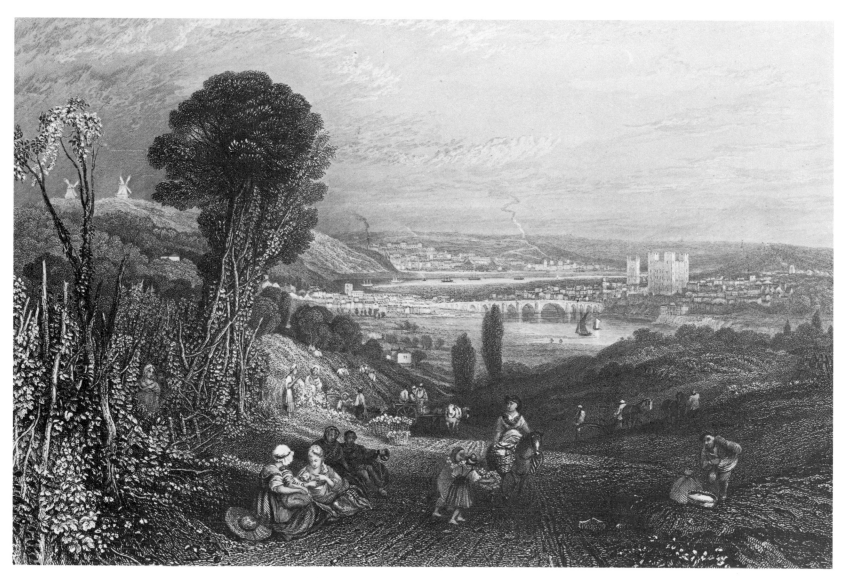

95 ROCHESTER, STROUD AND CHATHAM, MEDWAY British Museum, London

96 ASHBY DE LA ZOUCH Present whereabouts unknown

97 STRAITS OF DOVER British Museum, London

98 TREMATON CASTLE, CORNWALL British Museum, London

99 ST MAWES, CORNWALL British Museum, London

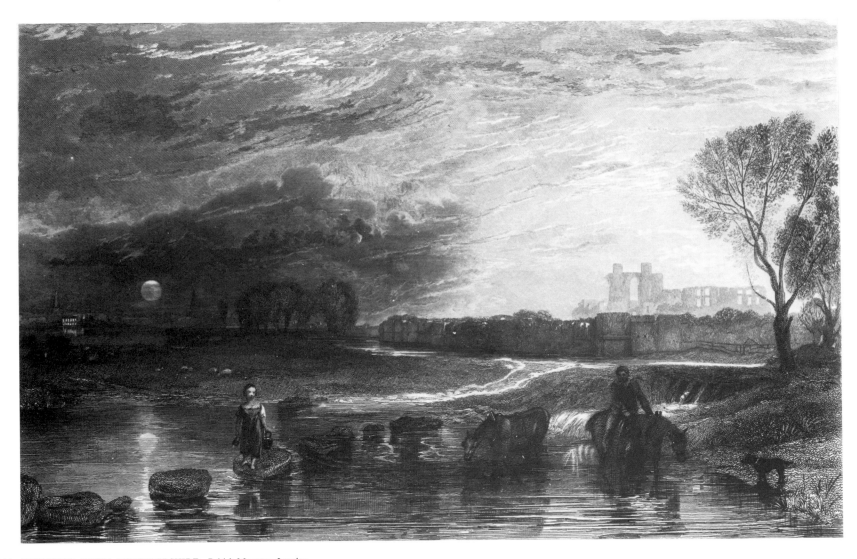

100 LEICESTER ABBEY, LEICESTERSHIRE British Museum, London

101 HARLECH CASTLE, NORTH WALES British Museum, London

102 HAMPTON COURT PALACE British Museum, London

103 LICHFIELD Private Collection, UK

88 THE HIGH STREET, OXFORD

38 × 56cm (15 1/16 × 22in) *c. 1830–5*
TB CCLXIII–362

This large 'colour-beginning' is one of a group of studies that Turner made for a possible 'England and Wales' drawing and its advanced stage affords us a precise insight into his working methods. On the right can be seen a group of children in front of Queens College, on the left what might be building works (Turner's association for Oxford—*see* 62 and 87) and an approaching stagecoach with St Mary's Church beyond. Apparent are the necessarily faint pencil outlines of the architecture and figures; the confident initial colour washes; and the areas and forms which have begun to emerge. Our conditioning to Turner's late works tempts one to see such a loosely defined and glowing picture as a completed work; but it was by no means so for Turner.

The group of studies to which this belongs were worked up from page 1a of the 'Kenilworth Sketchbook' (TB CCXXXVIII) used on Turner's tour of the Midlands in 1830. He had also depicted a very similar view of Oxford High Street in 1810, and when the work was subsequently engraved the figures were etched by Charles Heath.

89 FLINT CASTLE

23 × 33cm (9 1/8 × 12 7/8 in) Signed but not dated

This drawing was *not* made for the series but it provides an excellent opportunity to study Turner's development by comparison with the later drawing of the same subject for the 'England and Wales' series (75). It has never been precisely dated but its configuration and imagery suggest that it was made during the early 1820s.

The 'England and Wales' drawing demonstrates a greater degree of fantasy and an increased technical mastery. The flamboyant sunset is depicted in both works but here it is far more naturalistic and the foreground shrimpers and boatmen are far less fixed within the structural framework.

90 TYNEMOUTH, NORTHUMBERLAND

28 × 41cm (11 × 16in) *c. 1829–30*
Destroyed by fire February 1962

This drawing was reproduced in colour on two occasions: in *The Connoisseur* of November 1930 and in the catalogue of the 1951 Festival of Britain Exhibition of Local Treasures at the Atkinson Art Gallery, Southport. The catalogue colour plate is reproduced here. Naturally something of the original has been lost, but by 1902 Sir Walter Armstrong had already described the work as 'badly faded'.

91 TYNEMOUTH, NORTHUMBERLAND

Engraving size: 15 × 24cm (6 × 9 1/2 in)
Engraved: 1831 by W. R. Smith
(Part XI, No 3)
Rawlinson No 251

An engraving remarkable for its complete pessimism. Everywhere is relentless human activity and of all of Turner's depictions of 'wreckers' this is perhaps the most tragic in its equation of ruin with man's efforts to salvage something from the impersonal violence of nature. The lighthouse has once again failed in its purpose, and on the far right we see a lifeboat presumably going out to another wreck.

Finden's *Ports and Harbours* (1838) relates that 'in consequence of the danger of the entrance to Shields Harbour in stormy weather with the wind from the eastward, more vessels are lost there than at any other harbour in Great Britain'. Indeed, beyond the brig we can see another wreck, and doubtless the local inhabitants profited greatly from their wrecking (which helps explain the extent of the activity here). The composition is powerful and complex: diagonal lines fan out from the bottom right-hand corner, and the central line which runs up to the little sharp wave below the brig connects strongly with the diagonals of darkness descending from the right. In addition, Turner exerts a decisive zigzag motion through the wrecked masts, waves and brig in the centre of the picture, and this implied movement subconsciously evokes both the pattern of lightning and the dynamic motion of the sea. The foreground mast-stump repeats the shape of the distant lighthouse and reverses its light in the darkness of its aperture, an equation that is reinforced by the diagonal that links them.

Rawlinson describes this engraving as 'an impressive plate ... W. R. Smith's engraving is excellent'.[44] The ability of line-engraving to translate Turner's rendering of the sea is well demonstrated and it captures the fearful mood in the blackness of the sky. The use of highlights (e.g., on the ship's mast beyond the brig) gives the work an animation that is essential to its movement and drama. This print reveals how far Turner extended his expressive powers *through* the medium of engraving.

92 BEDFORD, BEDFORDSHIRE

34 × 50cm (13 3/4 × 19 1/2 in) *c. 1830*

A calm and lyrical scene where the colliding boats on the right add a humorous touch of action. The fisherman by the small weir on the left is studied with Turner's customary attention to angling detail. In the distance we see the spire of St Paul's Church with the Swan Inn and the bridge of 1811–13 in front of it. The work is structured by the upward diagonal lines of the weir on the left and the boats on the right, and these run up to the sun in the centre. This view is virtually unchanged today.

93 ARUNDEL CASTLE AND TOWN, SUSSEX *c.* 1830–3

Photograph of original drawing unobtainable.

Original drawing size: 29 × 44cm (11½ × 17½in)
Engraving size: 17 × 24cm (6 9/16 × 9 9/16 in)
Engraved: 1834 by Thomas Jeavons (Part XVIII, No 2) Rawlinson No 278.

Turner produced several drawings of this castle, two of which were subsequently engraved in the 'Rivers of England' series (although one of them was not completed due to failure of the steel). Here we see an infirm shepherd talking to two seated girls; a traveller being directed on his way; a stagecoach approaching in the distance up the Worthing Road; and beyond it the town and castle glistening in the moist light. Jeavons renders both the translucent dampness of the atmosphere and the richness of Turner's foliage with dexterity.

94 CHATHAM, KENT *c.* 1830–1

Photograph of original drawing unobtainable.

Original drawing size: 28 × 45cm (11 × 17⅞in)
Engraving size: 15 × 23cm (5 13/16 × 9¼in)
Engraved: 1832 by W. Miller (Part XIV, No 2) Rawlinson No 262

The view is from the Great Lines above Chatham, probably at Fort Amhurst. On the left is Fort Pitt (now demolished) and on the right at the bottom of the hill the old church of St Mary which was completely altered during the 1880s. In the distance we can see Rochester Cathedral and Castle and are therefore looking *towards* the viewpoint of *Rochester, Stroud and Chatham, Medway* (95).

The picture is a fine panorama of Britain's military in peacetime. The marines at left of centre are apparent in the basis-sketch (*see* Ill. 4) and the washing-basket, bed-roll, drum and sword litter the foreground with characteristic dual

purpose: to fill it with interest and to establish the character of time and place. The rendering of the distance and distribution of foreground shadows is especially fine in the engraving. Miller was one of Turner's 'elect' among engravers, and the depiction of architecture in particular has none of the stilted quality of Varrall's work (cf. 95). Note how the cross-webbing of the marine in the foreground is repeated by the windmill immediately above him; the cross-masts of the shipping on the right that lead the eye up to the tower of St Mary's; and the line of marines being marched down the hill towards the graveyard.

95 ROCHESTER, STROUD AND CHATHAM, MEDWAY, KENT *c.* 1836–7

Original drawing destroyed by fire in 1955

Original drawing size: 29 × 44cm (11¼ × 17¼in)
Engraving size: 24 × 16cm (9 7/16 × 6¼in)
Engraved: 1838 by J. C. Varrall (Part XXIV, No I) Rawlinson No 301

The view looks towards Strood on the left, Rochester with its cathedral and castle on the right and Chatham in the distance where one can see the Great Lines, Brompton Barracks and the ship-building sheds by the Medway. This growing conurbation is framed by a landscape full of activity, with labourers processing hops, a sower preparing his grain for 'casting' and beyond him men ploughing. The general foreground fecundity (as in the drawing of *Ludlow Castle*—37) is reflected by a mother suckling her child as children on the left watch her surreptitiously.

The depiction of Rochester and Strood is rather hard and stilted in the engraving, and one wonders how accurately it conveyed Turner's original handling of this passage. Note especially the line of smoke extending the zigzag of the Lines above Chatham: they not only display Turner's understanding of differentiated 'layers' of air-flow but also denote the approximate topographical viewpoint of the *Chatham* (94).

96 ASHBY DE LA ZOUCH, LEICESTERSHIRE

Present whereabouts unknown

30 × 44cm (11¾ × 17¼in) *c.* 1830–1

This drawing was sold in 1907 to a 'J. B. Phipps' by Messrs Thomas Agnew and Sons Ltd, but it has since disappeared. The photograph seen here is reproduced from Sir Walter Armstrong's book on Turner, published in 1902 (p. 106). Rawlinson wrote of this work in 1908 that 'The drawing is still very beautiful, although the sky has faded badly. The effect of the long rays of the setting sun breaking through the trees on the right is finely rendered.'[45] The drawing was based upon sketches in the 1830 'Kenilworth' sketchbook (*see* Concordance) and their number suggest that Turner went to great lengths to find a view of the scene that sparked his imagination.

97 STRAITS OF DOVER

Present whereabouts unknown *c.* 1825–7

Original drawing size unknown
Engraving size: 18 × 25cm (6 15/16 × 10in)
Engraved: 1828, by W. Miller (Part IV, No I) Rawlinson No 221

The original drawing for this engraving was last known to belong to Mr Edward Nettlefold but it was sold after his death in 1909 and has since disappeared.

Of the engraving Rawlinson says: 'This is one of the finest seas in the "England and Wales"; it is superbly engraved by Miller. The sky also, full of wind, light and cloud, is admirably rendered. And the whole scene is so *English*, so exactly what one sees on landing at Dover on a sunny, windy day'.[46] The small boat on the extreme right was added to the engraving on Turner's instructions. The view shows South Foreland lighthouse on the right and Dover Castle in the dip of the line of cliffs at the left

centre. The composition is subtly structured: the downward diagonal of the cliffs meets the upward diagonal of shadow upon the sea, and the upward line of cliff beyond the castle is repeated by the line of light descending diagonally from the clouds above it. These basic lines are constantly paralleled, and the particular ability of etched-line to render the flow of water is superbly demonstrated.

98 TREMATON CASTLE, CORNWALL

Present whereabouts unknown c. 1825–8

Original drawing size: 28 × 41cm (11 × 16in)
Engraving size: 24 × 17cm (9$\frac{3}{8}$ × 6$\frac{1}{2}$in)
Engraved: 1830 by R. Wallis (Part X, No 2)
Rawlinson No 246

The original drawing for this engraving was last seen publicly when it was auctioned at Fosters on 13 May, 1857 where it was sold to a 'James Mason, Esq' for £217 5s. The engraving displays a rich variety of tonal differentiations and these are most evident in the complexity of plants and grasses on the left and the beach in the right foreground. The solitary figure balances both halves of the picture and enhances the overall mood of serenity. The work is structured by a series of circular movements that take their cue from the shape of the castle, and its outline is exactly repeated by that of the girl's hat.

99 ST MAWES, CORNWALL

Present whereabouts unknown 1825–9

Original drawing size: 30 × 42cm (12 × 16$\frac{1}{2}$in)
Engraving size: 16 × 24cm (6$\frac{7}{16}$ × 9$\frac{3}{8}$in)
Engraved: 1830 by J. H. Kernot (Part X, No 3)
Rawlinson No 247

The drawing for this engraving was last known to belong to Senator William Andrews Clarke in 1908. Upon his death in 1926 he left the bulk of his collection to the Corcoran Museum in Washington

D.C., but the drawing was not listed in his will.

The view shows the east side of Falmouth Harbour with St Mawes Castle on the right and Pendennis Castle in the distance across Falmouth Bay. Turner was very fond of this scene and had used it for an oil-painting exhibited at the Royal Academy in 1812 (Tate Gallery, London, No 484). He also drew it in watercolour for subsequent engraving in the 'Southern Coast' series where it was published in September 1824. All three compositions are similar in their depiction of pilchard sorting.

100 LEICESTER ABBEY, LEICESTERSHIRE

Present whereabouts unknown c. 1830–2

Original Drawing size: 29 × 46cm (11$\frac{5}{8}$ × 18in)
Engraving size: 15 × 24cm (5$\frac{13}{16}$ × 9$\frac{5}{16}$in)
Engraved: 1834 by W. R. Smith (Part XVIII, No 4)
Rawlinson No 280.

The drawing was last known to be in the collection of John Ruskin. It has since vanished. This landscape gave Ruskin some difficulty. He attempted to explain its immediate juxtaposition of a sunset and a moonrise as: 'not meant to be actually contemporaneous. Strictly this is . . . two pictures in one; and we are expected to think of the whole as a moving diorama.'[47] This is a very unconvincing explanation. The sky (and indeed the whole work) may be a metaphor on Turner's part for the crossing-over from life to death, represented by the girl on the stepping stones in the foreground. This interpretation is supported by an entry, possibly suggested by Turner, in the letterpress issued with the engraving:

> The abbey is especially noted as the place where Cardinal Wolsey died . . . stripped of his dignities and wealth and humiliated by his Royal Master Henry VIII who had before heaped on him riches, power and honour equal to the greatest prince. He was so weak and depressed

when he reached the gate leading to the abbey that he could only thank the abbot and monks for their kindness and tell them that he was to lay his bones among them, in which he proved a true prophet, for he immediately took to his bed and died three days later.

101 HARLECH CASTLE, NORTH WALES

Present whereabouts unknown c. 1834–5

Original drawing size: 36 × 48cm (14 × 19in)
Engraving size: 16 × 24cm (6$\frac{3}{8}$ × 9$\frac{9}{16}$in)
Engraved: 1836 by W. R. Smith (Part XXI, No 3)
Rawlinson No. 291

The original drawing of this engraving was last known to belong to George W. Vanderbilt of Ashville, North Carolina who died in 1914. It has since disappeared.

The ruined castle presents an image of decay. Turner has increased the number of mean-looking houses from the original sketch (*see* Concordance) and both castle and town contrast with the magnificent panorama beyond. This pessimistic conjunction between bedraggled human poverty and the beauty of nature is further expressed by the figures. A girl with a baby has climbed the hill with a kettle to fill it at a water-trough. She is followed by an old woman whose effort to climb the steep hillside is clearly expressed. Her juxtaposition with the children and the dead bird in her hand intensifies the picture's sad mood.

102 HAMPTON COURT PALACE

Present whereabouts unknown c. 1825–8

Original drawing size unknown
Engraving size: 16 × 23cm (6$\frac{7}{16}$ × 9$\frac{1}{6}$in)
Engraved: 1829 by C. Westwood (Part VII, No 4)
Rawlinson No 236

The original drawing was last seen publicly at

Christie's on 14 May, 1859 when it was offered for auction (No 44) by Edward Rodgett. It was bought by 'Dixon' and is now untraced.

As with the other 'Thames' subjects in this series Turner depicts a sunlit summer's day. Note the crown-like remains of a basket on the left and the stately procession of ducks. The feathers and pebbles on the left are not included in the drawing, having been scratched in by Turner at proof stage. The sky is tonally rich and the shafts of light and reflections on the river are adroitly handled. In *Modern Painters* Ruskin cites the original drawing as one of the best examples of Turner's drawing of shadows.

103 LICHFIELD

29 × 44cm (11¼ × 17¼in) *c. 1834–8*

This drawing is another whose size and complexity suggest that it was made for subsequent inclusion in this series. Unfortunately the work is in poor condition, having faded and yellowed, and this deterioration has been compounded by retouching. However, in black-and-white the work's formal quality remains apparent.

Turner uses a theme similar to the *Salisbury*: the contrast between the rock-like stability of the cathedral and the tangible movement of the world around it. The weather is described with accuracy, the strong wind signified by blowing washing and approaching children leaning against it.

The architectural detail is very rich and delicate, and the reflections on the water, the fall of light from the left and the rainbow's appearance across the dark storm remain effective. This scene is virtually unchanged today.

CONCORDANCE OF WATERCOLOURS TO THEIR ORIGINAL SKETCHES

This correlates the drawings in the series with the original sketches upon which they were based. The Roman numeral, title and date below is that assigned to each sketchbook by A. J. Finberg in his 1909 inventory of the Turner Bequest. Below this is listed across the page (from left to right) the number of the reproduction of the final work in this book; the drawing's title; the corresponding sketch (or group of sketches) in the sketchbook to which the drawing can confidently be assigned; and finally the probable date of the earliest subsequent watercolour made from a sketch in the book (which might also suggest a similar dating for other drawings made from sketches in the same book if they were made in series).

Plate		Sketchbook Page	

XXIV 'Isle of Wight' 1795

24	*Salisbury*	14b	1829
29	*Carisbrook Castle*	25a	

XXVI 'South Wales' 1795

78	*Kidwelly Castle*	16	1832
57	*Laugharne Castle*	19	
60	*Carew Castle*	25	

XXXIV 'North of England' 1797

8	*Barnard Castle*	29	1825–6
90–91	*Tynemouth Priory*	35	
32	*Alnwick*	44	
28	*Dunstanborough*	45	
33	*Holy Island*	51	
18	*Louth*	79a–80	
67	*Boston*	81a–82	
31	*Stamford*	86	

XXXV 'Tweed and Lakes' 1797

77	*Keswick Lake*	19	
68	*Ullswater*	42	1834
82	*Winander-mere*	52,54,55,56 (synthesis)	

XXXVIII 'Hereford Court' circa 1798

20	*Malmsbury Abbey*	1

101	*Harlech Castle*	42a	
79	*Llangollen*	57	
69	*Powis Castle*	61	
37	*Ludlow Castle*	63	
64	*Llanberris*	86 (also XXXIX 'North Wales')	
21	*Kilgarren*	88	1828
65	*Caernarvon Castle*	89,93,94 (synthesis) (also 1798 watercolour XLIV-Y)	

XXXIX 'North Wales' circa 1798

83	*Crickieth*	23–25 (not much similarity)	
64	*Llanberris*	33,44,115,116,117	1833

XLV 'Lancashire and North Wales' circa 1797

35	*Stoneyhurst College*	42	spring 1829

XLVI 'Dolbadarn' circa 1799

61	*Penmaen-mawr*	90a,91 (very slight)	1833

CIII 'Tabley No 1' 1808

14	*Valle Crucis Abbey*	13	1825–7

CXXIII 'Devonshire Coast No 1' circa 1811

74	*Lyme Regis*	36,39,41 (very slight)	
99	*St Mawes*	133 (very slight)	1829

CXXV 'Ivy Bridge to Penzance' circa 1811

46	*Plymouth*	9,10,11,12 (synthesis)	
88	*Fowey*	18a–19	
86	*Mount St Michael*	42a–43	1828

ADD CXXVA 'Cornwall and Devon' circa 1811

73	*Longships Lighthouse*	27	1835

CXXXI 'Plymouth, Hamoaze' 1812–13

98	Trematon	43	1829
46	Plymouth	90 (?)	

CXXXIII 'Devon Rivers No 2' 1813

1	Saltash	26	1825
4	Dartmouth Cove	53a–54 (?)	

CXXXIV 'Devonshire Rivers No 3' and 'Wharfedale' 1812–15

These were originally two separate sketchbooks, mixed up by Ruskin and not now in their original order.

17	Okehampton	24	
15	Buckfastleigh Abbey	57	
9	Launceston	72	
5	Bolton Abbey	81a–82	1825

CXL 'Hastings to Margate' 1815–16

40	Windsor Castle	9a,10a,12,12a, 13,31a,82, 82a,83 (see also CCXXV)	
41	Eton College	14a–15	
44	Richmond Hill	19, 19a, 20	1828–9
38	Folkestone	35a (see also CXCVIII)	
36	Walton Bridge	45	
34	Winchelsea	58a–59	
85	Richmond Terrace	70a–78a	
45	Richmond Hill	(see also CCXII)	

CXLIV 'Yorkshire No. 1' 1815–16

19	Knaresborough	56a	

CXLVIII 'Yorkshire No 5' 1816

84	Chain Bridge/Tees	6a	
7	Fall of the Tees	7a	
23	Richmond, Yorks	11a–12	
10	Richmond Castle, Yorks	13a–14	
16	Lancaster Sands	33a–34 ?	
3	Lancaster/Aqueduct	35, 35a	1825–6

CLVII 'Durham North Shore' 1817

11	Prudhoe Castle	78–77a 1825–6	

CXCVIII 'Folkestone' circa 1821

95	Rochester, Stroud, Chatham	6a–7	
38	Folkestone	30a,31,32 (see also CXL)	
97	Straits of Dover	33	1825–7

CCIX 'Norfolk, Suffolk and Essex' 1824

6	Colchester	4a–7,61,62,71 1825–6	
26	Yarmouth	11,12,29,32 34,34a	
76	Lowestoffe	35a–36a	
12	Aldborough	57a–59	
13	Orford	86a	

CCXII 'Thames' c. 1825

85	Richmond Terrace/Hill	5a,6,6a,9a, 82,88,88a	

CCXXV 'Windsor and St Anne's Hill' circa 1827

40	Windsor	1,2,2a,3	1827–9

CCXXVI 'Windsor and Cowes' circa 1827

40	Windsor	2,2a,3	1827–9
30	Cowes	40a	

CCXXVII 'Isle of Wight' circa 1827

102	Hampton Court	1a,2a,3,39a	1827–9

CCXXXVIII 'Kenilworth' 1830

(This sketchbook had also been used around 1827 for sketches of Virginia Water but Turner re-utilized it for his 1830 Midlands tour.)

62	Christ Church, Oxford	1	1830
88	High Street, Oxford	1a	
52	Blenheim	11a–12	
100	Leicester Abbey	20	
51	Kenilworth	28a–37a (synthesis)	
50	Warwick Castle	30a–39,40	
96	Ashby-de-la-Zouch	45a,46,47,50, inside back cover	
103	Lichfield	50a	
55	Tamworth	51c,52,55	
66	Dudley	60–68	

CCXXXIX 'Worcester, Shrewsbury, Bridgenorth and Peak 1830'

70	Worcester	80–82a	1830

CCXL 'Birmingham and Coventry' 1830

58	Coventry	11a,13a–14, 16,16a,25a–26, 26a–27	
53	Northampton	16a–17, 17a–18	
66	Dudley	40a–50	

CCXLV 'Arundel and Shoreham' circa 1830

93	Arundel	60a–61	

CCLXXIX 'Gravesend and Margate' circa 1832

47	Margate	7,9a,26,26a 27,31a,32	1830–1
94	Chatham	42,44,45, 45a,46	

CCLXXXV 'Oxford' 1834

87	Merton College	23a	

CCLXIII 'Colour Beginnings' 1820–30

(These are rough colour sketches which may have been used as 'workings-out' for the final drawings.)

103	Lichfield	93	
80	Durham	125	
21	Kilgarren	148	
55	Tamworth	184	
83	Crickieth	220	
8	Barnard Castle	323 (very definitely)	
52	Blenheim	365 (very definitely)	

CCCLXIV 'Miscellaneous' after circa 1830

80	Durham	406 (very definitely)	

Other Sketches

49 Brinkburn Priory

(This drawing was based upon a sketch now in the Fogg Art Museum, Harvard University (No 1907.12). This is probably a leaf from the smaller 'Fonthill' sketchbook (XLVIII) circa 1800–1)

EXHIBITIONS

The following are the drawings from this series that were exhibited in Turner's lifetime with their original catalogue numbers (and the names of the lenders to the 1833 exhibition). The drawings lent by Charles Heath to that exhibition were presumably being engraved at the time.

June 1829, Egyptian Hall, Piccadilly
1 Salisbury, from Old Sarum Intrenchment
2 Eton College
3 Knaresborough
5 Orford
6 Malmsbury Abbey
7 Fowey Harbour
8 Lancaster Sands
10 Okehampton Castle
11 Buckfastleigh Abbey
12 Kilgarren Castle
13 Hampton Court Palace
14 Coast from Folkestone Harbour to Dover
15 Trematon (listed as 'Tamerton')
16 Louth, Lincolnshire
17 Saltash
18 Straits of Dover
19 Stoneyhurst College
20 Launceston
22 Walton Bridge
23 Plymouth Cove
24 Dartmouth Cove, with Sailor's Wedding
25 Dunstanborough Castle, Northumberland
26 Windsor Castle
27 Richmond Hill and Bridge with a Pic-nic Party
28 Stonehenge
29 Richmond [Castle], Yorkshire
30 Richmond, Yorkshire
31 Alnwick Castle, Northumberland
33 Exeter
34 Colchester
35 Yarmouth
37 Stamford
38 Valle Crucis Abbey, Wales
39 Holy Island Cathedral
41 Dock Yard, Devonport, Ships being Paid off.

Autumn 1829, Birmingham Society of Artists
388 Colchester, Essex
424 Richmond, Yorkshire
356 Entrance to Fowey Harbour, Cornwall
345 Kilgarren Castle
377 Stonehenge, Wiltshire

June–July 1833, Moon, Boys and Graves Gallery, No. 6, Pall Mall
1 Hampton Court Palace (T. Griffith)
2 Entrance to Fowey Harbour, Cornwall (G. Windus)
3 Stamford, Lincolnshire (T. Griffith)
4 Richmond Castle and Town, Yorkshire (G. Windus)
5 Pembroke Castle, Pembrokeshire (T. Griffith)
6 Valle Crucis Abbey (T. Griffith)
7 Devonport and Dockyard, Devonshire (T. Griffith)
8 Warwick Castle, Warwickshire (T. Griffith)
9 Buckfastleigh Abbey, Devonshire (G. Windus)
10 Walton Bridge, Surrey (T. Griffith)
11 The City of Exeter, Devonshire (G. Windus)
12 Okehampton (or 'Oakhampton') Devonshire (T. Griffith)
13 Plymouth (looking towards the Sound) – Devon (T. Griffith)
14 Malvern Abbey and Gate, Worcestershire (G. Windus)
15 Richmond (distant view), Yorkshire (G. Windus)
16 Tamworth Castle, Warwickshire (G. Windus)
17 Tynemouth Priory, Northumberland (T. Griffith)
18 Richmond Hill and Bridge, Surrey (T. Griffith)
19 Great Yarmouth, Norfolk (G. Windus)
20 Carisbrook Castle, Isle of Wight (G. Windus)
21 Orford, Suffolk (T. Griffith)
22 Kenilworth Castle, Warwickshire (T. Griffith)
23 Margate, Isle of Thanet, Kent (T. Griffith)
24 Launceston, Cornwall (J. H. Maw)
25 Eton College, Berkshire (T. Griffith)
26 Winchelsea, Sussex (T. Griffith)
27 Ashby-de-la-Zouch, Leicestershire (T. Griffith)
28 Kilgarren Castle, Pembrokeshire (T. Griffith)
29 St Catherine's Hill, Near Guildford, Surrey (T. Griffith)
30 Gosport (Entrance to Portsmouth Harbour) Hants (T. Griffith)
31 Alnwick Castle, Northumberland (T. Griffith)
32 Salisbury, Wiltshire (G. Windus))
33 Ludlow Castle, Shropshire (T. Griffith)
34 Trematon Castle, Cornwall (T. Griffith)
35 Louth, Lincolnshire (T. Griffith)
36 Holy Island, Northumberland (G. Windus)
37 Stonyhurst, Lancashire (G. Windus)
38 Folkestone, Kent (T. Griffith)
39 West Cowes, Isle of Wight (T. Tomkinson)
40 Malmsbury Abbey, Wiltshire (T. Tomkinson)
41 Dunstanborough Castle, Northumberland (T. Tomkinson)
42 Lancaster Sands, Lancaster (T. Tomkinson)
43 Windsor Castle, Berkshire (T. Tomkinson)
44 Dartmouth Cove, Devonshire (G. Windus)
45 Knaresborough, Yorkshire (Rev. E. Coleridge)
46 Brinkburn Priory, Northumberland (G. Windus)
47 Chatham, Kent (T. Griffith)
48 Saltash, Cornwall (G. Windus)
49 Langharne, or Talacharne Castle, Caermarthenshire (T. Griffith)
50 Upnor Castle, Kent (T. Griffith)
51 Blenheim House and Park, Oxfordshire (T. Griffith)
52 Bedford, Bedfordshire (J. H. Maw)
53 Ely Cathedral, Cambridgeshire (T. Griffith)
54 The Straits of Dover, Kent (G. Windus)
55 Northampton, Northamptonshire (C. Heath)
56 Colchester, Essex (J. H. Maw)
57 Penmaen-mawr, Caernarvonshire (C. Heath)
58 Stonehenge, Wiltshire (S. Rogers)
59 Carew Castle, Pembrokeshire (C. Heath)
60 Nottingham, Nottinghamshire (C .Heath)
61 Christ-Church, Oxford (C. Heath)
62 Coventry, Warwickshire (C. Heath)
75 Leicester Abbey, Leicestershire (C. Heath)
76 Llanberris Lake and Snowdon, Caernarvonshire (C. Heath)
77 Dudley, Worcestershire (C. Heath)
78 Arundel Castle, Sussex (C. Heath)
The drawing of Kidwelly was also included in this exhibition but omitted from the catalogue (see 78).

LIST OF ENGRAVINGS

The following lists the engravings from these drawings in their published order. The first number (i.e., R209) is that accorded the engraving by W. G. Rawlinson in his catalogue *The Engraved Work of* *J. M. W. Turner, R.A.*, Volume 1 (London, 1908). This is followed by the number of the watercolour as reproduced in this book, the work's title, the name of the engraver and its date of publication.

Rawlinson Number	Plate No	Title	Engraver	Date of Publication
R209	2	*Rivaulx Abbey, Yorkshire*	E. Goodall	1.3.1827
R210	3	*Lancaster, from the Aquaduct Bridge*	R. Wallis	1.3.1827
R211	4	*Dartmouth Cove*	W. R. Smith	1.3.1827
R212	5	*Bolton Abbey, Yorkshire*	R. Wallis	1.3.1827
R213	6	*Colchester, Essex*	R. Wallis	1.6.1827
R214	7	*Fall of the Tees, Yorkshire*	E. Goodall	1.6.1827
R215	10	*Richmond, Yorkshire*	W. R. Smith	1.6.1827
R216	9	*Launceston, Cornwall*	J. C. Varrall	1.6.1827
R217	8	*Barnard Castle, Durham*	R. Wallis	1.12.1827
R218	1	*Saltash, Cornwall*	W. R. Smith	1.12.1827
R219	12	*Aldborough, Suffolk*	E. Goodall	1.12.1827
R220	13	*Orford, Suffolk*	R. Brandard	1.12.1827
R221	97	*Straits of Dover*	W. Miller	1.3.1828
R222	11	*Prudhoe Castle, Northumberland*	E. Goodall	1.3.1828
R223	14	*Valle Crucis Abbey, Denbighshire*	J. C. Varrall	1.3.1828
R224	15	*Buckfastleigh Abbey, Devonshire*	R. Wallis	1.3.1828
R225	88	*Entrance to Fowey Harbour, Cornwall*	W. R. Smith	Jan, 1829
R226	17	*Okehampton, Devonshire*	Willmore	Jan, 1829
R227	16	*Lancaster Sands*	R. Brandard	Jan, 1829
R228	19	*Knaresborough, Yorkshire*	T. Jeavons	Jan, 1829
R229	20	*Malmsbury Abbey, Wiltshire*	J. C. Varrall	1829
R230	21	*Kilgarren Castle, Pembroke*	Willmore	1829
R231	22	*Exeter*	T. Jeavons	1829
R232	23	*Richmond, Yorkshire [From the Moors]*	Willmore	1829
R233	18	*Louth, Lincolnshire*	W. Radclyffe	1829
R234	26	*Great Yarmouth, Norfolk*	W. Miller	1829
R235	25	*Stonehenge, Wiltshire*	R. Wallis	1829
R236	102	*Hampton Court Palace*	C. Westwood	1829
R237	27	*Devonport and Dock Yard, Devonshire*	T. Jeavons	15.3.1830
R238	28	*Dunstanborough Castle, Northumberland*	R. Brandard	15.3.1830
R239	29	*Carisbrook Castle, Isle of Wight*	C. Westwood	15.3.1830
R240	30	*Cowes, Isle of Wight*	R. Wallis	15.3.1830
R241	31	*Stamford, Lincolnshire*	W. Miller	1.5.1830
R242	32	*Alnwick Castle, Northumberland*	Willmore	1.5.1830
R243	33	*Holy Island, Northumberland*	Tombleson	1.5.1830
R244	35	*Stoneyhurst, Lancashire*	J. B. Allen	1.5.1830
R245	34	*Winchelsea, Sussex*	J. Henshall	1830
R246	98	*Trematon Castle, Cornwall*	R. Wallis	1830
R247	99	*St Mawes, Cornwall*	J. H. Kernot	1830
R248	36	*Walton Bridge, on Thames, Surrey*	J. C. Varrall	1830
R249	37	*Ludlow Castle, Shropshire*	R. Wallis	1831
R250	38	*Folkestone Harbour and Coast to Dover*	J. Horsburgh	1831
R251	90, 91	*Tynemouth, Northumberland*	W. R. Smith	1831
R252	39	*Gosport, Entrance to Portsmouth Harbour*	R. Brandard	1831
R253	40	*Windsor Castle, Berkshire*	W. Miller	1831
R254	41	*Eton College, Berkshire*	W. Radclyffe	1831
R255	92	*Bedford, Bedfordshire*	Willmore	1831
R256	42	*Pembroke Castle, Wales*	T. Jeavons	1831
R257	44	*Richmond Hill and Bridge, Surrey*	W. R. Smith	1832
R258	43	*Malvern Abbey and Gate, Worcestershire*	J. Horsburgh	1832

Rawlinson Number	Plate No	Title	Engraver	Date of Publication
R259	46	*Plymouth, Devonshire*	W. J. Cooke	1832
R260	24	*Salisbury, Wiltshire*	W. Radclyffe	1.6.1830
R261	48	*St Catherine's Hill, Nr Guildford, Surrey*	J. H. Kernot	1832
R262	94	*Chatham, Kent*	W. Miller	1832
R263	47	*Margate, Kent*	R. Wallis	1832
R264	96	*Ashby-de-la-Zouch, Leicestershire*	W. Radclyffe	1832
R265	50	*Warwick Castle, Warwickshire*	R. Wallis	1832
R266	51	*Kenilworth Castle, Warwickshire*	T. Jeavons	1832
R267	49	*Brinkburn Priory, Northumberland*	J. C. Varrall	1832
R268	55	*Tamworth Castle, Staffordshire*	Willmore	1832
R269	54	*Ely Cathedral, Cambridgeshire*	T. Higham	1833
R270	52	*Blenheim, Oxfordshire*	W. Radclyffe	1833
R271	56	*Castle Upnor, River Medway*	J. B. Allen	1833
R272	57	*Laugharne Castle, Caernarvonshire*	J. Horsburgh	1833
R273	58	*Coventry, Warwickshire*	S. Fisher	1833
R274	59	*Nottingham, Nottinghamshire*	W. J. Cooke	1833
R275	60	*Carew Castle, Pembrokeshire*	W. Miller	1834
R276	61	*Penmaen-Mawr, Caernarvonshire*	Willmore	1834
R277	62	*Christ Church College, Oxford*	J. Redaway	1834
R278	93	*Arundel Castle and Town, Sussex*	T. Jeavons	1834
R279	64	*Llandberis Lake, Wales*	Willmore	1834
R280	100	*Leicester Abbey, Leicestershire*	W. R. Smith	1834
R281	65	*Caernarvon Castle, Wales*	W. Radclyffe	1835
R282	66	*Dudley, Worcestershire*	R. Wallis	1835
R283	67	*Boston, Lincolnshire*	T. Jeavons	1835
R284	68	*Ullswater, Cumberland*	Willmore	1835
R285	69	*Powis Castle, Montgomery*	Willmore	1836
R286	70	*Worcester, Worcestershire*	T. Jeavons	1835
R287	71	*Llanthony Abbey, Monmouthshire*	Willmore	1836
R288	73	*Longships Lighthouse, Lands End*	W. R. Smith	1836
R289	72	*Beaumaris, Isle of Anglesea*	W. R. Smith	1836
R290	74	*Lyme Regis*	T. Jeavons	1836
R291	101	*Harlech Castle, North Wales*	W. R. Smith	1836
R292	75	*Flint Castle, North Wales*	J. H. Kernot	1836
R293	76	*Lowestoffe, Suffolk*	W. R. Smith	1837
R294	78	*Kidwelly Castle, South Wales*	T. Jeavons	1837
R295	77	*Keswick Lake, Cumberland*	W. Radclyffe	1837
R296	79	*Llangollen, North Wales*	Willmore	1837
R298	82	*Winander-Mere, Westmoreland*	Willmore	1837
R299	81	*Whitehaven, Cumberland*	W. R. Smith	1837
R300	83	*Crickieth Castle, North Wales*	S. Fisher	1837
R301	95	*Rochester, Stroud and Chatham, Medway, Kent*	J. C. Varrall	1838
R302	84	*Chain Bridge over the River Tees*	W. R. Smith	1838
R303	85	*Richmond Terrace, Surrey*	Willmore	1838
R304	86	*Mount St Michael, Cornwall*	S. Fisher	1838

Others

Rawlinson Number	Plate No	Title	Engraver	Date of Publication
R314	45	*Richmond Hill*	E. Goodall	1826

NOTES

CHAPTER 1

1 Quoted in A. J. Finberg, *The Life of J. M. W. Turner, R.A.*, 2nd Ed (London, 1961) p. 297.

2 There are a number of reasons to assume it was in the summer of 1825 (and not 1826 as stated by Rawlinson) that the project was incepted. Apart from the essential evidence of Alaric Watts quoted later, the Publisher's 'crash' of January 1826, the general economic crash of December 1825 and the death of Fawkes in October 1825 would suggest that the agreement between Heath and Turner was reached either in the early autumn or, more probably, in the summer of 1825, Turner being on the Continent during late August and September. Finberg goes some way to support this assumption: 'the agreement . . . was probably made before the crash among the publishers occurred' (*op cit*, p. 297). Work on the engravings commenced during 1826 but Turner must have made the first group of drawings for the series before Fawkes's death. There is a discernible change in their mood around this time.

3 W. G. Rawlinson, *The Engraved Works of Turner* (London, 1908) Vol I, p. xlvii.

4 Finberg, *op cit.* p. 375.

5 Alaric Watts, biographical sketch, *Liber Fluviorum* (London, 1853) p. xxix.

6 Henry Vizitelly, *Glances back through 70 years* (London, 1893) pp. 143–4.

7 A. Alfred Watts, *Alaric Watts* (London, 1884) pp. 268–272. Longman ledger books record taking over the *Book of Beauty* and other publications in 1831.

8 This dating further suggests 1825 as the year of origin of the project. Turner may well have intended the patriotic *Saltash* to appear as the first image in the series and its late appearance in part III of the engravings may have been caused by delays during engraving.

9 Rawlinson, *op cit*, p. 117.

10 Mrs Tennant will be publishing the letter in full in the near future and I am indebted to her for permitting me to quote this excerpt.

11 There is a copy of it in the Dodds *Manuscript History of Engravers* (British Museum, Addit Ms 33401).

12 J. Rewald, '*Extraits du Journal Inedit de Paul Signac*', *Gazettes des Beaux Arts*, 39, 1952, pp. 156–7.

13 C. W. Radcliffe, *Catalogue of the Exhibition of Engravings by Birmingham Engravers* (Birmingham, 1877) pp. 5–6.

14 Rawlinson, *op cit*, p. lxiv.

15 Only the 'Liber Studiorum' is considered to be the engraved work of Turner himself on account of his having etched the first outlines personally. These impressions, rare as they are, consequently fetch the highest prices.

16 Frederick Goodall RA, *Reminiscences* (London, 1902) p. 57.

17 *ib*, pp. 50–51.

18 For this reason I have reproduced some drawings that might as easily have found their way into the 'England and Wales' series.

19 Obviously the drawing of *Richmond Hill and Bridge*.

20 The review goes on to mention briefly six other drawings.

21 Finberg, *op cit*, p. 323.

22 Goodall, *op cit*, pp. 56–7.

23 p. 75.

24 This includes *Kidwelly*, not engraved until 1837. Both Finberg (p. 514) and Sir Walter Armstrong (*Turner*, London, 1902, p. 260) tell us that this drawing was exhibited in the 1833 exhibition but inadvertently omitted from its catalogue. Unfortunately neither of them gives the source of their information although it was probably a newspaper review that I have been unable to trace. However, as Finberg usually errs on the side of caution I see no reason not to accept this information and the drawings inclusion in the show predates its engraving by four years.

25 Now in the collection of the British Museum, Department of Prints and Drawings.

26 *The University Magazine*, Vol I, No V, 1878, p. 301.

27 Details of the quarrel are given in the *Memoirs and Reminiscences* of Abraham Raimbach (London, 1843) pp. 135–6 and 141.

28 Longman note the takeover in their commission Ledger C5, folio 587 ff. The Longman Ledger books are in the collection of the Dept of Archives and Manuscripts, University of Reading, Berkshire.

29 Finberg, *op cit*, p. 375.

30 *ib*, p. 342.

31 Although the 1833 catalogue descriptions are anonymous, identical passages in the letterpress establish Lloyd as the author of the exhibition catalogue. To compare them see the two respective entries for *Dartmouth Cove*.

32 Although various writers have stated that Heath went bankrupt I have been unable to find any record of official bankruptcy proceedings against him either in the Public Record Office or in *The Times* index of bankruptcies between 1830 and 1841.

33 Here a slight discrepancy arises. Longman recorded the result of this part of the sale in their Commission Ledger No 6, Folio 526, where they note: 'Mem[o]: all the volumes, letterpress, odd plates and reprints made into sets and sold at Southgates £3063-3/-6d.' This must be the sum paid by Turner. The £63-3/-6d was most probably the storage and removal charge for the stock which was considerably bulky.

34 Alaric Watts, *art cit*, p. xxi.

35 I estimate this as follows:
payments to engravers @ £100 each £9,600
payments to Turner @ average
£25–30 per drawing £2,400–2,880
paper, coppers, printing costs etc. £3,000–5,000
TOTAL £14,000–17,480

36 Alaric Watts refers in his *Biographical sketch* to 'so Flemish a balance of profit' accruing to the publishers ('Fleming' meaning fine, as in the fineness of Flemish painting) and by this he may have meant gross profit (i.e., income *before* deductions for costs) in which case the sale of the engravings must have been very minute. If on the other hand he meant net profit (i.e., profit *after* expenses had been paid), even a tiny profit would have meant a loss in real terms if it neither afforded Heath any income or his publishers any substantial return on capital invested. I think that it is more likely, considering the length of time that the scheme lasted (twelve or so years) that the latter was the case, but sales must have dried up by the mid 1830s.

37 C. F. Bell, 'Turner and his Engravers', published in *The Genius of Turner*, (London, 1903) pp. E-xxi-xxii.

CHAPTER 2

1 Now in the collection of Hounslow Library Services, London.
2 Preface to *The Harbours of England by J. M. W. Turner, R.A.* (Gambart, 1856).
3 Most notably by P. G. Hamerton in his *Life of J. M. W. Turner* (London, 1879) pp. 201–2. Apart from being incorrect on some minor details Hamerton completely missed the point of the series whose connection lies not in the range of its landscape depiction but in its survey of mankind.
4 The drawing is now in the Cecil Higgins Art Gallery, Bedford. A full account of its creation is given in Martin Butlin's *Turner Watercolours* (London, 1962) p. 36. It is also reproduced there in colour.
5 Quoted in Finberg, *op cit*, p. 293.
6 *Notes by Mr Ruskin on his drawings by . . . J. M. W. Turner*, (London, 1878) pp. 33–34.
7 Finberg, *op cit*, p. 322.
8 Ruskin, *Modern Painters* 1897 Ed, Vol V, p. 325.
9 Rawlinson, *op cit*, p. 'l'.
10 Ruskin, *Modern Painters*, 1897, p. 368n.
11 Rawlinson, *op cit*, p. 'l'.
12 Ruskin, 1897, p. 201.
13 Television programme: *Seeing Through Drawing* (BBC 2). Transmitted 11 March 1978.
14 Further evidence of Turner's phenomenal memory resides in the fact that although he titled the sketchbooks he rarely titled the pages. He must, therefore, have remembered the names and locations of thousands of places depicted. As can be imagined such a mind would easily have remembered the Boswell.
15 W. Stokes in R. G. Graves's *Studies in Physiology and Medicine*, 1863, p. xi.
16 Walter Shaw Sparrow on Turner's watercolours in *The Genius of Turner* (London, 1903) pp. W/vii–viii.
17 W. Robinson, *The History and Antiquities of Tottenham*, Vol I, 1840, pp. 83–90, discusses Windus's collection in detail.
18 B. Webber, *James Orrock, R.I.* (London, 1903) Vol I, pp. 60–1.
19 W. L. Leitch, 'The Early History of Turner's Yorkshire Drawings' (*The Atheneum*, London, 1894, p. 327).
20 John Gage, *Colour in Turner* (London, 1969) p. 8.
21 This interview with John Pye is recorded in a handwritten note by Dr John Percy, dated 11 April, 1869. It is now in the collection of the British Museum Department of Prints and Drawings where it is kept with the very rare impression of the *Wycliffe* engraving that is reproduced (*see* Ill. 6).
22 Rawlinson, *op cit*, p. 35.
23 Ruskin, *Notes, 1878*, p. 40.

THE COMMENTARIES

1 Rawlinson, *op cit*, p. 119.
2 J. Ruskin, *Modern Painters*, 1897 Edition, Vol V, p. 323.
3 Ruskin, *op cit*, 1897, Vol III, pp. 127–8.
4 A.J. Finberg, *Turners Sketches and Drawings* (2nd Ed, London 1911, pp. 111–112).
5 Rawlinson, *op cit*, p. 122.
6 Ruskin, *op cit*, 1897, Vol. 1 p. 340.
7 Rawlinson, *op cit*, p. 126.
8 Andrew Wilton, *Turner in the British Museum* (London, 1975) p. 109.
9 Ruskin, *op cit*, 1897, Vol I, p. 274.
10 Ruskin, *op cit*, 1878, p. 42.
11 Rawlinson, *op cit*, p. 131.
12 *ib*, p. 129.
13 *ib*, p. 130.
14 Ruskin, 1897, Vol V, pp. 162–3.
15 Ruskin, *op cit*, 1897, Vol I, pp. 276–77.
16 Louis Hawes, *Constable's Stonehenge* (London 1975) p. 17.
17 Ruskin, *op cit*, 1897, Vol. I, p. 406n.
18 Ruskin, *op cit*, 1878, p. 38.
19 Ruskin, *op cit*, 1897, Vol V, p. 323.
20 Rawlinson, *op cit*, p. 136.
21 Ruskin, *Pre-Raphaelitism*, 1904 Ed, p. 384.
22 Ruskin, *op cit*, 1878, p. 39.
23 *ib*, pp. 35–36.
24 Article by P. G. Palmer entitled 'Katern Hill Fair' which appeared in *The Keep*, the magazine of the Guildford Institute, October 1915, pp. 4–5. The name of the woman is not given but her account, recorded in 1893, is described as 'lucid'.
25 The work is listed in Armstrong (*op cit*) and his description of it clearly relates it to Scott's novel: 'Reception of Elizabeth by Leicester. Full moon rising to left of castle, reflected in water. Castle lit up by fireworks with wreaths of smoke. Crowded F[oreground].' The work is tiny ($3\frac{3}{8} \times 5\frac{1}{4}$ in), although it does not appear to be a vignette.
26 Ruskin, *Præterita*. Vol II, (London, 1908), pp. 305–6.
27 Eric G. Forrester, *Northamptonshire County Elections and Electioneering 1695–1832* (Oxford University Press, 1941), p. 128.
28 As John Gage points out (*Turner, Rain, Steam and Speed*, London, 1972, p. 19) Turner may have also referred to this dance in his 1844 oil-painting *Rain, Steam and Speed* where he juxtaposes the railway train (i.e., speed) with a distant ploughman ('speed the plough').
29 This meeting was held at the Crown and Anchor Tavern in the Strand on 25 May, 1829. It celebrated the 22nd anniversary of the election to Parliament of Sir Francis Burdett who, characteristically, was himself absent. Present, however, at the meeting were Hunt, French, Cobbett, Hobhouse and Daniel O'Connell.
30 Letter to the Home Office (HO 52/47) from J. H. Rees, Llanelli, 11 December, 1840.
31 Ruskin, 1897, Vol I, pp. 398–99.
32 *ib*, p. 270.
33 Ruskin, 1897, Vol IV, p. 31.
34 Ruskin, 1897 Vol I, p. 382.
35 *ib*, p. 343.
36 Robinson, *op cit*, p. 90.
37 Ruskin, 1897, Vol I, p. 342.
38 *ib*, p. 393.
39 *ib*, p. 267.
40 *ib*, pp. 269–70, 401.
41 Daniel Defoe, *Tour through the whole island of Great Britain*, 1962 Ed, vol I, p. 71.
42 Ruskin, 1897, Vol I, pp. 397–98.
43 *ib*, pp. 389–90, 418.
44 Rawlinson, *op cit*, p. 141.
45 *ib*, p. 148.
46 *ib*, pp. 125–6.
47 Ruskin, *op cit*, 1878, p. 43.